PHOTO-
GRAPHY

CURRENT PERSPECTIVES

INTRODUCTION

The preparation of this book began with the following letter sent to prospective contributors: "The Massachusetts Review, *as a journal of literature, the arts, and public affairs has had a long-standing interest in presenting works of art from all media within a general aesthetic and cultural context. We have now received a grant from the National Endowment for the Arts which will allow us to devote one of our quarterly issues to highlighting the current debate between proponents of photography as a detached, symbolic, and formalistic art and those who regard the photographer as necessarily mediating between the objective world and a particular, humanistic, and engaged vision of it. This debate concerns the formal properties of the photograph, as well as the attitude of the photographer toward both the photographic object and the larger world in which both photographer and object participate. To address this problem, we are printing a large number of full-page black and white photographs with accompanying statements from photographers and critics about their own conception of the nature of the art. The philosophical and aesthetic implications of this debate should be addressed, and we hope this 'issue' will interest you and that you would consider becoming a contributor.*"

The following issue of The Massachusetts Review *is the response of our contributors to the above request. The writers, critics, photographers included have used the "issue" as a rallying point pertinent to their own point of view, or as a point of departure to broaden the scope of the discussion. Still others have made their own way and their own 'issues.'*

All continuously reinforce through their photographs and writing the vitality that photography presents for concerned thought in the arts and culture.

Jerome Liebling
Editor

CONTRIBUTORS

JAMES AGEE (1909-1955) well-known American writer, close friend of Walker Evans and Helen Levitt, was co-author (with Walker Evans) of *Let Us Now Praise Famous Men*. BILL ARNOLD is a photographer, former chairman of the Photography Department at Pratt Institute, and organizer of the Bus Show. KATE CARLSON is a graduate student in education-photography at the University of Massachusetts at Amherst. CARL CHIARENZA, photographer, writer, and teacher is the biographer of Aaron Siskind and chairman of the Department of Art History at Boston University. ROGER COPELAND is a professor in the Inter-Arts at Oberlin College and has written extensively on dance and the arts for the *New York Times*, *The New Republic*, and other publications.

Copyright, 1978, THE MASSACHUSETTS REVIEW, INC.
Hard Cover Edition
LIGHT IMPRESSIONS CORPORATION
P.O. Box 3012, Rochester, N.Y. 14614
ISBN 0-87992-013-0

JAMES P. ADAMS LIBRARY
RHODE ISLAND COLLEGE

WALKER EVANS (1903-1975) was one of America's foremost photographers. His well-known books include *Let Us Now Praise Famous Men* (with James Agee), *Messages From the Interior*, and *Many Are Called*. ROBERT FRANK has been actively involved as a film maker since publishing his master work in photography, *The Americans*. ANNE HALLEY is a poet and fiction writer, has translated Kurt Tucholsky's book *Deutschland, Deutschland Uber alles*. ROBERTA HELLMAN and MARVIN HOSHINO have written for *The Village Voice* and *Arts Magazine*. BILL JAY, Professor of Photography at Arizona State, is a writer and editor.

ESTELLE JUSSIM teaches Film and Visual Communication in the Graduate School of Simmons College, Boston. She is the author of *Visual Communication and the Graphic Arts* (1974). HELEN LEVITT is a well-known photographer and film maker. Her films include *In the Street* and *The Quiet One* (with James Agee and Janice Loeb). Her book of photographs is called *A Way of Seeing*. JEROME LIEBLING is professor of Film and Photography at Hampshire College. He has exhibited widely and is the subject of a recent monograph written by Estelle Jussim and published by Friends of Photography (Carmel, California). ELIZABETH LINDQUIST-COCK has recently published *Influence of Photography on American Landscape Painting*. ROBERT LYONS, photographer and photography conservationist, is presently studying at Yale University.

WRIGHT MORRIS, author and photographer, has long been concerned in relating photography and literary text. His books include *The Inhabitants*, *The Home Place*, and *God's Country and My People*. A forthcoming book, *Earthly Delights, Unearthly Adornments*, concerns American writers as image-makers. AUGUST SANDER (1876-1964) was a distinguished German photographer whose masterwork, *Men Without Masks* continues to exert influence on new generations of photographers. ALLAN SEKULA teaches at the University of California, San Diego, works with video as well as photography. AARON SISKIND, among the foremost of American photographers, works from his home in Providence, Rhode Island. The bulk of his work is now with the Photographic Center, University of Arizona in Tucson. MAREN STANGE is completing her Ph.D. in American Studies at Boston University. She has written on photography for the *New Boston Review*.

SALLY STEIN received her M.F.A. from the Rhode Island School of Design, and teaches photographic history at Parsons School of Design. JOHN SZARKOWSKI, author of *The Idea of Louis Sullivan* (1956) and *The Face of Minnesota* (1958), is presently director of photography at the New York Museum of Modern Art. ALAN TRACHTENBERG, professor of American Studies at Yale University, has written extensively on aspects of American culture and photography. PAUL VANDERBILT studied with Clarence White, Sr., worked with Roy Stryker, held the Chair of Fine Arts at the Library of Congress, and is Curator emeritus for the Wisconsin State Historical Society. ROBERT WILCOX (1925-1970) lived and worked in Wisconsin and Minnesota and graduated from the University of Minnesota. His work is in the Robert Wilcox Collection of the Minneapolis Institute of Art.

3

ACKNOWLEDGMENTS

James Agee's essay is from *Many Are Called* by Walker Evans, reprinted here with permission by Houghton Mifflin. "Photography" by Walker Evans is from *Quality: Its Image in the Arts*, edited by Louis Kronenberger, Balance House, New York. Photographs of August Sander are by courtesy of the Sander Gallery, Washington D.C. and C.J. Boucher of Luzern and Frankfurt. Photographs by Lewis Hine are with the permission of International Museum of Photography, George Eastman House, Rochester, New York. Photographs by Walker Evans appear by permission of the Walker Evans estate. For help in the preparation of photographs by Robert Wilcox we are indebted to Ted Hartwell and Allen Schumeister of the Minneapolis Institute of Art. The photograph by Alfred Stieglitz appears with the permission of Georgia O'Keeffe. Mishiko Yajima, of the Yajima Gallery of Montreal, supplied the photographs by Robert Frank. Credits for cover photographs are as follows: the photograph of Robert Frank is by Roberta Neiman; that of Paul Vanderbilt by Barbara Crane; James Agee by Walker Evans; the painting of Helen Levitt is by Janice Loeb. This collection has been made possible by a grant from the National Endowment for the Arts, Washington, D.C.

CONTENTS

IN OUR IMAGE

WRIGHT MORRIS

LET US IMAGINE a tourist from Rome, on a conducted tour of the provinces, who takes snapshots of the swarming unruly mob at Golgotha, where two thieves and a rabble rouser are nailed to crosses. The air is choked with dust and the smoke of campfires. Flames glint on the helmets and spears of the soldiers. The effect is dramatic, one that a photographer would hate to miss. The light is bad, the foreground is blurred, and too much is made of the tilted crosses, but time has been arrested, and an image recorded, that might have diverted the fiction of history. What we all want is a piece of the cross, if there was such a cross. However faded and disfigured, this moment of arrested time authenticates, for us, time's existence. Not the ruin of time, nor the crowded tombs of time, but the eternal present in time's every moment. From this continuous film of time the camera snips the living tissue. So that's how it was. Along with the distortions, the illusions, the lies, a specimen of the truth.

That picture was not taken, nor do we have one of the flood, or the crowded ark, or of Adam and Eve leaving the garden of Eden, or of the Tower of Babel, or the beauty of Helen, or the fall of Troy, or the sacking of Rome, or the landscape strewn with the debris of history —but this loss may not be felt by the modern film buff who might prefer what he sees at the movies. Primates, at the dawn of man, huddle in darkness and terror at the mouth of a cave: robots, dramatizing the future, war in space. We see the surface of Mars, we see the moon, we see planet earth rising on its horizon. Will this image expand the consciousness of man or take its place among the ornaments seen on T-shirts or the luncheon menus collected by tourists? Within the smallest particle of traceable matter there is a space, metaphorically speaking, comparable to the observable universe. Failing to see it, failing to grasp it, do we wait for it to be photographed?

There is a history of darkness in the making of images. At Peche Merle and Altamira, in the recesses of caves, the torchlit chapels of worship and magic, images of matchless power were painted on the walls and ceilings. These caves were archival museums. Man's faculty for image-making matched his need for images. What had been seen in the open, or from the cave's mouth, was transferred to

5

the interior, the lens in the eye of man capturing this first likeness. The tool-maker, the weapon-maker, the sign-maker, is also an image-maker. In the fullness of time man and images proliferate. Among them there is one God, Jehovah, who looks upon this with apprehension. He states his position plainly.

> Thou shalt not make unto thee any
> graven image, or any likeness of
> any thing that is in heaven above,
> or that is in the earth beneath, or
> that is in the water under the earth:
> . . . for I the Lord thy God am a jealous
> God. . . .

Did Jehovah know something the others didn't, or would rather not know? Did he perceive that images, in their kind and number, would exceed any likeness of anything seen, and in their increasing proliferation displace the thing seen with the image, and that one day, like the Lord himself, we would see the planet earth orbiting in space, an image, like that at Golgotha, that would measurably change the course of history, and the nature of man.

Some twenty years ago, in San Miguel Allende, Mexico, I was standing on a corner of the plaza as a procession entered from a side street. It moved slowly, to the sombre beat of drums. The women in black, their heads bowed, the men in white, hatless, their swarthy peasant faces masks of sorrow. At their head a priest carried the crucified figure of Christ. I was moved, awed, and exhilarated to be there. For this, surely, I had come to Mexico, where the essential rituals of life had their ceremony. This was, of course, not the first procession, but one that continued and sustained the tradition. I stood respectfully silent as it moved around the square, in the direction of the church. Here and there an impoverished Indian, clutching a baby, looked on. The pathetic masquerade of a funeral I had observed in the States passed through my mind. Although a photographer, I took no photographs. At the sombre beat of the drums the procession approached the farther corner, where, in the shadow of a building, a truck had parked, the platform crowded with a film crew and whirring cameras. The director, wearing a beret, shouted at the mourners through a megaphone. This was a funeral, not a fiesta, did they understand? They would now do it over, and show a little feeling. He wrung his hands, he creased his brows. He blew a whistle,

and the columns broke up as if unravelled. They were herded back across the square to the street where they had entered. One of the mourners, nursing a child, paused to ask me for a handout. It is her face I see through a blur of confusing emotions. In my role as a gullible tourist, I had been the true witness of a false event. Such circumstances are now commonplace. If I had been standing in another position or had gone off about my business, I might still cherish this impression of man's eternal sorrow. How are we to distinguish between the real and the imitation? Few things observed from one point of view only can be considered *seen*. The multifaceted aspect of reality has been a commonplace since cubism, but we continue to see what we will, rather than what is there. Image-making is our preference for what we imagine, to what is there to be seen.

With the camera's inception an *imitation of life* never before achieved was possible. More revolutionary than the fact itself, it might be practiced by anybody. Intricately part of the dawning age of technology, the photographic likeness gratified the viewer in a manner that lay too deep for words. Words, indeed, appeared to be superfluous. Man, the image-maker, had contrived a machine for making images. The enthusiasm to take pictures was surpassed by the desire to be taken. These first portraits were daguerreotypes, and the time required to record the impression on a copper plate profoundly enhanced the likeness. Frontally challenged, momentarily "frozen," the details rendered with matchless refinement, these sitters speak to us with the power and dignity of icons. The eccentrically personal is suppressed. A minimum of animation, the absence of smiles and expressive glances, enhances the aura of suspended time appropriate to a timeless image. There is no common or trivial portrait in this vast gallery. Nothing known to man spoke so eloquently of the equality of men and women. Nor has anything replaced it. With a strikingly exceptional man the results are awesome, as we see in the portraits of Lincoln: the exceptional, as well as the common, suited the heroic mould of these portraits. Fixed on copper, protected by a sheet of glass, the miraculous daguerreotype was a unique, one-of-a-kind creation. No reproductions or copies were possible. To make a duplicate one had to repeat the sitting.

Although perfect of its kind, and never surpassed in its rendering of detail, once the viewer's infatuation had cooled, the single, unique

image aroused his frustration. Uniqueness, in the mid-19th century, was commonplace. The spirit of the age, and Yankee ingenuity, looked forward to inexpensive reproductions. The duplicate had about it the charm we now associate with the original. In the decade the daguerreotype achieved its limited perfection, its uniqueness rendered it obsolete, just as more than a century later this singularity would enhance its value on the market.

After predictable advances in all areas of photographic reproduction, it is possible that daguerreotype uniqueness might return to photographic practice and evaluation. This counter-production esthetic has its rise in the dilemma of over-production. Millions of photographers, their number increasing hourly, take billions of pictures. This fact alone enhances rarity. Is it beyond the realm of speculation that single prints will soon be made from a negative that has been destroyed?

Considering the fervor of our adoption it is puzzling that some ingenious Yankee was not the inventor of the camera. It profoundly gratifies our love for super gadgets, and our instinct for facts. This very American preoccupation had first been articulated by Thoreau:

> If you stand right fronting and face to face to a fact, you will see the sun glimmer on both its surfaces, as if it were a cimiter, and feel its sweet edge dividing you through the heart and marrow, and so you will happily conclude your mortal career. Be it life or death, we crave only reality.

This might serve many photographers as a credo. At the midpoint of the 19th century a new world lay open to be seen, inventoried, and documented. It has the freshness of creation upon it, and a new language to describe it. Whitman has the photographer's eye, but no camera.

> Wild cataract of hair; absurd, bunged-up felt hat, with peaked crown; velvet coat, all friggled over with gimp, but worn; eyes rather staring, look upward. Third rate artist.

Or the commonplace, symbolic object:

> Weapon shapely, naked, wan,
> Head from the mother's bowels drawn

Soon enough the camera will fix this image, but its source is in the eye of the image-maker. Matthew Brady and staff are about to photograph the Civil War. In the light of the camera's brief history, does

this not seem a bizarre subject? Or did they intuit, on a moment's reflection, that war is the camera's ultimate challenge? These photographers, without precedent or example, turned from the hermetic studio, with its props, to face the facts of war, the sun glimmering on all of its surfaces. Life or death, what they craved was reality.

A few decades later Stephen Crane stands face to face to a war of his imagination.

> He was being looked at by a dead man who was seated with his back against a columnlike tree. The corpse was dressed in a uniform that once had been blue, but was now shaded to a melancholy shade of green. The eyes, staring at the youth, had changed to the dull hue to be seen on the side of a dead fish. The mouth was open. Its red had changed to an appalling yellow. Over the gray skin of the face ran little ants. One was trundling some sort of bundle along the upper lip.

Crane had never seen war, at the time of writing, and relied heavily on the photographs of Brady and Gardner for his impressions. A decade after Crane this taste for what is real will flower in a new generation of writers. The relatively cold war of the depression of the 1930's will arouse the passions of the photographers of the Farm Security Administration, Evans, Lee, Lange, Vachon, Rothstein, Russell, and others. They wanted the facts. Few facts are as photographic as those of blight. A surfeit of such facts predictably restored a taste for the bizarre, the fanciful, the fabled world of fashion, of advertising, of self-expression, and of the photo as an *image*.

Does the word image flatter or diminish the photographs of Brady, Sullivan, Atget, and Evans? Would it please Bresson to know that he had made an "image" of Spanish children playing in the ruins of war? Or the photographers unknown, numbering in the thousands, whose photographs reveal the ghosts of birds of passage, as well as singular glimpses of lost time captured? Does the word image depreciate or enhance the viewer's involvement with these photographs? In the act of refining, does it also impair? In presuming to be more than what it is, does the photograph risk being less? In the photographer's aspiration to be an "artist" does he enlarge his own image at the expense of the photograph?

What does it profit the photograph to be accepted as a work of art? Does this dubious elevation in market value enhance or dimin-

ish what is intrinsically photographic? There is little that is new in this practice but much that is alien to photography. The photographer, not the photograph, becomes the collectible.

The practice of "reading" a photograph, rather than merely looking at it, is part of its rise in status. This may have had its origin in the close scrutiny and analysis of aerial photographs during the war, soon followed by those from space. Close readings of this sort result in quantities of disinterested information. The photograph lends itself to this refined "screening," and the screening is a form of evaluation. In this wise the "reading" of a photograph may be the first step in its critical appropriation.

A recent "reading" of Walker Evans "attempted to disclose a range of possible and probable meanings." As these meanings accumulate, verbal images compete with the visual—the photograph itself becomes a point of referral. If not on the page, we have them in mind. *The Rhetorical Structure of Robert Frank's Iconography* is the title of a recent paper. To students of literature, if not to Robert Frank, this will sound familiar. The ever expanding industry of critical dissertations has already put its interest in literature behind it, and now largely feeds on criticism. Writers and readers of novels find these researches unrewarding. Fifty years ago Laura Riding observed, "There results what has come to be called Criticism. . . . More and more the poet has been made to conform to literature instead of literature to the poet—literature being the name given by criticism to works inspired or obedient to criticism."

Is this looming in photography's future? Although not deliberate in intent, the apparatus of criticism ends in displacing what it criticizes. The criticism of Pauline Kael appropriates the film to her own impressions. The film exists to generate those impressions. In order to consolidate and inform critical practice, agreement must be reached, among the critics, as to what merits critical study and discussion. These figures will provide the icons for the emerging pantheon of photography. Admirable as this must be for the critic, it imposes a misleading order and coherence on the creative disorder of image-making. Is it merely ironic that the rise of photography to the status of art comes at a time the status of art is in question? Is it too late to ask what photographs have to gain from this distinction? On those occasions they stir and enlarge our emotions, arousing us in a manner that exceeds our grasp, it is as photographs. Do we register a gain, or a loss, when the photographer displaces the photograph, the shock of recognition giving way to the exercise of taste?

10

In Our Image

In the anonymous photograph, the loss of the photographer often proves to be a gain. We see only the photograph. The existence of the visible world is affirmed, and that affirmation is sufficient. Refinement and emotion may prove to be present, mysteriously enhanced by the photographer's absence. We sense that it lies within the province of photography to make both a personal and an impersonal statement. Atget is impersonal. Bellocq is both personal and impersonal.

In photography we can speak of the anonymous as a genre. It is the camera that takes the picture; the photographer is a collaborator. What we sense to be wondrous, on occasion awesome, as if in the presence of the supernatural, is the impression we have of seeing what we have turned our backs on. As much as we crave the personal, and insist upon it, it is the impersonal that moves us. It is the camera that glimpses life as the Creator might have seen it. We turn away as we do from life itself to relieve our sense of inadequacy, of impotence. To those images made in our own likeness we turn with relief.

Photographs of time past, of lost time recovered, speak the most poignantly if the photographer is missing. The blurred figures characteristic of long time exposures is appropriate. How better visualize time in passage? Are these partially visible phantoms about to materialize, or dissolve? They enhance, for us, the transient role of humans among relatively stable objects. The cyclist crossing the square, the woman under the parasol, the pet straining at the leash, are gone to wherever they were off to. On these ghostly shades the photograph confers a brief immortality. On the horse in the snow, his breath smoking, a brief respite from death.

These photographs clarify, beyond argument or apology, what is uniquely and intrinsically photographic. The visible captured. Time arrested. Through a slit in time's veil we see what has vanished. An unearthly, mind-boggling sensation: commonplace yet fabulous. The photograph is paramount. The photographer subordinate.

As a maker of images I am hardly the one to depreciate or reject them, but where distinctions can be made between images and photographs we should make them. Those that combine the impersonality of the camera eye with the invisible presence of the camera holder will mingle the best of irreconcilable elements.

The first photographs were so miraculous no one questioned their specific nature. With an assist from man, Nature created pictures.

11

Wright Morris

With the passage of time, however, man predictably intruded on Nature's handiwork. Some saw themselves as artists, others as "truth seekers." Others saw the truth not in what they sought, but in what they found. Provoked by what they saw, determined to capture what they had found, numberless photographers followed the frontier westward, or pushed on ahead of it. The promise and blight of the cities, the sea-like sweep and appalling emptiness of the plains, the life and death trips in Wisconsin and elsewhere, cried to be taken, pleaded to be reaffirmed in the teeth of the photographer's disbelief. Only when he saw the image emerge in the darkness would he believe what he had seen. What is there in the flesh, in the palpable fact, in the visibly ineluctable, is more than enough. Of all those who find more than they seek the photographer is preeminent.

In his diaries Weston speaks of wanting "the greater mystery of things revealed more clearly than the eyes see—" but that is what the observer must do for himself, no matter at what he looks. What is there to be seen will prove to be inexhaustible.

Compare the photographs of Charles van Schaik, in Michael Lesy's *Wisconsin Death Trip,* with the pictures in *Camera Work* taken at the same time. What is intrinsic to the photograph we recognize, on sight, in van Schaik's bountiful archive. What is intrinsic to the artist we recognize in Stieglitz and his followers. In seventy years this gap has not been bridged. At this moment in photography's brief history, the emergence and inflation of the photographer appears to be at the expense of the photograph, of the miraculous.

If there is a common photographic dilemma, it lies in the fact that so much has been seen, so much has been "taken," there appears to be less to find. The visible world, vast as it is, through overexposure has been devalued. The planet looks better from space than in a close-up. The photographer feels he must search for, or invent, what was once obvious. This may take the form of photographs free of all pictorial associations. This neutralizing of the visible has the effect or rendering it invisible. In these examples photographic revelation has come full circle, the photograph exposing a reality we no longer see.

The photographer's vision, John Szarkowski reminds us, is convincing to the degree that the photographer hides his hand. How do we reconcile this insight with the photo-artist who is intent on maximum self-revelation? Stieglitz took many portraits of Georgia O'Keefe, a handsome unadorned fact of nature. In these portraits we see her as a composition, a Stieglitz arrangement. Only the photog-

rapher, not the camera, could make something synthetic out of this subject. Another Stieglitz photograph, captioned "Spiritual America," shows the rear quarter of a horse, with harness. Is this a photograph of the horse, or of the photographer?

There will be no end of making pictures, some with hands concealed, some with hands revealed, and some without hands, but we should make the distinction, while it is still clear, between photographs that mirror the subject, and images that reveal the photographer. One is intrinsically photographic, the other is not.

Although the photograph inspired the emergence and triumph of the abstraction, freeing the imagination of the artist from the tyranny of appearances, it is now replacing the abstraction as the mirror in which we seek our multiple selves. A surfeit of abstractions, although a tonic and revelation for most of this century, has resulted in a weariness of artifice that the photograph seems designed to remedy. What else so instantly confirms that the world exists? Yet a plethora of such affirmations gives rise to the old dissatisfaction. One face is the world, but a world of faces is a muddle. We are increasingly bombarded by a Babel of conflicting images. How long will it be before the human face recovers the aura, the lustre and the mystery it had before TV commercials—the smiling face a debased counterfeit.

Renewed interest in the snapshot, however nondescript, indicates our awareness that the camera, in itself, is a picture-maker. The numberless snapshots in existence, and the millions still to be taken, will hardly emerge as art objects, but it can be safely predicted that many will prove to be "collectibles." Much of what appears absurd in contemporary art reflects this rejection of romantic and esthetic icons. The deployment of rocks, movements of earth, collections of waste, debris and junk, Christo's curtains and earthbound fences, call attention to the spectacle of nature, the existence of the world, more than they do the artist. This is an oversight, needless to say, the dealer and collector are quick to correct. Among the photographs we recognize as masterly many are anonymous. Has this been overlooked because it is so obvious?

If an automatic camera is mounted at a window, or the intersection of streets, idle or busy, or in a garden where plants are growing,

or in the open where time passes, shadows shorten and lengthen, weather changes, it will occasionally take exceptional pictures. In these images the photographer is not merely concealed, he is eliminated. Numberless such photos are now commonplace. They are taken of planet earth, from space, of the surface of the moon, and of Mars, of the aisles of stores and supermarkets, and of much we are accustomed to think of as private. The selective process occurs later, when the photographs are sorted for specific uses. The impression recorded by the lens is as random as life. The sensibility traditionally brought to "pictures," rooted in various concepts of "appreciation," is alien to the impartial, impersonal photo image. It differs from the crafted art object as a random glance out the window differs from a painted landscape. But certain sensibilites, from the beginning, have appreciated this random glance.

The poet, Rilke, snapped this:

> In the street below there is the following composition: a small wheelbarrow, pushed by a woman; on the front of it, a hand-organ, lengthwise. Behind that, crossways, a baby-basket in which a very small child is standing on firm legs, happy in its bonnet, refusing to be made to sit. From time to time the woman turns the handle of the organ. At that the small child stands up again, stamping in its basket, and a little girl in a green Sunday dress dances and beats a tambourine up toward the windows.

This "image" is remarkably photogenic. Indeed, it calls to mind one taken by Atget. The poet is at pains to frame and snap the picture, to capture the look of life. His description is something more than a picture, however, since the words reveal the presence of the writer, his "sensibility." This very sensitivity might have deterred him from taking the snapshot with a camera. Describe it he could. But he might have been reluctant to take it. In his description he could filter out the details he did not want to expose. From its inception the camera has been destined to eliminate *privacy*, as we are accustomed to conceive it. Today the word describes what is held in readiness for exposure. It is assumed that privacy implies something concealed.

The possibility of filming a life, from cradle to the grave, is now feasible. We already have such records of laboratory animals. If this film were to be run in reverse have we not, in our fashion, triumphed over time? We see the creature at the moment of death, gradually growing younger before our eyes. I am puzzled that some intrepid avant garde film creator has not already treated us to a sampling, say the death to birth of some short-lived creature. We have all shared

14

this illusion in the phenomenon of "the instant replay." What had slipped by is retrieved, even in the manner of its slipping. Life lived in reverse. Film has made it possible. The moving picture, we know, is a trick that is played on our limited responses, and the refinement of the apparatus will continue to outdistance our faculties. Perhaps no faculty is more easily duped than that of sight. Seeing is believing. Believing transforms what we see.

If we were to choose a photographer to have been at Golgotha, or walking the streets of Rome during the sacking, who would it be? Numerous photographers have been trained to get the picture, and many leave their mark on the picture they get. For that moment of history, or any other, I would personally prefer that the photograph was stamped *Photographer Unknown*. This would assure me, rightly or wrongly, that I was seeing a fragment of life, a moment of time, as it was. The photographer who has no hand to hide will conceal it with the least difficulty. Rather than admiration, for work well done, I will feel the awe of revelation. The lost found, the irretrievable retrieved.

Or do I sometimes feel that image proliferation has restored the value of the non-image. Perhaps we prefer Golgotha as it is, a construct of numberless fictions, filtered and assembled to form the uniquely original image that develops in the darkroom of each mind.

Images proliferate. Am I wrong in being reminded of the printing of money in a period of wild inflation? Do we know what we are doing? Are we able to evaluate what we have done?

15

PHOTOGRAPHY

WALKER EVANS

THE EMERGENCE, in some force, of serious, non-commercial still photography as an art is comparatively recent. It may plausibly be dated from the 1930s (not counting the work of a few previous, isolated individuals).

Modern photographers who are artists are an unusual breed. They work with the conviction, glee, pain, and daring of all artists in all time. Their belief in the power of images is limitless. The younger ones, at least, dream of making photographs like poems—reaching for tone, and the spell of evocation; for resonance and panache, rhythm and glissando, no less. They intend to print serenity or shock, intensity, or the very shape of love.

More soberly, the seasoned serious photographer knows that his work can and must contain four basic qualities—basic to the special medium of camera, lens, chemical, and paper: (1) absolute fidelity to the medium itself; that is, full and frank and pure utilization of the camera as the great, the incredible instrument of symbolic actuality that it is; (2) complete realization of natural, uncontrived lighting; (3) rightness of in-camera view-finding, or framing (the operator's correct, and crucial definition of his picture borders); (4) general but unobtrusive technical mastery.

So much for material matters. Immaterial qualities, from the realms of the subjective, include: perception and penetration; authority and its cousin, assurance; originality of vision, or image innovation; exploration; invention. In addition, photography seems to be the most literary of the graphic arts. It will have—on occasion, and in effect—qualities of eloquence, wit, grace, and economy; style, of course; structure and coherence; paradox and play and oxymoron. If photography tends to the literary, conversely certain writers are noticeably photographic from time to time—for instance James, and Joyce, and particularly Nabokov. Here is Nabokov: ". . . Vasili Ivanovich would look at the configurations of some entirely insignificant objects—a smear on the platform, a cherry stone, a cigarette butt—and would say to himself that never, never would he remember these three little things here in that particular interrelation, this pattern, which he could now see with such deathless

16

Photography

precision . . ." Nabokov might be describing a photograph in a current exhibition at the Museum of Modern Art. Master writers often teach how to see; master painters sometimes teach *what* to see.

Mysterious are the ways of art history. There *is* a ground-swell, if not a wave, of arresting still photography at this time, and it may perhaps be traced to the life work of one man: Alfred Stieglitz. Stieglitz was important enough and strong enough to engender a whole field of reaction against himself, as well as a school inspired by and following him. As example of the former, Stieglitz's veritably screaming aestheticism, his personal artiness, veered many younger camera artists to the straight documentary style; to the documentary approach for itself alone, not for journalism. Stieglitz's significance may have lain in his resounding, crafty fight for recognition, as much as it lay in his *oeuvre*. Recognition for fine photography as art. We may now overlook the seeming naiveté of the Stieglitz ego; it wasn't naive at the time, it was a brand of humorless post-Victorian bohemianism. We may enjoy the very tangible fruits of his victories: camera work placed in major art museums, in the hands of discriminating private collectors, and on sale at respectable prices in established galleries. In short, Stieglitz's art was not entirely paradigmatic, but his position was.

As we are all rather tired of hearing, the photographer who knows he is an artist is a very special individual. He really is. After a certain point in his formative years, he learns to do his looking outside of art museums: his place is in the street, the village, and the ordinary countryside. For *his* eye, the raw feast: much-used shops, bedrooms, and yards, far from the halls of full-dress architecture, landscaped splendor, or the more obviously scenic nature. The deepest and purest photographers now tend to be self-taught; at least they have not as a rule been near any formal photography courses. Any kind of informal access to an established master is the best early training of all.

Whether he is an artist or not, the photographer is a joyous sensualist, for the simple reason that the eye traffics in feelings, not in thoughts. This man is in effect voyeur by nature; he is also reporter, tinkerer, and spy. What keeps him going is pure absorption, incurable childishness, and healthy defiance of Puritanism-Calvinism. The life of his guild is combined scramble and love's labor lost.

The meaning of quality in photography's best pictures lies written in the language of vision. That language is learned by chance, not system;

and, in the Western world, it seems to have to be an outside chance. Our overwhelming formal education deals in words, mathematical figures, and methods of rational thought, not in images. This may be a form of conspiracy that promises artificial blindness. It certainly is that to a learning child. It is this very blindness that photography attacks, blindness that is ignorance of real seeing and is perversion of seeing. It is reality that photography reaches toward. The blind are not totally blind. Reality is not totally real.

In the arts, feeling is always meaning. —Henry James. Leaving aside the mysteries and the inequities of human talent, brains, taste, and reputations, the matter of art in photography may come down to this: it is the capture and projection of the delights of seeing; it is the defining of observation full and felt.

THE ROMANTIC MACHINE

TOWARDS A DEFINITION OF
HUMANISM IN PHOTOGRAPHY

BILL JAY

THROUGHOUT THE MEDIUM'S HISTORY, photography has been defined, analyzed, categorized, described; its images have been segregated into movements, style, camps, and ideologies; their contents have been "read" as equivalents, metaphors, allegories. Endless (or seemingly so) debates have raged over functionalism versus expressionism, symbolism versus representationalism, objectivity versus subjectivity, pictorialism versus purism, and a variety of other "antagonisms" that all essentially encompass the same points of disagreement. Photographs are used, misused, described and discussed by specialists from psychology, psychiatry, sociology, anthropology, architecture, history, literature, film, behavioral science and every other discipline to which a name has been given. It is strange (and indeed meaningful) that every academic can find points of recognition and contact within the common room of photography. Even within that esoteric, elitist fraternity of university educators in photography, the medium is approached, and students' work critiqued, from a bewildering diverse set of standards. The result is chronic confusion over the nature of the medium.

Perhaps it is time to understand that such confusion is inevitable. That is, it is inevitable while we persist in clinging to two basic misconceptions about the medium of photography.

It is a misconception to believe that photographic styles and movements have played any significant role in the development of the medium.

It is a misconception to assume that photography can be understood from the *appearance* of the image.

Each of these statements deserve expansion.

Photography of merit is, and always has been, a mixture of antithetical concerns and styles of equal value. At any point in time many, widely different styles and attitudes have coinhabited the field of photography and produced such a plethora of diverse images, all of which could be considered as having merit, that no period in the medium's history has been stamped with the look of a single, domin-

19

ant movement. By and large photography is bereft of styles, groups, movements, collectives. At least, such stylistic movements, when they have existed, have not played such crucial roles in the development of the medium as they have in painting. Efforts at defining photography, at any period, in terms of a manifesto or a group's dictatorial style have always been short-lived—and they have always coexisted, reasonably amicably, with widely different stylistic movements simultaneously. Indeed the arch protagonists of different styles often professed their admiration for each other.

This is not the place to expand on this theme but the reader might consider it instructive to take a decade at random and list the various stylistic attitudes which existed in harmony within the medium. The conclusion of such a test would be that no single "look" of a photograph was predominant at any period. As Susan Sontag has written:

> What is most interesting about photography's career . . . is that no particular style is rewarded; photography is presented as a collection of simultaneous but widely differing intentions and styles, which are not perceived as in any way contradictory.[1]

We can push this point further into the body-photographic. At this level it hits a nerve: any attempt at defining photography by the *appearance* of the image, and that alone, is futile at best, dangerous at worst. Yet what a picture *looks like* is the basis of practically all photographic criticism today.

Even though one must agree with Henry Holmes Smith that "intelligent critical literature on photographs is barely discernible,"[2] an analysis of photographic criticism has been made by John L. Ward in his book *The Criticism of Photography as Art*.[3] Ward has discerned five major approaches to the study of photographs: pictorialism, purism, intentionalism, archetypal criticism and reading.[4] All of these approaches are based on the content of the paper surface.

Without denying the validity of these approaches I should like to suggest that a total understanding of photography based on image appearance is confusing to say the least. Nothing is more disconcerting than to discover that stylistically disparate images seem to be stating identical messages, or that two images of almost identical appearance are diametrically opposed in goals. Photography is damned inconvenient; imagine the dismay of a mother sparrow who builds a nest to protect her eggs, only to find that one hatches into a cuckoo.[5] In the same way, it is natural to build structures in which

to house the photographers' products according to "species" but we must be aware that, all too often, there might be a stranger among the siblings. Such "exceptions" are in too great a number than would be conducive to "prove the point." So how do we deal with such a multiplicity of ambiguities? In the past critics and historians have either ignored the "cuckoos," or built yet another critical structure into which they can be squeezed.

The work of Diane Arbus is a case in point. Since her images did not fit comfortably into any category in common use (a cuckoo in a nest of sparrows), critics, like the mother bird, flew in confusing circles, seemingly powerless to prevent this strange offspring from wrecking the structure of the nest. Even today, a smart student can wreck a teacher's carefully woven argument by innocently or ingeniously asking: what about Diane Arbus? Her photographs are certainly documents of reality, but the assumption that they are mere transcriptions of reality leaves no room for the gothic power of her pictures. But if they are "art," where does the hand/mind of the artist encroach upon the blatant flash-in-the-face approach of a newspaperman recording a traffic accident? The questions are endless; the answers few—if we look only at the surface of the prints.

What a photograph looks like tells us precious little about its meaning. For a more complete answer we must delve deeper and take a dive of faith beyond the print's appearance into the realm of concept and precept. At this level, the issues are clear. It seems to me that there are two basic attitudes worth considering, *neither of which is based on the appearance of the photographic image:* Naturalism and Humanism. Let me admit that both words are unsatisfactory due to connotations borrowed from other associations, but they will suffice, once defined for this specific context. Since definitions all too often require their own definitions, *ad infinitum, ad absurdum,* please keep in mind these two key sentences for the remainder of this discussion.

The naturalistic photograph states *what is.*

The humanistic photograph states *what could or should be.*

NATURALISM

If it is true that the early experience of art was its ability to project the viewer's mind away from the earthbound, material facts of everyday life into the realm of the spirit, it is interesting that the symbolic

functionalism of image-making took a decidedly materialistic turn during the Renaissance. Suddenly, in the early fifteenth century, a new type of vision, a different function of art, occupied man's mind— the desire to organize the appearance of nature in terms of the human figure, to systematically reconstruct in two dimensions familiar objects and views with meticulous exactitude. For the first time the artist's concern was to reveal the objective appearance of reality. As Leonardo da Vinci stated so succinctly:

> The most excellent painting is that which imitates
> nature best and produces pictures which conform most
> closely to the object portrayed.[6]

It is no coincidence that da Vinci describes a mechanical drawing device in his notebooks, or that mechanical and lenticular aids to the artist increased in popularity as the need for accurate transcriptions of reality became more firmly rooted. It is in the Renaissance, as opposed to the 1830s, that the value of the camera (obscura) became apparent. But the introduction of photography was the culmination of art's aspirations since the Renaissance. The dream of transfixing the three-dimensional outer world onto a two-dimensional surface without the intervention of the human hand was realized. It is not surprising, therefore, that during the 1840s and 50s there was no debate concerning the art-nature of photography—it was automatically, almost by definition, a fine art. The (mere) transcription of reality was enough; the prosaic document was Art. Early photographic and lay literature is full of expressions of wonder that such an automatic recording of the minutiae of the real world in such accurate detail was possible. Witness the enthusiasm of Jules Jannin, editor of the influential magazine *L'Artiste,* which was, significantly, the mouthpiece to the avant-garde *Romantic* painters:

> Note well that Art has no contest whatever with this new
> rival [photography], . . . It is the most delicate, the finest,
> the most complete reproduction to which the work of man
> and the work of God can aspire.[7]

The ability of the camera to transcribe reality so intently and accurately not only fulfilled man's artistic quest, but also appeared at exactly the right moment in time to complement a cultural need. The *zeitgeist* was there. All the pieces that made up the jigsaw of photography were available for several decades before the medium's

invention. Johann Zahn, a monk in Wurzburg, described several types of neat, functional and sophisticated camera obscura in 1685. Yet the puzzle was suddenly completed, by a dozen men in various continents, independently and to all extent simultaneously, in the 1830s. The cultural need that catalyzed the introduction of such a documentation process was the urgent interest in the close observation in the *facts* of the material world. The early 1800s were marked by a surge of enthusiasm for categorizations, listings, statistics, data production. The Victorians were fanatical in their passion for collecting details of the physical world in such a multitude of fields as astronomy, anthropology, physiology, physiognomy, botany, geology, sociology. Meaning could wait; the facts, and millions of them, were needed *now*. They were like people possessed, flogging themselves mercilessly in order to appease this tyrant of trivia. Their only satisfaction: a sharp, clear, closeup of the physical world, its people, places and objects, seen not in its entirety but from a conglomeration of detail. No wonder that the microscope, telescope and camera were such indispensable tools of the age. Photography was born, raised and matured within this atmosphere of fanaticism for facts. Photography was, and is, the ideal instrument for examination, for documenting what *is*. The Victorians were appreciative. The Mayor of New York, on examining a daguerreotype marvelled that:

> Every object, however minute, is a perfect transcript of the thing itself; the hair of the human head, the gravel on the roadside, the texture of a silk curtain, or the shadow of the smaller leaf reflected upon the wall, are all imprinted as carefully as nature or art has created them in the objects transferred . . .[8]

In the *Pencil of Nature* Fox Talbot recommended the examination of photographs with a magnifying glass which "often discloses a multitude of minute details, which were previously unobserved and unsuspected."[9]

Photography owes its origin to this desire for detail, for information, for a closeup, impartial, non-judgmental examination of the thing itself. There is no doubt in my mind that the greatest social achievements of photography, even to the present day, have been in this naturalistic spirit. Our knowledge of the material world has been immeasurably enhanced, widened, deepened because of photographs and their all-pervasive abundance. As Sontag has written: "to collect photographs is to collect the world."[10] It might also be said: to make photographs is to reshape the world, because the cam-

era sees no difference in significance between the sublime and the silly. In a photograph, a cup of tea is impressed with the same degree of value as the Grand Canyon. No value judgments are made, except in the sense that photography defines what is worth looking at. One can sense the bemusement, even slight resentment, in Fox Talbot's tone of voice when he acknowledged that: "the instrument chronicles whatever it sees, and certainly would delineate a chimney-pot or a chimney-sweeper with the same impartiality as it would the Apollo of Belvedere." [11]

This is both the power and the bane of photography, evident from its first decades when the prosaic and puny, perhaps a rubber machine, was viewed and in many ways respected as much as the exotic and ambitious, perhaps the pyramids. Since the daguerreotype, however, the problem has been compounded a billion fold, buried as we are under a mountain of sand, each grain an image of an object. Such indiscriminate recording has given us a catalog of trivia that is impossible to understand in terms of value. There is something sad about a truckload of caviar. So the Victorian's desire for facts has come full circle—so many facts defy understanding. The result is a debasement of the idea of naturalism to a superficial, meaningless, "unserious" attitude that has nothing to tell us about ourselves or the world. Now the habit of collecting facts is more significant than the facts themselves, like the partygoer's pleasure in posing for polaroids that no one wants and which are discarded with the beer cans.

With this thought in mind, it is interesting that one of the most potent movements in contemporary photography has been a return to the idea of naturalism in a pure, serious state. I am referring to New Topographics. When first given coherence as a style (at the International Museum of Photography in 1975), it immediately struck a responsive chord in so many young photographers. The reason is not difficult to understand. Apart from the photographers' efforts to define their work in terms of art—ideas, the central core of their work is pure naturalism, taking off directly from the point at which photography intersected the nineteenth-century desire for facts and the Renaissance dream of pure representationalism. New Topographies—which could have been called Original Naturalism—defines the world *as it is*. Appearance is all. The photographers, significantly, refuse to make value judgments, to either praise or condemn the content of their work. The thing exits—therefore it is worth recording. The catalog of the original exhibition[12] contains brief quotations from several of the participating photographers. Phrases and words like: "utilitarian," "of the world," "they describe their subject ac-

curately and objectively"; the photographer has "set aside his imaginings and prejudices," "the ideal photographic document would appear to be without author or art," "prosaic, with the minimum of interference (i.e. personal preference, moral judgment)," "pure subject matter," are typical and highly revealing.

All the photographers in this exhibition tended to use a static camera for their documentations, relying on a straight printing technique ensuring maximum image sharpness and tonal fidelity. But it would be a mistake to see this as a *stylistic* need or bond. The naturalistic photograph owes no such allegiance to the appearance of the image. As one example, I might contrast the *appearance* of their images with those by Garry Winogrand, who shoots fleeting moments with a miniature hand-held camera, distorting tonal values with flash, arbitrarily cropping reality with the frame, tipping the horizontal. Yet, so different in style, his photographs, by his own definition, are naturalistic. They record the subject, as it is, without moral judgments, with a cataloging, sharply focused, objective detachment. He has said: I photograph to find out what something will look like when photographed.

This could be the perfect credo of the naturalistic photographer.

HUMANISM

The antithesis of the naturalistic attitude can be defined as the humanist approach to photography. The photographer is no longer recording what is, but what could or *should be.* Again, we must backtrack into the past to find the path along which this idea developed, and in this case we have to travel in time beyond the Renaissance, when art was not imitation but an incantation. This early experience of art must have been imagery as ritual; a picture *of* a real object but *about* a separate idea embodied in that reality, which stood as a talisman or oracle for messages "from another world." (Having just written those last few words I am reminded of the remark by Bill Brandt:

> I felt that I understood what Orson Welles meant when he said "the camera is much more than a recording apparatus. It is a medium via which messages reach us from another world." and)[13]

This sense of "otherness" is very evident in Brandt's series, *Perspective of Nudes,* or in his images of Avebury and Stonehenge. Al-

though instantly recognizable as women and monoliths, his images are not about the surface facts of the subject, but act as doors, opened a chink, through which we obtain glimpses of Brandt's *personal* relationship with reality. The doors of perception stand slightly ajar.

To the pre-Renaissance worshipper it did not matter whether or not the image over the altar was an accurate representation of the reality that was Jesus; no one cared. The quality inherent in the image was based not on factual accuracy but on its ability to focus attention on an idea or ideal. Perhaps "focus" is the wrong word since it implies a narrowing of the beam of concentration. The function of the icon was, paradoxically, a widening of perception until the trivial details of daily existence seemed inconsequential compared to the individual's broad connection with the expanses of the spirit. As William Gass pointed out: "A flashlight held against the skin might as well be off. Art, like light, needs distance . . ." [14] The icon of Christ, like the humanistic photograph, is a visual aid towards, not an end product of, truth or meaning. And I, for one, find it most interesting and significant that the medium, photography, which fulfilled the naturalist's ideal is the same medium that is performing the pre-Renaissance idea of images as expressions of the romantic spirit.

And here is the essence of humanistic photography. In order to make photographs that transcend "what is," the photographers must make value judgments; in order to make value judgments he must have an all-pervasive personal code of values or ethics; in order to use this code of values he must make choices; in order to make choices he must be aware of the alternatives; in order to understand the alternatives he must have a sure knowledge of, and be constantly involved in, the nature of self. The humanistic photographer has a philosophy or attitude to life based on his personal relationship with reality. This is the real subject of his photographs, not the material objects as they exist; even though they might appear to be *of* something, they are *about* the photographer as a transmitter of messages though metaphor. He deals with the ideal, not the *is*. To exaggerate the position, the naturalist acts as a passive acceptor of facts, and is prone to a deterministic view of life (at least while photographing), while the humanist acts out of volition, towards change.

Value judgements are essential to humanism; they are not essential to the naturalist's attitude.

I believe it was Aristotle who said: history records things as they are, while fiction represents them as they might be or ought to be.

The Romantic Machine

Does this mean that the humanistic photographer is limited to fictional manipulations of reality? Not at all. It is possible, but admittedly difficult, to be a humanistic photographer in the tradition of realism and with a medium as rooted in representation as photography. Art, by which I mean literature and music as well as painting, has always been an indispensible process for communicating a moral idea. It merely means that the nature of photography, its dogmatic assertion of fact, has a built-in inertia barrier which makes the morality more difficult to achieve *and communicate*. The camera is not predisposed to be a romantic machine. But I would argue that the photographer who works from a position of moral volition, acknowledged or denied, produces a body of work which *as a whole* reveals the author's value judgments. For this reason it is next to impossible to gauge a photographer's intent from the appearance of a single image. In photography, quantity is as important as quality. It would be difficult for example, to deduce anything from a single Dorothea Lange photograph of, say, a bed in a sharecropper's cabin,[15] except the literal fact, in a naturalistic vein, that the thing existed as depicted. Yet in the body of Lange's work, seen in quantity, the value judgments of the photographer become powerfully and abundantly evident. This one photograph therefore *can* be selected from the work as a single image, but only because it represents, is a reminder of, the value judgments inherent in the quantity of images produced by the one author. The single picture becomes a talisman of a talisman.

Before misunderstandings occur, it is important to state that moral judgments should not be confused with didactic propaganda. Humanistic photography is not concerned with "real life" and the rectitude of the world's problems in any direct way. In fact, didactic photography usually fails both as art and as propaganda, with a few notable exceptions such as Heartfield and Riefenstahl. Yet so much of humanistic photography *does* seem concerned with the ills of society, and, to confuse the issue, the photographers themselves often state that the function of the image is to solve a specific problem. It has yet to be demonstrated to me that a photograph changes anything; fiction more than fact is a much more potent force for direct social action or for changes in the nature of the audience's behavior. I have never been moved to tears by reading an account or seeing a picture of a car accident in a newspaper; yet I am often moved immeasurably by a fine piece of literature or music. Some degree of aloofness, a standing back, is necessary for humanistic art. (Remember the metaphor of Gass's flashlight.) Direct social action is not synonymous with humanism. The humanistic photographer is less

27

concerned, no matter how much he lies, with the specific event or object, but more with his own value system, integrating and incorporating personal volition, value judgments and the *generalized* relationship of himself as a human being with the real world. It is this two-way, infinitely complex process that defines humanism, not a single picture of a specific event. A humanistic photograph therefore, is about both the photographer and the world simultaneously, the contact point being an object, the print, that signifies both value judgment and volition. It is metaphysical, not factual. Dorothea Lange understood when she wrote:

> . . . the great photograph first asks, then answers, two questions. "Is that my world? What, if not, has that world to do with mine?"

Colin Wilson, in *The Mind Parasites,*[16] uses a beautiful analogy, likening the human mind to an earthbound telescope, scanning the skies for new planets. An astronomer discovers new planets by comparing old star photographs with new ones. If a star has moved, then it is not a star, but a planet. Our minds and feelings are constantly scanning the universe for "meanings." A "meaning" happens when we compare two lots of experience, and suddenly understand something about them both. The naturalistic photographer only uses one star map, and meaning is sacrificed for objective clarity. The humanistic photographer, it must be admitted, is often working with one blurred image, either self or subject, and the position is even more dangerous, for the meanings are arrived at by guesswork or presumption.

The humanistic photograph, then, is about both reality and the mind, which, in unison, reveal value judgment. Subject matter alone is not enough. Let us examine the well-known photograph by Don McCullin[17] of a young Biafran mother, with starvation swollen belly, attempting to suckle a doomed baby from shrunken milk-empty breasts. It might seem shocking to say so, but this is not a humanistic photograph *per se*. The subject belongs to a humanistic attitude and the image depicts an appalling, heart-wrenching fact. This mother existed. But the appearance of the image need not tell the truth. The photograph might or might not be didactic. I would doubt its value as propaganda, horrific as its story might be. The technique is naturalistic—a direct documentation of what is. There is no plea for help, merely a recognition that this woman happened to be in front of McCullin's camera at the moment of exposure. This one image could be as cold and as banal as yet another newspaper picture; or

as moving as Agee prose, if appearance of the picture is the criterion of humanism. The question remains unanswered. Although I feel guilty admitting the fact, this one image, beautiful as it is as a picture, does not stir any depths of emotion within me. I might feel slight pity; but more likely a relief that it is not me. The telephone rings and within seconds I have forgotten its existence. Humanistic photography is not specific—this woman and her baby are irrelevant as individuals, or even as representatives of all the sufferers of the Biafran war. So what is the point of publishing a "good" photograph like this in a news magazine, as opposed to a crap shot by any old Joe? None, except that if a magazine is publishing photographs, it might as well show good ones. But the point is sharpened by placing this photograph in the body of McCullin's work. Don McCullin is a humanist. He has a value system expressed through his medium, for which this particular print serves as a reminder. His talismans are conflict situations. Therefore it is not at all incongruous to see the photographs in a monograph, photography magazine or museum context, where quantity is possible.

As another example of a humanist, whose value judgments pervade his work, yet who works in a stylistic manner widely separated in the photographic spectrum from McCullin, I would mention Robert Heinecken. Even Heinecken's series of a Vietnam soldier carrying two severed heads, overprinted onto magazine advertisements, is not didactic. He has unequivocally stated that he is not interested in making direct political statements. "If I really wanted to do something on the level of the society, I wouldn't be making pictures. I'd be acting in it more directly." [18] Heinecken's work is astonishingly varied in terms of techniques, processes and subject matter—but as a whole his body of work is suffused with the artist's volition and value system. The moral ideal prevails. In one sense, of course, humanism in photography is *always* a political act since it disturbs the *status quo*. The photographer, by the very nature of his insistence on making value judgments, is anti-establishment and therefore radical. Although space does not permit; a discussion of the early nineteenth-century dialog between classicism and romanticism would fit reality into this place, with classicism standing for naturalism, and romanticism for humanism.

Back on the main track, a rail engine might pull widely different freight cars, and humanism in photography pulls many types of people and their pictures. There are differences in the *appearance* of naturalistic photographs but the varieties are nothing like as extreme as in humanism, which encompasses both McCullin and Heinecken. In photographic criticism based on appearance, McCullin would be a

photojournalist with close affinities to a newspaper photographer. In humanistic photography, McCullin and Heinecken are bound much closer together than with any naturalistic attitude. Merely as a point of debate I would throw in the remark that this is the prime difference between New York street photographers, like Winogrand and Fried-lander, and the European equivalent, such as Tony Ray-Jones or Ian Berry. Although the style, manner and content of their pictures seem so similar, they are poles apart in attitude, which is a source of confusion in much analysis of their work based on what the work looks like. The differences are clear if the former are considered naturalistic and the latter humanistic.

If it is irrelevant to categorize photographs according to image appearance in terms of style, it is equally misleading to associate humanistic photography with specific types of subject matter. Slums, starving natives, the old, decrepit, insane and sick are *not* the prerog-atives of the humanistic photographer. No subject is intrinsically a moral issue. Even the decision of the photographer to use ugliness, sickness, or sordidness as a prime motif is not necessarily volitional based on a value system. In fact it is usually naturalistic (yet more *facts*) posing as humanism, and fooling most of the people, most of the time. For the same reasons, humanism should not be confused with sentiment. It is not, *a priori,* a moral or volitional issue to photo-graph mountain streams, picturesque nature, sublime mountains, pretty little girls in soft focus, and so on. Pictorialism appealing to sentiment is not implicitly romantic or humanistic. It is merely a stylistic device that determines the appearance of the image, and allows categorization of the photograph according to what the print looks like. While we are listing what humanism in photography is *not,* I would like to add another one. Humanism should not be con-fused with emotion, as opposed to naturalism's intellect.

Notwithstanding current ideas about left and right halves of the brain, the split of emotion and intellect, instinct and rationality, emotion and mind, etc.—humanism in photography is not anti-intel-lectual. It cannot be. The ability, even need, of a photographer to project value judgments is not a mystical, instinctive, feeling only attained by intuitive, non-rational insight. True, the existence of a value system can be felt, but it cannot be understood, and intelli-gently used, by vague hopes and wishes. To be productive and power-ful the individual's sense of life has to be analyzed and verified con-ceptually. Humanism in photography is an intellectual as well as an emotional endeavor. The two together, in perfect harmony produce quality.[19] Making humanistic photographs is a thinking process, by definition, and does not belong to the "if it feels good, do it" cult

of the inarticulate. William Gass, again, said it so well: "I am firmly of the opinion that people who can't speak have nothing to say." [20]

The humanistic photograph is not defined by style, subject or sentiment, but by an all-pervasive value system that is implicit in the photographer and which permeates the body of work. It is a fulfillment of a need, not in the sense of resolving questions, preaching morals, or asking forgiveness, but permitting him to contemplate abstractions about his relationship to life through the specific nature of photography. Such individualism cannot be easily defined, or even discussed, since each individual will present different value systems based on a myriad complex interrelationships. It would be incongruous and silly to speak of a humanistic *movement*. Yet these photographs exist, and must be dug out of the stylistic categories defined for naturalists where they have been buried by critics.

Since all individuals will display different value judgments, it seems self-evident that sympathies with a photographer's work will be on the basis of similar value systems, rather than on stylistic compatibilities. This explains why a photographer can admire the work of another photographer from a widely different stylistic area. But there is a danger here. Agreement or disagreement with the attitude to life presented through the photograph is not an aesthetic concern or a valid method of establishing merit. The humanistic spirit is not determined by truth or falsehood. It is perfectly feasible to find oneself in conflict with the specific value judgments of the photographer, yet appreciate his or her humanism, as defined. John Heartfield is not a "better" photographer because one might sympathize with his anti-Nazi attitude; Leni Riefenstahl is not a "bad" photographer because of her pro-Nazi sympathies. In fact, humanists invite such disruptions in the critical approach due to their need to create ideals. Not being content with what is, the humanistic photographer is constantly striving for what should be, a forward motion that creates exaggerations. The exaggerations will be heroes or anti-heroes, saints or devils, fairy princesses or witches depending on whether or not the life attitudes of the photographer are in obvious agreement or disagreement with those of the viewer. Not everyone's value judgments will be affirmative. Even with a seemingly naturalistic approach, there is no doubt that Diane Arbus was a humanistic photographer, except that her value judgments were both anti-heroic and contrary to the life attitudes of the majority. It is not truth or falsehood, agreement or disagreement that matters; but an *implicit* view of life is essential.

It is not the prime responsibility of humanistic photography to answer questions, give information, educate or provide moral guid-

31

ance, no matter how intriguing the images might be as artifacts. Humanism in photography fulfills a more profound need for the photographer—the contemplation of abstractions. If naturalism provides answers, humanism asks questions. To borrow Schumacher's terminology, naturalism is concerned with convergent problems; humanism with divergent problems. How deeply and efficiently the photographs deal with the problems is the nature of photographic merit, and a reflection on the stature of the photographer. Since the naturalistic attitude is to provide facts about what is, it is evident that the convergent problem is solved by a quantity of images that incessantly and systematically present data in a non-judgmental way. For this reason, it is not at all difficult to deduce that Joseph Deal is a better photographer in the pure naturalistic spirit than a real estate photographer. This is merit by control of the medium. Francis Frith was a better photographer than most of his long-forgotten contemporaries largely because the sheer volume of his output is, in itself, an expression and affirmation of the naturalistic process. This is merit by quantity. Perceptive observations are in the nature of the medium. For this reason, even second-rate naturalism has a great deal to offer since information is carried by even a "bad" photograph, or even by a remote machine without the intervention of the human controller, as witnessed by the astonishing images transmitted to Earth from Mars. The value of the naturalistic photograph is in the reproduction of the specifics and the photographer can be judged by the accuracy with which the information is restated. That's the essence—all else is sugar on the pill.

There is no such leniency in humanism. A man's value judgments are deemed valid—since they are evident—or remain unexpressed and the work is a misshapen parody of a bad naturalistic photograph. Photography is kind to naturalism, and cruel to the romantic humanist. There are very few humanists in photography, a medium that was born in an atmosphere of naturalism and which, by its very nature, is conducive to facts rather than philosophies. Then there is the feeling that photography does not, as a medium, attract many philosophers—or has not done so to date. I am not pessimistic about this point—the rarity of the emergence of a true humanist, one who counters the naturalistic clarity of the process with a dynamic personal manifesto reveals the heights to which photography can aspire. The humanist might be rare among the numbers of people who call themselves photographers, but he accounts for a disproportionally large number of those who are at the cutting edge of the medium in any generation.

The Romantic Machine

Ours is a time of the machine and ours is a need to know that the machine can be put to creative human effort. If it is not, the machine can destroy us. It is within the power of the photographer to help prohibit this destruction . . . And it is with responsibility that both the photographer and the machine are brought to their ultimate tests. His machine must prove that it can be endowed with the passion and the humanity of the photographer; the photographer must prove that he has the passion and the humanity with which to endow the machine.[21]

IN CONCLUSION

The humanistic photograph is not concerned with *what is,* but with what *could or should be.*

It is made by a photographer who, working from a deep-rooted sense of self, pervades his work with his own value judgments. Photography for the humanist becomes a moral act, not a method of gathering facts.

This attitude is volitional and presumes intellect, but the view of life is implicit, never didactic.

Humanistic photography is not a medium but a life-style.

The humanistic photograph is not of any particular subject, and owes no allegiance to any movement, group, style, process or appearance.

Photography is by definition more suitable to a naturalistic approach. Therefore, the humanistic photograph is rare, although it accounts for a disproportionately large percentage of the medium's greatest achievements.

Humanism in photography is not fashionable, is impossible to promote as a style, is radical in spirit, and does not suffer fools at all.

Humanism in photography has been a candle in a cathedral, and the slightest draft can extinguish it. It might be out already.

The Romantic Machine

NOTES

[1] "Photography in Search of Itself," Susan Sontag, *New York Review of Books*, 20 January 1977, p. 56.

[2] "Images, Obscurity and Interpretation," Henry Holmes Smith, *Aperture*, Vol. 5, No. 4, 1957, p. 138.

[3] Gainesville, Florida, University of Florida Press, 1970.

[4] For definitions of these terms and a rationale for the last approach, see "Reading as a Method of Photographic Criticism," by Terry Barrett, *Exposure*, Vol. 15, No. 4, p. 3.

[5] Since I am not sure if the cuckoo is known in the USA, let me explain the idea. In England, the mother cuckoo does not build her own nest. She finds another bird's nest containing recently laid eggs and deposits her own, much larger egg, into the cluster. That's the last the cuckoo sees of her offspring. The unsuspecting mother sparrow hatches the cuckoo egg with her own. On hatching, the baby cuckoo is larger and more powerful than the young sparrows, and keeps its foster parents in an exhausting mad scramble for food. It grows at an astonishing rate, kicking the sparrow young out of the nest as it needs room to grow and move. The sparrow mother is apparently unable to recognize that the monster she has hatched is not of her own body.

[6] Leonardo da Vinci, *Trattato della Pittura III*, Codex Urbinas, English translation by A. P. McMahon, Princeton, Princeton University Press, 1956, p. 161.

[7] Quoted by Beaumont Newhall, *The Latent Image*, New York, Doubleday, 1967, p. 105.

[8] Quoted by Beaumont Newhall, *The Latent Image*, p. 105.

[9] Plate xiii, "Queen's College, Oxford," London, Longman, Brown, Greer, & Longmans, 1844.

[10] *On Photography*, New York, Farrar, Straus & Giroux, 1977, p. 3.

[11] *The Pencil of Nature*, Plate II, "View of the Boulevards of Paris," 1844.

[12] *New Topographics; Photographs of a Man-Altered Landscape*, Introduction by William Jenkins, International Museum of Photography, 1975.

[13] *Album* 2, 1970, p. 47.

[14] *On Being Blue*, Boston, Godine, 1976, p. 19.

[15] A fictional photograph—it is more likely to be by Walker Evans.

[16] Berkeley, Calif., Oneiric Press, 1967, p. 83.

[17] Widely reproduced; for example, front cover of *Album*, no. 11, 1970.

[18] Interview by Chuck Hagen, *After Image*, April 1976, p. 10.

[19] Highly recommended for a light read which deals with this point: *Zen and the Art of Motorcycle Maintenance*, Robert Pirsig, 1974.

[20] *On Being Blue*, p. 19.

[21] Dorothea Lange, *Aperture*, Vol. 1, No. 2, 1952.

AUGUST SANDER

ANNE HALLEY

THE LECTURE WE TRANSLATE in the pages following this intro-
duction is one of a series August Sander gave on German radio in
1931. Under a main title, "The Nature and Growth of Photography,"
Sander included such topics as "From the Alchemist's Workshop to
Exact Photography," "From Experiment to Practical Use," and
"Scientific Photography." Sander divided the history of photography
into three periods. He named the first two periods of positive achieve-
ment after the daguerreotype and the collodion process. He defined a
third period of decline, of *Kitsch* portraiture and confused aims, that
had begun around the turn of the century. In his present he saw a possi-
ble fresh start with the "new objectivity" movement, which he thought
might redirect photography to the true concerns that scientific and in-
dustrial uses of the medium had continued. Aware of techniques and
interests very different from his own, like that in photogram and photo-
montage, Sander declared his allegiance to photography as a scientific
and documentary, objective-reality-related, truth-telling language.[1]

In 1931 when Sander was fifty-five, he had exhibited and won
prizes and medals and published his book *Antlitz der Zeit* (The Face
of the Time) with an introduction by Alfred Döblin.[2] He was the
proprietor of his own studio in Cologne. Yet he may have had mixed
feelings about venturing into public speech and writing. The German
educational system has encouraged such feelings in people who hold
no degrees or titles, and Sander had none. He had learned photo-
graphy by himself as a boy, and gone on to jobs in studios during
apprentice and journeyman years.[3] Sander's son tells an anecdote
in the matter of the lectures which shows his father, nervously self-
reliant, self-willed, a little defensive, probably suffering microphone-
fright.

> My father hesitated and was probably a little upset [at the
> invitation to lecture on photography]. He had never
> interested himself in writing. But the subject tempted
> him. After we had repeatedly promised to stand by him,
> he accepted . . . August Sander buried himself in his
> books and read. After a few days he began to dictate.

My brother Erich, with the best intentions, smoothed
over the somewhat awkward style. But my father's
vanity was wounded and he fired his instructor. Then
my mother and I took over—at first full of confidence . . .
When we read back his dictation—and we thought it
needed correcting occasionally—my father would deny
that he had ever said anything of the kind. He would
already be thinking of something else . . . There were
further difficulties during his speech-test . . . [but] he
was unwilling to let an announcer read for him . . . my
father gave his lecture himself. In spite of several
sedative pills, he became nervous and confused the
time, so that the supposed twenty-minute broadcast
shrank to only thirteen. After a short pause we heard
August Sander's voice from the sky, "Well, what now?"
. . . It was the first time that an important photographer
had spoken about photography on the air, and he had
done so absolutely in his own way. . . .[4]

Beyond such human and humanizing comedy, Sander's fifth lecture
has seemed to us interesting in at least two ways. It includes a state-
ment of Sander's commitment to "straight" photography and to the
photograph as document; it discusses what he saw as his discipline's
importance in the world; it tells us something of a belief that may
be strange to us—that human physiognomy, the appearance of face
and body, faithfully and thoughtfully recorded in a photograph, can
speak truths about human character and experience.

First then, this statement, like others by pioneering craftsmen and
artists, may add to our understanding of Sander's work and of photo-
graphy. Second, from the photographer who wrote "with photo-
graphy we can fix the history of the world" in 1931 and in Germany,
and who in 1927 had written in a "Credo to Photography" that he
intended "to give an image of our time in absolute natural form"
and "in all honesty [to] speak the truth about our epoch and its
people,"[5] such a statement may have a special retrospective poign-
ancy.

I want to address that special, second poignancy. The period of
experimentalism, political and artistic ferment—of modernism—
flowered vigorously but, we know, all too briefly in Germany. The
political, economic, and social crises which fed experiment would
ultimately smother it and the Weimar Republic.

Sander's photographs, which show us some of the inhabitants, are
an invaluable part of the epoch's record and a product of its spirit

as well. Sander had abandoned picturesque and painterly reproduction techniques in the twenties. He had begun to print on shiny, smooth, technical or scientific papers, without retouching, and gone back to purify older negatives. He had been making portrait studies outside the studio for many years: people in the open or where they lived and worked and could present the tools of their trade, on a country road or building site, in office or doorway or on the city street or in the farmyard. He seems to have been stimulated in his drive to produce an image of apparent total objectivity and clarity within a formally composed—or *posed*—sharply contrastful, black and white, monumental portrait conception, by a circle of friends, expressionist painters, with whom he was able to discuss the nature of painting, of photography, and their differing excellencies and limits.[6]

According to Willy Rotzler, the Swiss art historian and former editor of *Du,* "a peak in the employment of the different and sometimes contradictory uses of photography was reached around 1928." We don't know whether Sander would have traveled to Stuttgart to see the exhibition "Photo and Film" which Rotzler tells us "provided a magnificent panorama of all progressive achievements . . . from the then new 'objective photography' to the abstract experiments by the constructivists" nor whether the volume *Foto-Auge* (Photo-Eye) published in 1928 would have been one of the books in which Sander buried himself preparatory to his lecture. But the "tradition-shattering" impact and emphasis on "creative experiment" which Rotzler assigns to these two "important events in the history of photography" would have been felt in Cologne.[7] In the twenties and first in discussion with other artists, Sander seems to have clarified his plan for his major work: to record *the* German people of the twentieth century according to the estates, their classes or social groupings, and their work. With that record Sander intended to establish a typology which would show the expressive possibilities of human physiognomy within his society.

To this end Sander collected and ordered his work in his personal archives; a selection of sixty prints was shown in Cologne in 1927 and published in book form in 1929.[8] A contemporary statement, probably a publisher's announcement, describes the work. "Sander begins with the peasant, the earth-bound man, and leads the observer through all the classes and callings, to the heights of the representatives of the most exalted civilization and down to the depths of the idiot." [9] Sander portrayed peasants and urban workers, artisans and society ladies, bankers, priests, Jews and National-Socialists and revolutionaries of the left, artists, the lame, the halt and the blind, provincial business people and the unemployed, and derelicts and soldiers, students, political figures, mothers and their children,

37

family groups and clubs. He was not interested in a subject's name or individual accomplishment beyond a general category, although names have been added to identify a good many in postwar editions of his work. He seems to have wanted to test what human, specifically German, possibility their appearance could express when he placed them, nameless, inside his groupings, fixed as they had been by his organizing eye as representative types. Whether all observers will perceive the same "heights" and "depths" and whether these are to be judged in the tone of the blurb-writer quoted above, and whether these were indeed the same "heights" and "depths" that Sander intended, remains a central and teasing question. Can we consider the photographs not only as documents of a time and place and its sampled population, but as directly expressive, legible units? Sander, after all, wrote that "every person's story is written plainly on his face." He implies that we can read a person's work and life, happiness or unhappiness, perhaps even good or evil, from a first visual impression, and that the conscientious photographer could tell us even more, even more plainly. But history continues to teach us the difficulties of establishing correspondences between human appearance and other realities: appearance shifts day by day and minute by minute, from observing eye to observing eye. Nazi Germany itself provides enough examples (we need only consider the people in Ophuls' *The Memory of Justice* to be reminded) which make it difficult to retain faith in our final ability to learn to read accurately these—or any but the most banal or blatant—uncaptioned or unannotated photographs.

One needs to be deeply inside a culture to be able to read its non-verbal signs and gestures, postures and insignia, its—are they stern or stolid, fierce or earnest or only kindly?—faces. Although vestiges remain, the Wilhelminian and Weimar culture in which Sander's subjects lived their callings and physiognomies is gone. What the images represent—even as they present us with swastika or aviator's helmet or mason's trowel—may become as mysterious as the specifics represented in pictorial medieval typologies. We may need guidebooks to read Sander, as we need them to read the sculptured friezes and stained glass windows that represent the seasons and men's work, vices and virtues, saints and sinners.

That Sander's photographs survived in significant numbers was in part accident. The free creative, if confused and often contradictory, spirit that had made Weimar's art part of international modernism, was quickly and efficiently expunged from the Germany of 1933. That year the art exhibits which pilloried and ridiculed modernism with brutal slogans and ugly display techniques, and which were to

end in the expulsion of works and of artists, began in various German cities. In 1934 what was left of the first edition of Sander's book was seized by the Gestapo and the plates destroyed. The works of Alfred Döblin, who had written the preface, had been included in the infamous book-burnings that took place at major German universities in 1933. Sander's oldest son was jailed for political anti-Nazi activity in 1934 and would die for lack of medical care—still in prison—in 1944. Sander himself seems to have been implicated and suffered at least one search-and-seizure. After 1934 Sander turned to botanical studies, to plant and landscape photography, which he was allowed to publish. His plan to record the German people in their unretouched functions and faces, honestly pursued, would by then have been dangerously subversive. During the war years, however, he was able to move a good part of his archives to the country. He added relatively few types to his collection in later years, but was honored with prizes and exhibitions after the war, and selections from his typology continue to be published and exhibited.[10]

It may be useful to recall names and fates of some others who had concerned themselves with photography in the twenties in Germany. Erich Salomon, a very different kind of photographer and the first to whom the term "candid-camera" was applied, had also been recording unretouched physiognomies—often those of the powerful in moments of decision. His book, *Berühmte Zeitgenossen in unbewachten Augenblicken* (Famous Contemporaries in Unguarded Moments)[11] was published the year Sander gave his lectures. Salomon was to die in Auschwitz. Kurt Tucholsky and John Heartfield had published their picture book in 1929;[12] they too had intended to arrive at an image, or cross-section, of Germany—again with intentions different from Sander's. They combined wire-service photos with Heartfield's photomontage and Tucholsky's satirical essays and caused a scandal. Heartfield could flee Germany and continue his political work abroad, but Tucholsky killed himself in exile. Moholy-Nagy and Bayer, the Bauhaus theoreticians and practitioners of photography, were able to leave Germany and go on to American success, in 1935 and 1938 respectively. Walter Benjamin, critical theorist and man of letters, a Jew passionately interested in society and the arts, who had published his *"Kleine Geschichte der Photographie"* (A Brief History of Photography) in 1931, would die of Nazism.

Benjamin had singled out Sander's portrait work for praise and sensitive comment. He compared Sander's portraiture to the use Eisenstein and Pudovkin had made of nameless, class-determined human beings in film, and assigned to Sander's work a similar "new and immense importance." What Benjamin saw in Sander was what Döblin had seen: a "sociology without words" and a "comparative

photography" through which students might arrive at the underlying type. Benjamin's description of Sander's sensibility—"unprejudiced, even daring, but tender at the same time"—is one that can stand. But Benjamin goes on to a passage which in our context is of even greater interest.

> It would be a pity if economic considerations were to prevent the further publication of this extraordinary body of work. Besides that fundamental encouragement, we can offer the publisher another reason to go on with the project. Almost overnight, works like this one by Sander could gain unsuspected immediate relevance. The shifts in power that we can look forward to are of a kind to make a practiced and sharpened grasp of physiognomy vitally necessary. Rightists or leftists—we will have to get used to having our origins read in our faces. For our part, we will have to read their origins on the faces of others. Sander's work is more than a picture book: a training-manual.[13]

There is heavy irony in this passage and it becomes bitterer if we know—as Benjamin could not have avoided knowing—the kind of picture book and training-manual that was actually a bestseller in Germany in the twenties and throughout the thirties. Not all racist theory was promulgated from the gutter by papers like Streicher's *Der Stürmer* (The Storm-trooper). Hans F. K. Günther's *Rassenkunde des deutschen Volks* (Racial Elements of the German People)[14] first published in 1922, had gone through sixteen editions in 1933 and sold 420,000 copies by 1944—figures which in the context of publishing at the time made it a sensational success. Günther was appointed professor at the University of Jena in 1930, although he had none of the usually expected qualifications, and the book was favorably reviewed by professional anthropologists. We need not argue here whether Günther was a "charlatan" as David Schoenbaum in *The Brown Revolution* maintains, or simply working at a level of investigation and induction now obsolete; the *Rassenkunde* must seem to us pseudo-science and repulsively tendentious. Written to a publisher's order, the book was profusely illustrated with photographs, which gave it an air of providing empirical proof for its theories. It seems to have been the basic text to define Nordic racial characteristics and superiority, other European races' concomitant inferiority, and what was then called the "Nordic Idea." [15] It contained all the racial myths of blood and character and soul, of moral

and intellectual qualities in inherited association with the shape of a head, hair and eye color, nose, forehead, and chin configurations.

The photographs, which may have accounted for some of the book's popularity, are primarily heads in full-face and profile, six to a page; there are also some group photographs, often of people in regional costumes. The writer, in prefatory remarks, thanks friends and various professors and institutes for contributing photographs: the preface to the ninth edition specifically asks that pictures of people of "pure racial characteristics" be sent to the publisher, and enumerates the racial types especially needed. One might read all kinds of things in these faces; the captions, however, tell us what to see: for instance, "From the Silesian nobility. Dominantly Nordic." or "Berlin. Mostly Nordic (with slight East-Baltic influence? Breadth of lower jaw?)" or "Freudenstadt . . . Dinaric. Forehead bulge plainly visible." Or a clean, pleasant family group not unlike some of those taken by Sander: "Saxony. Grandfather (father of wife) and grandchildren apparently more Nordic than the parents." There are more representatives of noble families and more military officers and obviously upper-class shirtfronts among the Nordics than the others; more wrinkled peasant countenances and folk-headdresses among the less desirable races. Physiognomy was—and would continue to be—a question of vital interest in the Germany that could not tolerate Sander's photographic *Face of the Time,* or a Benjamin or Salomon or Tucholsky in the flesh. An appendix contains Günther's anti-Semitic treatise, *Rassenkunde des jüdischen Volks* (Racial Elements of the Jewish People) which was also illustrated with photographs.[16]

It is mere chance, of course, that at least once the same face appears in both Sander's and Günther's collections of physiognomies. Still, such a chance occurrence might—like the belief in a *speaking* or *telling* physiognomy itself—point to unities within a society even as that society is in process of tearing itself apart. The face is Erich Mühsam's, poet and anarchist.[17] Mühsam was well-known. He had been a member of the short-lived Workers' Council government in Munich in 1919; he and Ernst Toller had called for the transformation of the world into a flowering meadow. Mühsam and Toller served prison terms together and Mühsam, who was arbitrarily arrested after the Reichstag fire, was finally murdered by concentration camp guards. In Günther, Mühsam's photograph—probably a publishing-house or book-jacket picture—appears in the Jewish appendix. Below the bearded, dark- and long-haired head—eyes, behind thin glasses, looking into the camera—is the legend "German Jew (Communist leader). Apparently Oriental-Nordic." Karl Marx and

Erich
Mühsam
HANS F. K. GÜNTHER

444. Jude aus Deutschland (Kommunistenführer).
Anscheinend orientalisch-nordisch.

Revolutionaries
AUGUST SANDER

August Sander

Bertold Auerbach, the popular nineteenth-century novelist, appear named on the same page.

Günther told his readers that physiognomies like those of Marx and Auerbach and Mühsam would communicate the message "alien being . . . incomprehensible . . . hateful" to the Nordic soul and that the Jewish soul could best be characterized as "rigid" and "changeable."[18] And of course a good deal more we need not repeat. Günther provided photographs, readings, and physiognomic theory for truly sinister parlor-games.

In Sander, Mühsam's head is shot from a slightly different angle, and Sander's portrait shows Mühsam between two comrades.[19] The three men are pushed rather closely together to sit on some neat brick steps. Their heads are backed by an expanse of pure white-painted door with a sharply contrasting thin black latch. A bit of brick wall shows on one side. They sit with their knees awkwardly pushed up in front of them. Their trousers are rumpled and worn. One foot extends down in a clumsy shoe, breaking the dominant horizontal organization. Their hands have the startling graceless prominence that seems to me typical of Sander. The two other men lean towards Mühsam in the middle and one has an arm around Mühsam's back. The two others wear black-rimmed small round spectacles and one looks cross-eyed in spite of that correction. I am still close enough to Weimar culture to read in their wrinkled shirt collars and carelessly cropped or longish hair, that they cannot have been conventional professors or upper-class gentlemen. What else can I read on their unsmiling faces (only female actresses would have smiled for the photographer in Weimar) and their uncomfortably informal bodies? What did Sander, who classified them simply "revolutionaries," expect us to read? Certainly none of the information and ugly speculation that *Rassen-Günther* would have taught his readers to associate with Mühsam's face and other wholly unlike faces.

We have an alternate reading of Mühsam from an authoritative source in the preface to *Menschen ohne Maske* (People Unmasked), a compilation of Sander's photographs published in 1971. Professor Golo Mann's essay, written in 1959, tells us in no uncertain terms what we are to see in Sander's photograph.

> The way a person imagined the future and the ideal, so he presented himself. The three revolutionaries, who have here met conspiratorially on a stair-step, could not represent what they were more fully if a theater director of genius had thus posed them. Not nineteenth century revolutionaries—those had stronger faces. Not

43

from 1959: there are no more revolutions, only power-seizures. No, these are carriers of the dream-revolution, the European revolution of 1919, which basically no one won, except in Russia, where it was entirely different. And when we contemplate these bearers of the revolution, we understand why it won nowhere. They could have played "Soviet Republic" in Munich in 1919 and they might have perished then; their fate might have caught up with them fourteen years later in Germany or a little later still in Russia. That their lives will be disastrous is written on their foreheads. Hands off, one would like to say. How can you hope to tear the tightly-woven web of a modern society, make a revolution, exercise power?—Useless advice. They know better . . .[20]

It is really Professor Mann, thirty-two years after Sander's photo was taken, who knows. Nothing of the sort is written, as the German phrase has it, on these men's foreheads. Professor Mann brought his own knowledge of German history and his own theory of that history—perhaps also a theory of physiognomy—to his somewhat disingenuous reading. Heinrich Mann and Mühsam had been acquainted in Munich. A German historian does not need to suppose or speculate about Mühsam's life and political unsuccess, as it might be read from a photograph. He knows it, as he knows the face. This reading has all the spurious authority of informed hindsight. Once we know that Mühsam was hanged in a latrine in Oranienburg, we may judge that Professor Mann displays an excessively-distanced, elegant lack of charity towards non-survivors. When he reads Mühsam's fate on his face, he suggests that we—who survive? who know better than to revolutionize? who have stronger faces?—can resign ourselves easily to *his* fate. Or, in inelegant American: Just a born loser!

Even photographs as honest and straightforward as Sander's, can be used to document every kind of opinion, judgment, or fashion in belief. In good faith or bad. The twenties' racist and the contemporary German historian seem to share an implied faith in physiognomy as destiny, revealed through photographs. I do not know whether Sander's brilliantly composed, intensely seen and rendered, portraits ask us to share that idea, or its opposite—that class and work determine appearance and character. I know they can startle us by the immediacy with which the subjects look out from their culture that already works to estrange them from us. They await, demand, a reading that will be "unprejudiced, even daring, tender at the same time." From

August Sander

inside a different, visually careless culture in which venal human images multiply as products on the market, we can try to let our eyes—helped by a truth-seeking photographer—expand to take in ordinary mortality again made rich and strange. We can ask our minds and our emotions to undergo like purification.

NOTES

[1] The German text, a typescript of the original lectures, courtesy and permission of Christine Sander, Washington, D.C., Sander Gallery.

[2] München, Transmare Verlag, 1929. (Unless otherwise noted, translations of titles and of quotations from the German are my own.)

[3] Günther Sander, "Aus dem Leben eines Photographen" (From a Photographer's Life) in August Sander, *Menschen ohne Maske* (People Unmasked), Luzern and Frankfurt/M, Verlag C. J. Bucher, 1971, pp. 286-288.

[4] "Aus dem Leben," pp. 307-308.

[5] *August Sander 1876-1976:* A retrospective in honor of the artist's 100th birthday, ed. Christine Sander, Washington, D.C., Sander Gallery, Inc. No pagination.

[6] "Aus dem Leben," pp. 307-308.

[7] *Photography as Artistic Experiment,* Garden City, American Photographic Book Publishing Co., Inc., 1976, p. 86.

[8] *August Sander 1876-1976.*

[9] Quoted by Walter Benjamin, "Kleine Geschichte der Photographie," *Gesammelte Schriften,* VII, 1, ed. Adorno, Sholem, Tiedemann, Schweppenhäuser, Frankfurt, M, Suhrkamp Verlag, 1977, p. 380.

[10] "Aus dem Leben," *passim.*

[11] J. Engelshorn Nachf., Stuttgart, Gathorne-Hardy, G. M. (Information in Erich Salomon, *Portrait einer Epoche,* ed. Hans DeVries, intr. Peter Hunter-Salomon, Berlin, Frankfurt/M, Verlag Ullstein Gmbh., 1963.)

[12] *Berlin W8,* Neuer Deutscher Verlag, 1929.

[13] "Kleine Geschichte," pp. 380-381.

[14] München, J. F. Lehmanns Verlag, 1926.

[15] All biographical and publishing information about Günther and the *Rassenkunde,* except as noted, in Hans-Jürgen Lutzhöft, *Der Nordische Gedanke in Deutschland, 1920-1940* (The Nordic Idea in Germany), Stuttgart, Kiel Historische Studien, Ernst Klett Verlag, 1971; in particular, pp. 28-45.

[16] *Rassenkunde, passim.*

[17] *Rassenkunde,* p. 460.

[18] *Rassenkunde,* p. 476.

[19] *Menschen ohne Maske,* photograph number 117.

[20] *Menschen ohne Maske,* p. 10.

from THE NATURE & GROWTH OF PHOTOGRAPHY

LECTURE 5: PHOTOGRAPHY AS A UNIVERSAL LANGUAGE

AUGUST SANDER

translated by Anne Halley

Human beings, unlike animals, live in societies that are constantly changing. Thus people develop, adjusting to their changing conditions, and subjected to more change in their environment than other living beings. Man has always had to solve the problems of his changing environment. The intelligence, which distinguishes man from animals, made him their ruler. He recorded his first victory over the animals when he invented the first tool.

Language too may have developed out of human need. The growth of language implies an enormous strengthening and clear consciousness of social drives, and is itself a powerful means of establishing social cohesion. The formation of social groups may have given rise to the first verbal communication, which we call dialect. Social thinking and its accompanying language were encouraged to spread by the dangers to which human beings have always been exposed. Communication by signs became necessary because people who were separated in space and time needed to maintain connections between individuals, groups, and times, and sound was still fugitive. Picture language existed before the written word, and primitive peoples used pictures to bridge the gaps in time and place. We have proof of this from the Ice Age, the period of the cave dwellers, the ancient Egyptians, the Africans, etc. In its beginnings Christianity also used picture language to promulgate and teach the word of Christ.

Once a child has begun to have ego-consciousness, his conception of objective reality can be stimulated and developed with pictures. Pictures and sounds are the only possible means of communication for illiterates; pictures are also the best way to communicate useful or persuasive information to the masses of people; pictures inform more quickly than written words and are not limited to a single group or by a language boundary. We all know how impressive a picture can be—whether it be amusing or serious.

The invention of photography returned our attention to picture language; today the language of pictures has become a popular means of communication, unlimited by language barriers, as sound

46

Photography: Universal Language

must be. Today with photography we can communicate our thoughts, conceptions, and realities, to all the people on earth; if we add the date of the year we have the power to fix the history of the world. I should like now to begin with some examples.

Even the most isolated Bushman could understand a photograph of the heavens—whether it showed the sun, the moon, or the constellations. In biology, in the animal and plant world, the photograph as picture language can communicate without the help of sound. But the field in which photography has so great a power of expression that language can never approach it, is physiognomy, which we will discuss more especially in the second half of this lecture.

Our eyes convey to us an external image of the objects around us, and our intelligence assimilates the visualized objects to make concepts and create our inner world, which we then interpret according to the most diverse principles. Thus we arrive at distinctions between good and evil as well as between human and animal; we recognize danger and we experience beauty or ugliness or fear. With photography we are in a position to reproduce all such experiences and to make ourselves understood in that way. We can mention the continuous photograph, or film, by means of which we have learned to know the most secret processes in the life-cycle of plants. With photography the popular expression—"someone can see the grass grow"—has become a reality. By means of photography we have already begun to record all the phases of human growth—from germinating cell to death.

In my last lecture I mentioned the cooperative work of scientists in observatories, who have taken approximately 20,000 photographs of the heavens from 18 observatories for our total orientation in the universe. In this case the photograph speaks the universally understood language of a high culture; the photograph would speak a different but equally expressive language if the film camera were set up and simultaneously activated in the 365 unemployment bureaus which exist today in Germany alone. If we photographed the people there, fit our results together, and labeled the whole with the date, 1931, the tragedy of our photographic language would be understood by all present and future human beings without further commentary. No language on earth speaks as comprehensibly as photography, always providing that we follow the chemical and optic and physical path to demonstrable truth, and understand physiognomy. Of course, you have to have decided whether you will serve culture or the marketplace.

I want to cite a further instance. The newspapers are now preparing the populace for a coming bestial war in which poison gas

will be used; they recommend gas masks to protect the civilian population's lives. To photograph an infant wearing a gas mask, instead of at its mother's breast, and to label the photograph as from the twentieth century, would be sufficient. The photograph would not only fix and hold fast history, but would express the whole brutal, inhuman spirit of the time in universally comprehensible form.

I don't, of course, mean that the recreation of life and death, descriptions and experiences, is the sole province of photography. Such a statement would be presumptuous and mischievous. That words and the written language can recreate experience has long been established fact. But with the advance of civilization verbal expression has become progressively more complicated and abstract, until more and more knowledge and intellectual training is needed to understand it. In contrast, photography has the advantage of being instantly and immediately perceptible.

In our age of intellectualism, literary work becomes increasingly directed to the interests of an intellectual upper class, while a photograph adjusts without trouble to the capacities of the broadest, intellectually least trained masses of people. I believe we can say that no national language anywhere could function as universally as photography, or could have greater significance. Because it can be universally understood, photography—as image and film—is already first among picture languages for the masses of people of the world.

For instance, it is the universal language in which reportage brings us events more powerfully than words can. The print-runs—in the millions—of illustrated newspapers demonstrate this fact—although of course such papers speak their own language in their own special way. The so-called "language of deception"—or diplomatic language—can be imitated easily by photography, and imitated so well that the written word fades before it. For instance, in the World War, I saw a photograph picturing a German soldier cutting a French child's throat, and more photographs of that kind. They were so . . . [*Here, a line of the original typescript is missing*] . . . But the message of the photographic image was effective: with that evidence the French people took a make-believe manual construction for an image of reality.

In addition to what I have already described, I should mention that in photography we have a medium for every kind of expression. We can tell the truth or we can spread lies; we can spread the language of all life and being from country to country and from person to person. Photography's universal comprehensibility erases the boundaries of language. I hope this short discussion has shown the importance of photography as a universal language. Photography should become a field of study in schools and educational and cul-

Photography: Universal Language

tural institutions, so that the light and the shadowy side of its use is understood; for besides its enormous importance in demonstrating truth, photography makes very dangerous kinds of deceptions possible. It can not only enlighten the people, but also cause terrible confusion. My photographic work—"Human Beings of the Twentieth Century"—which I began in 1910 and which contains approximately 500-600 pictures from which a selection—"The Face of the Time"— appeared in 1929, is basically a declaration of faith in photography as universal language; I attempted to arrive at a physiognomic definition of the German people of the period by means of the chemical and optic, historically developed methods of photography—that is, by the creation of images through the use of light alone.

We can now move to the second part of my lecture, which will deal with physiognomy in photography. And what do we mean by physiognomy? More than anything else, physiognomy means an understanding of human nature—that understanding which nature imparts freely to human intelligence, although perhaps more to some people than to others. It will be necessary here to give some examples.

When we meet a person for the first time we get an impression— that he is good or evil, that we feel attracted or repelled, that we feel spiritual kinship or do not. Such responses are the result of inborn feeling. Children have this feeling and even animals have the instinct for such judgment. Almost all women have it, although it exists less often in men. But the man's intellectual predisposition, in contrast to the woman's emotional one, can develop the feeling to a special and heightened capability of great sharpness and exactness.

All things that happen have their appearance, or "face," and an event's total appearance is its physiognomy. The ability to judge physiognomy can be inherited; it can also be developed by education. We know that people are formed by the light and air, by their inherited traits, and their actions, and we recognize people and distinguish one from the other by their appearance. We can tell from appearance the work someone does or does not do; we can read in his face whether he is happy or troubled, for life leaves its trail there unavoidably. A well-known poem says that every person's story is written plainly on his face, although not everyone can read it. These are the runes of a new, but likewise an ancient, language.

The human eye's glance belongs to physiognomy: we know that a look is more quickly understood and more persuasive and makes a stronger impression than a word, because we can repel or attract

49

another person with a single look. Popular wisdom says, One look will tell me where I am. Popular wisdom also asserts that some people have special power in their glance—that is, they have the evil eye. Wilhelm von Humboldt states that occult effects of that kind are not based on simple superstition, but on perceptions of truth. Today they are confirmed by hypnosis.

The individual does not make the history of his time, but he both impresses himself on it and expresses its meaning. It is possible to record the historical physiognomic image of a whole generation and—with enough knowledge of physiognomy—to make that image speak in photographs. The historical image will become even clearer if we join together pictures typical of the many different groups that make up human society. For instance, we might consider a nation's parliament. If we began with the Right Wing and moved across the individual types to the farthest Left, we would already have a partial physiognomic image of the nation. The groups would divide further into subgroups, clubs and fraternities, but all would carry in their physiognomies the expression of the time and the sentiments of their group. The time and the group-sentiment will be especially evident in certain individuals whom we can designate by the term, the Type. We can make similar observations about sport clubs, musicians, business and the like organizations. The photographer who has the ability and understands physiognomy can bring the image of his time to speaking expression.

I also want to give a negative example. If we photograph a contemporary person in antique or medieval or Victorian dress in his own milieu, the photograph will be unable to express even a modicum of reality: the twentieth-century person will always impart his own speaking expression to the photo. Thus we see that the human being leaves his own mark on his time, and thus the photographer with his camera can grasp the time's physiognomic image. Not only a person's face, but his movements, define his character. It is always the photographer's responsibility to stabilize and record characteristic movement, which will then express physiognomy in a single comprehensible image.

If we ignore the higher powers for the moment, we can say that man shapes the world's image and inhabits the foreground of all events. Then—when we have described human physiognomy—we may move to the human being's world, that is, to the works of men. We can begin with landscape. Man puts his own stamp on the landscape with his works, and thus the landscape, like language, changes in accord with human need; man often modifies the results of biological evolution. Likewise, we can see the human spirit of a particular age expressed in the landscape, and we can comprehend it with the

Photography: Universal Language

camera. It is the same for architecture and industry and all other large and small human works. The landscape within a particular language boundary expresses the historic physiognomic image of a nation. If we expand our point of view beyond such boundaries, we can arrive at a comprehensive vision of the nations of the earth, in the same way that the observatories arrive at a complete image of their observed heavenly universe. We can arrive at a total vision of the people on earth—a vision which would be of enormous importance to our understanding of humanity.

We must finally expand our discussion to include the relation of photography to art. I shall make this clear by making a central distinction: one may press a button, or one may take photographs. Pressing a button implies that one relies on chance; taking photographs means that one works with forethought—that is, tries to understand a scene, or to bring a conception out of its beginning in a complex of ideas into finished form. If we are successful photographers we reach that goal.

The camera does not determine the quality of photographic work, any more than canvas and paint make a painter, not to say, artist, or a block of stone and hammer a sculptor. On the other hand, the creator depends on his material, and one cannot be a photographer without a camera. The fields of painting, music, architecture, sculpture, literature, photography, technology, mathematics, etc. exist and their accomplishments, the works, teach us the languages of their practitioners.

Our discussion of photography should lead us to conclude that photography is a special discipline with special laws and its own special language. By sight and observation and thought, with the help of the camera, and the addition of the date of the year, we can hold fast the history of the world. We can influence all humanity with the expressive possibilities that photography as a universal language possesses. Thus I conclude my general remarks on photography. . . .

ICONS OR IDEOLOGY:
STIEGLITZ AND HINE

ESTELLE JUSSIM

ALFRED STIEGLITZ AND LEWIS HINE: the maker of icons and the apostle of social reform. Their careers ran closely parallel in time, but seem completely antithetical in every respect. Stieglitz became the Messiah of the avant-garde in both photography and painting; Hine languished as a documentarian, overlooked and ignored by the practitioners of purism, who were themselves rejected by the academy and the people whom H. L. Mencken called "the booboisie."

Stieglitz was repelled by the masses, believing them incapable of an educated response to "beauty." Hine sought out the working class, finding in them an eternal human spirit surviving even under despicable oppression, and that was his "truth." Stieglitz was a disciple of Nietzsche, viewing the task of the artist as a Promethean commitment to uplifting mankind by heroic deeds, by standing upright and awesome on the mountaintop, far above the squalid materialism of the late nineteenth and early twentieth centuries, keeping alive the flame of idealism and perfectionism by a strength of will and purpose to which the common man, destroyed by meaningless labor and abased by the sordid ignorance of the slums, could not possibly aspire. Hine was unassumingly non-heroic, but a fighter who believed that God's grace was the birthright of every American, that nobility lay in work, that the masses, despite their ignorance and their lack of taste for the "finer things," were intrinsically worthy.

The ardor of Stieglitz was expended in the struggle to have photography accepted as a peer of the other fine arts. The passion of Hine was devoted to the use of photography as a tool for social reform. Stieglitz seemed non-political, an idealist whose implied optimism about the ability of an individual to change and uplift the world was unshakable. Hine seemed political, a realist whose implied pessimism about an individual's capability for changing society was the result of a Marxist-derived interpretation of the world as class struggle, group organization, communal effort. Stieglitz was an optimist about individuals, a pessimist about changing society. He withdrew into solitary effort. Hine was just the opposite, pessimistic about the individual as social reformer—even though he himself was one—and optimistic that society could achieve change. He entered the fray.

Stieglitz seems to represent the final outcome of the inexorable progress of the nineteenth century's art-for-art's-sake formalist ide-

ology. Hine seems to represent the spirit of what used to be called "social consciousness," of art-for-society's-sake. In other words, we seem to have here the perfect models to represent the present debate as formulated by the editors of this issue of *The Massachusetts Review*: should photography be regarded as a "detached, symbolic, and formalistic art" or should the photographer see his purpose as "necessarily mediating between the objective world and a particular, humanistic, and engaged vision of it."

How can these extreme positions be reconciled, or should they be considered eternally in conflict? In one corner: *Beauty,* art-for-art's-sake, the pursuit of bold experimentation without regard for easy comprehensibility; in the other corner: *Truth,* art-for-society's-sake, the pursuit of revelations in which human beings would be made to feel empathy for each other's sufferings. The elite versus the hoi-polloi. Is this a true logical dichotomy? Must we profess allegiance to one and not the other? Is this the ultimate *Either/Or*?

The debate is as modern as photography itself, and as ancient as Plato's *Republic*. In fact, the question as to whether or not photography must pursue a particular ideological stand—whether this is called "beauty" or "truth," "art" or "human concern"—has a long history and is as saturated with political implications as were Platonic aesthetics. Furthermore, a philosopher might indicate to us, with considerable justice, that we are being asked to choose, perhaps arbitrarily, between aesthetics and ethics. It is as if the question were whether individual photographers should be considered immoral, unethical and irresponsible if they pursue the play of formal elements so beloved of modern painters like Picasso and Kandinsky. It is as if individual photographers are to be judged anti-humanist if they are not somehow politically *engagé*.

But how, precisely, are we to identify, with perfect surety, this humanism which the formalist is denied? To push that question to its extreme: is formalism necessarily against humanity and against concern? We might even ask, does an interest in aesthetics necessarily obstruct, obliterate, or simply overwhelm an ethical commitment? We know the answer which Soviet "socialist realism" supplies; we can perhaps recall the answer which Nazi "aryan art" supplied: in both these political situations, the arts were, and are, circumscribed in content, approach, subjectivity, comprehensibility. Every reader will recognize the dangers implicit in too extreme a response to the present debate.

What the debate revives, once again, are old and unresolved problems dealing with the functions and purposes of the arts, the uses of art by audiences, the intention of the artist as opposed to the

actual psychological effects of the work of art, not to mention the huge complexities of whether or not exposure to works of art makes for any changes whatsoever in individuals or in societies, and by what means these changes are precipitated.

Alfred Stieglitz obviously considered the arts as a spiritual connection between humanity and nature. Lewis Hine, just as obviously, considered photographs as some sort of direct communications, bearers of messages which would call for specific responses from an audience. The difficulty arises not in reading about these two photographers in their biographies or in critical essays, but in confronting the photographs themselves out of the context in which they were produced, long after the peculiar metaphysics of Stieglitz and the specific political situation of Hine have disappeared, have become meaningless, or seem incomprehensible to those among us who will live to see the year 2001. How do we judge, today, now, in 1978, whether or not Stieglitz was being "humanistic" when he photographed the chilled workman and the steaming horses of *The Terminal* (1892), or whether he should be considered arcane and unconcerned about humanity's fate when he pictured cloud forms in his famous series *Songs of the Sky* (1922 on)? Are we automatically forced to consider Lewis Hine the more moral and responsible photographer because he bravely climbed the Empire State Building during its construction to photograph noble steelworkers grinning among the girders? And are we automatically forced to consider Hine less the artist because he seemed to be pursuing "facts"? Can we really separate the heroism of the steelworkers from the way in which Hine meticulously posed them, and can we really differentiate their heroism from the kind of ennoblement which enshrined tractor-drivers and women farmers in Soviet posters of the 1930's? Do the seemingly cold abstractions of Stieglitz's cityscapes of this same decade make no human comment or have no human concern simply because we see none of the proletariat? Is the chill of those Stieglitz cityscapes—with their frozen shadows and harsh lights—the chill of an aging, possibly embittered artist, or is it the chill of the ultimate dehumanization, the desperate anomie of the megalopolis? Is making a pictorial statement to the effect that fragile humanity seems to be excluded from the monoliths of capital enterprise (Stieglitz) any less "humanistic" or less "concerned" than making a pictorial statement to the effect that steelworkers were enjoying building what was to become the very symbol of capitalist success (Hine)? At the very least, we should admit a paradox or two.

Why is there this deep-rooted suspicion of the formal elements of the visual arts by all those who profess engagement? Is there, in fact, no redeeming humanism in the play of symbolic forms even if

they can be viewed as having connection with deep human needs, needs which can be discovered evolving throughout all we know of human history? Would it be unthinkable, a jolt to our psyches, if we suddenly confronted the possibility that, in their own way, symbolic formalists might also be "necessarily mediating between the objective world and a particular humanistic and engaged vision of it"?

I suggest that among the origins of the modern dilemma are serious confusions about the meaning of "art-for-art's-sake," the functions of the arts in the lives of individuals, the nature of the social contract, the freedom of the individual to choose non-conforming values and to seek pleasure, as well as seriously rigid interpretations concerning the notions of what ends humanity must struggle to achieve both individually and collectively. If Susan Sontag's latest opus is any indication, we are witnessing a powerful swing of the philosophical pendulum away from the question of aesthetics to the question of ethics. The swing has taken almost two centuries, from the eighteenth century's creation of the very term "aesthetics" to increasingly somber moralities which request of the arts that they once again assume the didactic, political, quasi-totalitarian functions which they have so often served. It was the nineteenth century which was quite literally a battleground for these conflicting positions, yet the origins of these essentially political arguments begin in that same eighteenth century which gave us the obsession with "beauty."

One of the ideals, first of the Enlightenment and then of the American Revolution, was that individuals are free to exercise choice, free to enjoy not only life and liberty but something called "the pursuit of happiness." By contrast, the French Revolutionists, busy with class warfare, did not prattle about individual "happiness." Yet the most influential exponent of class warfare, Karl Marx, was at first interested in the restoration of the whole human being, restored to a sense of harmony, community and selfhood from which the Industrial Revolution had cast him out into a brutalizing and brutalized alienation. That Americans should have talked about the pursuit of happiness given their masochistic, tortured, and self-denying Puritan origins, should be regarded as something of a miracle. That the French should have almost immediately instituted a tyranny more despotic and cruel than its royal antecedents—including a centralized censorship of the arts—is surely amazing in view of their contributions to the idea of individual freedoms as articulated by Rousseau. That Marx wanted precisely to see individuals being granted the right to pursue full and happy lives, without persecution and starvation, free to enjoy the fruits of their labors and to experience life with a measure of control and satisfaction is perhaps the most astonishing in the light of subsequent developments.

Estelle Jussim

In the midst of this turbulent philosophizing and the wretchedly failed revolutions of the nineteenth century, while the self-perpetuating engines of capitalist power continued to increase their dominance over every aspect of life, the *artist* was discovered to be the sole survivor of industrialism, for it was the artist who combined that sense of the love of one's own work, dedication to serious creation, and a passion for individual freedom which epitomized the Utopian view of the ideal person. The artist became invested with a mythology of freedom and independence which had characterized the intellectual and political events of the eighteenth century, and in the nineteenth century we hear George Sand sighing:

> To be an artist! Yes, I wanted to be one, not only to escape from the material jail where property, large or small, imprisons us in a circle of odious little preoccupations, but to isolate myself from the control of opinion . . . to live away from the prejudices of the world.[1]

That could be Stieglitz speaking, and Stieglitz was the child of the nineteenth century's notion that it was in the very practice of art that a contribution could be made to the progress of humanity, without reference to any edification through moral subjects. As Geraldine Pelles observes, it was "through the activity of art itself"[2] that artists believed a healing influence could be brought to bear on dehumanized, corrupt and materialist society. The problem for moralists became the fact that artists turned from didacticism to aesthetics.

At the time of the infancy of photography, during the 1830's and 40's, the idea of "art-for-art's-sake" began to be promulgated by a growing corpus of philosophical thought about the nature of the aesthetic experience, about "beauty" and whether or not it was a condition of objects or a subjective response to a stimulus. It is an overlooked but nevertheless remarkable fact that the history of photography and the history of a clashing antithesis between "beauty" and "truth," between aesthetics and ethics/politics, should have been so closely linked. By no means are Stieglitz and Hine the first to represent this clash. By 1850, when Talbot released his patents for paper photography, the various processes of photography were all embedded in a series of violent disputes concerning "the proper end of art." The disputes were made even more violent because documentary photography seemed to have the capacity, unique among the graphic media, to provide direct access to "truth."

European photographers were at first unable to resolve the dilemma of "art" versus "truth" because their thinking was almost

Stieglitz and Hine

completely subjugated by the prevalent views concerning the goals and values of painting. In America, however, photography seemed simply to be a mechanism for transmitting information about people and places. Until Stieglitz, then, there was relatively little thought about the artist-photographer as a paradigm of individual freedom, a hero who represented the last vestige of selfhood. Art-for-art's-sake was a comparatively distant and exotic notion, remote from everyday practical affairs.

As the century wore on, and as photographers like Rejlander and Robinson began to imitate the moral tales and spiritual uplift of paintings, the art-for-art's-sake struggle—which had already burgeoned into a full-scale replica of the war between the European aristocracy and the masses—erupted with particular bitterness. Socialist Utopian critics like Proudhon and his followers vowed that art was the moral conscience of society, not a pleasurable act of free will or free response. The excoriations were polemic and violent:

> *Art for Art,* as it has been called, not having its lawfullness in itself, and resting on nothing *is* nothing. It is a debauch of the heart and dissolution of the mind. Separated from right and duty, cultivated and sought after as the highest thought of the soul and the supreme manifestation of humanity, art, or the ideal, shorn of the best part of itself, reduced to nothing more than an excitement of fancy and the senses, *is the principle of sin, the origin of slavery, the poisoned source whence flow, according to the Bible, all the fornications and abominations of the earth.* From this point of view the pursuit of letters and of the arts has been so often marked by historians and moralists as the cause of the corruption of manners and the decadence of states . . .[3]

This vitriolic paragraph was quoted by Philip Gilbert Hamerton, an influential English critic, graphic artist, and frequent commentator on things photographic, who made a mild and polite reply:

> Let us examine for one moment what the principle of Art for Art really is. It simply maintains that works of art, as such, are to be estimated purely by their artistic qualities, not by qualities lying outside of art.[4]

That was precisely Proudhon's bone of contention, of course, that art which was judged purely for its internal qualities had divested itself of its most sacred functions. For Proudhon, like other social

reformers, considered art to have primary responsibilities in the political arena. It was to be used as a force for Good, with a definite hierarchy of approvable subjects; it was not to be allowed to become a focus for mere Pleasure, especially since the pleasures seem to be becoming more and more perverse.

Proudhon's jeremiads were not destined to stop the progression of the visual arts from purely sensory delights—the Impressionists—to arcane, remote allegories embodied in the works of the Symbolists, whose worst and most decadent tendencies were considered to be most evident in the paintings of Moreau or Fernand Khnopff, and in the photographs of, for example, the American F. Holland Day and certain European aristocrats who delighted in sunstruck pictures of nubile young boys in pseudo-classical poses. Like the preciosities of the earlier Mannerists, the so-called "Decadents," who included Aubrey Beardsley and Arnold Böcklin, were the outcome of an historical development:

> . . . a relatively unified culture, which transcended national boundaries, and which was directed by an elite determined to emphasize the distance which lay between itself and the mob. Both put forward the proposition that the arts were a closed, special world with its own rules and its own languages . . .[5]

We can see now why humanitarians and revolutionists were outraged, and why Alfred Stieglitz was to bear the stigma of this kind of elitism even if he did not share, in any possible way, the goals of the Decadents. To political critics, however, it was seen that now the elite not only held a monopoly on the means of production but were extending that monopoly to the arts. Access to the pleasures of the fine arts would lie in the hands of the high priests of culture who understood the obscure symbols of classical antiquity or of modern poetry; the common folk were severed not only from satisfactions with daily work but from the comforts and simple pleasures of homey art.

It was to demolish the artists who painted Salomés, chimeras, sphinxes, ghosts with severed heads, and other such vanities, and, simultaneously, to excoriate the elite who supported such artists, that Count Leo Tolstoi wrote *What Is Art?*, "one of the most vigorous attacks upon formalism and the doctrine of art for art's sake ever written."[6] Published in English translation in 1898, the book evinces little differentiation between one aspect of modernism and another; that is, Tolstoi blasted Impressionists and Decadent Symbolists with

equal relish. In an exceptional survey of the history of aesthetics (see his Chapter 4), Tolstoi condemned any art which could not be easily comprehended by "the people." The idea that any art should require the study of some special grammars of form or of symbolism was anathema to him, as this represented the parasitic and despotic dominance of the elites over the common folk who could not easily understand allegorical references or non-representational art. Deciding what was to be considered "good" or "bad" in the subject matter of a painting was simple:

> Art, like speech, is a means of communication, and therefore of progress, i.e., of the movement of humanity forward to perfection . . . And as the evolution of knowledge proceeds by truer and more necessary knowledge, displacing and replacing what is mistaken and unnecessary, so the evolution of feeling proceeds through art—feelings less kind and less needful for the well-being of mankind are replaced by others kinder and more needful for that end.[7]

Feeling: this was the crucial word; feeling was to be all-important in this evolutionary progress which placed art alongside science in the onward and upward betterment of mankind. In a truly Wordsworthian sentence, Tolstoi sums up what was for the great author of *War and Peace* the true means by which human beings could be united with one another in spirit—amazingly, it was to be through art.

> To evoke in oneself a feeling one has once experienced, and having evoked it in oneself, then, by means of movements, lines, colors, sounds, or forms expressed in words, so to transmit that feeling that others may experience the same feeling—this is the activity of art.[8]

But that could be Stieglitz speaking; at least that was the way in which he was perceived by his critics in *America & Alfred Stieglitz.* It would be particularly in the "Equivalents," first shown in 1925, that his ideals would match those of Tolstoi:

> The prints included pictures of natural objects, clouds, a poplar tree, its leaves shimmering in wind and sunlight, which were recognized as portraits. The translation of experience through photography, the storing up of energy, feeling, memory, impulse, will, which could find release through subject matter later pre-

senting itself to the photographer, were thus made evident. This should have ended for all time the silly and unthinking talk to the effect that the photographer was limited to a literal transcript of what was before him.[9]

Tolstoi had been dead since 1910, but it is not too difficult to imagine his approving not only of such expression of feeling and its transmission through suitable "movements, lines, colors, sounds" but further, of Stieglitz's fight against the crassness of artistic exploitation, in his role as gallery owner and art dealer:

> For it was not mere economic sustenance that the Intimate Gallery was standing for, it was the relationship of the divinity in men and women as represented by the creative artist, with the entire nation and the life of the world.[10]

The nineteenth-century notion that the creative artist was invested with mythic powers, that artists were representing both the last anarchic independence of individuals and some kind of divine metaphysical beneficence, had by no means expired. Indeed, it was not class warfare which would bring down the exploiters, but some inexorable process within history:

> The civilization that could neglect or refuse its best, yield its choicest spirits to ostracism, exclusion, starvation, and extinction, was in that degree signing its own death warrant.[11]

The artist, the best and choicest spirit, was obviously paying a heavy price for his special status as redeemer of the world. The fact was that the artist had been split off from society in much the same way and at much the same time as the split between the worker and his work, between the moral function of art and the formal aspects of art.

There is one more bit of history which should be considered in any attempt to understand what Stieglitz represents, and whether or not he stands for some kind of empty-headed creation of artistic icons or for a humane concern. This was the advent of abstractionism and the influence of Wassily Kandinsky. It was only one year after Tolstoi died that his compatriot Kandinsky published a manifesto called *Concerning the Spiritual in Art,* in which Tolstoi would have

had great difficulty discerning the evolution of his own ideas. Kandinsky here would sever the last connection between the visual arts and any representational forms, with the aim of creating a formal grammar of means which would permit artists to express their "inner need." This inner need was composed of three mystical elements:

> (1) Every artist, as a creator, has something in him which calls for expression (this is the element of personality). (2) Every artist, as child of his age, is impelled to express the spirit of his age (this is the element of style) . . . (3) Every artist, as a servant of art, has to help the cause of art (this is the element of pure artistry, which is constant in all ages and among all nationalities . . .[12]

Furthermore, every artist was free to invent whatever forms would make possible the expression of his inner need. Kandinsky did not invent abstraction, although he may be said to have been the first to carry abstraction to a complete severing with the representational in art. Actually, many of his ideas about a formal grammar which would have universal meaning come out of a movement which had already influenced Stieglitz through the work of Maurice Maeterlinck. This was Theosophy, a movement much too complex to be here discussed in any detail. Suffice it that the followers of Madame Blavatsky believed in Platonic ideas concerning the nature of reality: that somewhere there was an ultimate ideal which the real world represented rather poorly. These thought forms were shapes which corresponded to ideas, and Stieglitz, Kandinsky, Arthur Dove, Georgia O'Keeffe, and other moderns were transcendentalists who are best explained, perhaps, in the words of their fellow-traveler, Paul Klee: "We are striving for the essence that hides behind the fortuitous." [13] If one reads the many statements of Alfred Stieglitz, it is not the word "Beauty" which appears, but the word "Truth."

The simple fact would seem to be that Stieglitz was seeking a universal and metaphysical "truth" which did not match the political expectations, needs, desires, and fantasies of many of his contemporaries. In other words, his "truth" and the "truth" of a photographer like Lewis Hine were completely different. Yet they were both "truths." The problem then continues to be the one in which we must decide whether or not one truth or one pursuit is necessarily more moral, more authentically human, and more expressive of humane concern than any other truth or pursuit. I call on the philosopher and art historian, Sir Herbert Read, to see if he can help us:

61

Estelle Jussim

I believe that we have reached a certain crisis in the development of our civilization in which the real nature of art is in danger of being obscured; and art itself is dying of misuse. It is not altogether a question of indifference . . . It is rather a question of forcing art into moral issues; of confusing art, which is an intuitive faculty, with various modes of intellectual judgement; of making art subordinate, not merely to political doctrines, but also to philosophical points of view. But art, I shall maintain, is an autonomous activity, influenced like all our activities by the material conditions of existence, but as a mode of knowledge at once its own reality and its own end. It has necessary relations with politics, with religion, and with all other modes of reacting to our human destiny. But as a mode of reaction it is distinct and contributes in its own right to that process of integration which we call a civilization or a culture.[14]

Is Sir Herbert Read a victim of the nineteenth-century fallacy concerning the unique attributes of art? He wrote the above paragraph in 1945, at a time in history when it had become impossible to remain detached: the Nazi holocaust had demanded a choosing of sides. It may therefore be somewhat surprising to hear Herbert Read proclaiming that art must remain autonomous, outside political activity, apart from "false moral issues." Read apparently believed that there were intuitive, spiritual, instinctual levels of human experience which could become suppressed if the rational moralizing aspects of our personalities were always overseeing our activities. It is not necessarily a frivolous act of play but a grander game of metaphysical communion with being ourselves, being human, and of a universal civilizing spirit.

The debate as it was formulated implied that photographers who concerned themselves with symbolic forms rather than with some unspecified but still "necessary" humane concern were somehow less moral, less ethical, and less committed to humanistic efforts. I believe that this mistaken idea comes out of the past century of struggle between competing ideologies concerning the arts as they reflected the political realities and ethical ideals of a particular time. Stieglitz apparently believed, in good faith, that he was upholding the very foundations of civilization, by seeking universal "truths." Hine was serving the best tradition of those who believed that photography, like any other "art," should be used to foment

62

social reform. Stieglitz was expressing what Kandinsky called the "inner need." Hine was communicating what he thought was the "social need." But Karl Marx had already identified the ultimate *social* need: it was precisely the *inner* need, the needs of individuals to pursue free and meaningful lives. One way in which we might solve this apparent contradiction is to pursue the hierarchy of needs proposed by the social psychologist, Abraham Maslow, who suggested that survival needs like food and shelter precede more advanced needs having to do with the development of selfhood and the expansion of personal competence.

This sounds like a fine solution until we encounter the response of someone like Lewis Mumford:

> The materialist creed by which a large part of humanity has sought to live during the last few centuries confused the needs of survival with the needs of fulfillment; whereas man's life requires both . . . In terms of life-fulfillment, however, this ascending scale of needs, from bare physical life to social stimulus and personal growth, must be reversed. The most important needs from the standpoint of life-fulfillment are those that foster spiritual activity and promote spiritual growth: the needs for order, continuity, meaning, value, purpose and design—needs out of which language and poesy and music and science and art and religion have grown.[15]

Mumford, of course, had spent his entire career tracing the complex interconnections between modes of production and the development of societies—see his *Technics and Civilization* and *The Pentagon of Power*—so he cannot be called naive or a neophyte in the history of the relationship of culture to the lives of individuals. He is surprisingly insistent that both the inner need and the social need require satisfaction or what is specifically human about us will shrivel and die:

> . . . for even the humblest person, a day spent without the sight or sound of beauty, the contemplation of mystery, or the search for truth and perfection is a poverty-stricken day; and a succession of such days is fatal to human life.[16]

For Mumford, the human spirit requires humanizing nourishment, of a kind that deepens and intensifies responses, increasing the human

Estelle Jussim

potential for cooperation and true communion.

How, then, do we balance the satisfaction of the inner need with the responsibilities of the social need? How much individual freedom and how much social responsibility? I believe that Northrop Frye put the matter very well:

> The myths of concern and of freedom are ultimately inseparable, and the genuine individual can exist only where they join. When a myth of concern has everything its own way, it becomes the most squalid of tyrannies, with no moral principles except those of its own tactics, and a hatred of all human life that escapes from its particular obsessions. When a myth of freedom has everything its own way, it becomes a lazy and selfish parasite on a power-structure.[17]

To achieve a genuine humane commitment, the photographer as artist, as person, as member of a social organism, may need to seek this balance between the myth of freedom—the "inner need"—and the myth of concern—the "social need"—with a conscientious effort; as do we all.

NOTES

[1] Quoted by Geraldine Pelles, *Art, Artists and Society,* Prentice Hall, Englewood, N.J., 1963, p. 18.

[2] *Ibid.,* p. 19.

[3] Quoted from Proudhon's *Du principe de l'art et de sa destination sociale,* in Philip Gilbert Hamerton, *Thoughts about Art,* Boston, Roberts, 1871, p. 319.

[4] *Ibid.,* p. 320.

[5] Edward Lucie-Smith, *Symbolist Art,* New York, Praeger, 1972, p. 143.

[6] Vincent Tomas, "Introduction" to Leo N. Tolstoy, *What Is Art?* Translated by Almyer Maude, New York, Bobbs-Merrill, 1960, p. vii.

[7] Tolstoy, pp. 142-43. (see reference 6)

[8] *Ibid.,* p. 51.

[9] Herbert J. Seligmann, "A Vision Through Photography," in *America and Alfred Stieglitz,* New York, Literary Guild, 1934, p. 121.

[10] *Ibid.,* p. 124.

[11] *Ibid.*

[12] Wassily Kandinsky, *Concerning the Spiritual in Art,* New York, Dover, 1977, p. 34.

[13] Quoted in Etienne Gilson, *Painting and Reality,* New York, Meridian, 1957, p. 258.

[14] Herbert Read, *Art and Society,* New York, Pantheon, 1945, 2nd ed., p. 2.

[15] Lewis Mumford, *The Condition of Man,* New York, Harcourt Brace, 1944, p. 413.

[16] *Ibid.,* p. 420.

[17] Northrop Frye, "The Critical Path," in *Theory in Humanistic Studies; Daedalus,* Spring 1970, p. 315.

PHOTOGRAPHY AND THE INSTITUTION: SZARKOWSKI AT THE MODERN

MAREN STANGE

IN THE YEARS since John Szarkowski became Director of the Department of Photography at the Museum of Modern Art, photographers, critics and the public have witnessed a photography boom of gigantic proportions. Its manifestations surround us and need not be chronicled here. The new interest in photography has meant an increase not only in the number of photographers, but also in the number of cultural institutions providing support and structure for that interest. The conditions and problems of the situation are perhaps unique for the Modern, which began collecting photographs in 1930 and which, in the words of its first director, Alfred Barr, always "exhibited photography . . . as a peer of painting."[1]

Szarkowski described this situation in a recent interview with Jerome Liebling, from which most of his remarks below are taken: "I think that there's a very real, not just fashionable, but a real and broad interest in photography. But there's a very severe financial problem, and there's also a very serious problem about how you get to do it, because you want someone [to curate photography] who might be willing, to some degree, to discipline himself to general museum discipline. I don't mean getting around; I mean understanding the general functions and responsibilities." For the photographer, too, the boom creates "a very different situation. I think that the horribly new kind of circumstance a photographer finds himself in now is very much a double-edged sword and, if one could have any kind of circumstance one wished, this wouldn't necessarily be the kind of circumstance one would wish for now."

Criticism of recent photography exhibitions must cope with esthetic and philosophical ramifications of novel sorts. There is opportunity now, provided by such burgeoning plenty, for curators to exercise unprecedented authority. Curators can control taste—that is, the esthetic significance of individual works as implied by exhibition policy —and also construct photographic history with authoritative collection and publication policies.

When Szarkowski became Director in 1962, his predecessors were Beaumont Newhall, who had been the Librarian of the Museum since its founding in 1929 and who became Curator when the Department was established in 1940, and Edward Steichen, appointed in 1947, who retired in 1962. Szarkowski came to the museum with experience as a

Maren Stange

photographer, museum worker, writer, and teacher of photography and art history. His formative years were spent in the Middlewest, studying art history at the University of Wisconsin (1944-1948), and working at the Walker Art Center in Minneapolis (1948-1951), where he met Jerry Liebling. In 1951, Szarkowski began teaching at the Albright Art School in Buffalo and began work on his book, *The Idea of Louis Sullivan,* published in 1956. In 1958, he published *The Face of Minnesota,* commemorating the centennial of Minnesota's statehood.

As Szarkowski became known in New York, his curatorial persona grew clearer and more settled, and critics and observers became more perspicacious in their judgements of his work. Early criticism was generous, if cautiously aware of dealing with firm preferences. Reviewing Szarkowski's first major exhibition, "The Photographer and the American Landscape," in 1963, Minor White wrote:

> I was grateful to Mr. Szarkowski for materializing an exhibition on a subject that is not modern, art or in fashion; to the Museum for offering the show to the public in a setting that allowed and encouraged the pictures to speak for themselves; and to the photographers, one and all, for being in love with nature and camera.

But White also wondered why Szarkowski used the word "insistence" in his catalog essay when, White felt, "that is the personal word. The word 'preference' in that place would indicate a broader view of photography." [2]

Szarkowski has remained remarkably calm and evenhanded in the face of increasingly vehement and various critical comment—an achievement that in itself must be counted a success, if only of a personal sort. "Of course, a lot of exhibitions that people don't like, they're just different views," he pointed out. More seriously, however, he spoke to the issue:

[SZARKOWSKI]: I think there is a large body of the opinion or feeling, generally outside of the schools, that our program has not really concerned itself with social issues. It hasn't concerned itself with reportage. I've never understood and therefore do not accept the notion that something should be shown because it's happening. . . . [And] we've never done an exhibition designed to show that women were a good idea, that youth was a good idea, that poor people were a good idea, that rich people were a good idea, or that everybody was the same all over. I can't think of one exhibition that we've ever done that could be thought of as having been designed to demonstrate any such thing.

Now, there are shows about which you could say the work of this

66

photographer makes it clear that people are no damn good and all basket cases. Or the work of this photographer indicates that people are all really very beautiful and lovely. Then the question is: is that an accurate selection of that work, or is it a tendentious selection of the work, and does the work itself have enough vitality and quality to deserve being exhibited regardless of what it means. In which case, by and large, I would be willing to defend it.

I really get more and more persuaded that if you want to regard [exhibition policy] as a formal issue, you can do that, or if you want to regard it as a question of content, you can do that, but you can't say that it's half and half. I've given up on thinking that you can regard it as being half and half. It just gives you places to dodge and hide. It came to me once, a while ago, that if you're trying to write a sentence as precisely and accurately as you can, there are not really two ways of saying the same thing. You can say similar things. Using different words or even reversing the order of certain words, you can say similar things, even closely related things. But I can't conceive of being able to say exactly the same thing in two different ways. Now that's fascinating. That's true in pictures, too: you can't say the same thing in two different ways. So, if you change the form, you change the meaning, too. If you can't change one without the other, then you can regard either one of them as being the dictatorial issue, and it doesn't make any difference. Right?

One kind of criticism that has been directed at Szarkowski is represented by A. D. Coleman's 1972 review of "Atget's Trees," a selection of prints from the museum's Atget Collection. Coleman's point of view is worth quoting at length:

> Atget's Trees is a show which only a curator could love. . . .
> Since [the selection] is so untypical of Atget's imagery, it can only be taken as a manifestation of the Puritan, ascetic aesthetic behind the show: Thou shalt get no joy from Art. Proving that Atget's work is capital-A Art seems to be the purpose of this exhibit. Capital-A Art, as defined in Szarkowski's peculiar wall label, is neither accidental nor intuitive in origin; it is exclusively a process of conscious problem-solving, the problems in question being purely intellectual and aesthetic. Such problems, according to this definition, are formal issues posed by the artist. Hence Szarkowski's unimpeachable-since-unverifiable claim that "Atget's decisions were apparently based not only on intuition but on a conscious analysis of his own earlier work."
> . . . Szarkowski is out to prove, in this show, that Atget's

67

work is about itself—not about Paris, or Atget's life, or being enchanted by reality and trying to preserve some slice of it.

Claiming that the exhibition is "the most unenjoyable group of Atget photographs I have ever seen, apparently picked in total defiance of the lyrical yet robust romanticism which is the hallmark of Atget's vision," Coleman blames this disappointment on the "labor-union mentality" of curators and critics. They all too often wish to reinforce their "delusion that their training in the history of art and the formal problems confronted by artists—which are a part, but only a part, of the creative act—give them the power of ultimate insight into the nature of any creative work."[3]

Another point of view, also focused on the effects of the institutionalization of modern art, decries not the self-serving curatorial mechanisms evidently discernible in the arrangement of images on the walls, but rather the possibly uncontrollable taste-making forces generated by the giants of the culture industry. In a clever article written in 1974, Gene Thornton traces the career of Lee Friedlander, who "already seems a little bit passé." The reason for this, Thornton implies, is that Friedlander has had too many shows at the Modern, so that he has garnered too much exposure and influence, and allowed too many followers to "gallop on" past him, followers who themselves have now also had shows at the Museum. The result of all this is that Mark Cohen's photographs "made Friedlander's 'accidents' look quite purposeful," that the emergence of Photo-Realist painting raises the problem that "when the average gallery goer sees a Friedlander today, he may mistake it for a small black-and-white reproduction of a painting by Richard Estes or Ralph Going," and that the "Law of Obsolescence" has unfortunately made the average viewer's major sentiment regarding Friedlander not admiration for his pioneering originality, but deprecation of his passé quality in relation to the present state of avant-garde esthetic affairs.[4]

There is the kind of criticism that flatly disagrees with the esthetics of an exhibition and takes the entire institution to task for it. This is, in effect, Hilton Kramer's view of the 1976 William Eggleston show:

> The truth is, these pictures belong to the world of snapshot chic—to the post-Diane Arbus, antiformalist esthetic that is now all the rage among many younger photographers and that has all but derailed Mr. Szarkowski's taste so far as contemporary photography is concerned.
>
> To this snapshot style, Mr. Eggleston has added some effects borrowed from recent developments in, of all

things, photorealist painting—a case, if not of the blind leading the blind, at least of the banal leading the banal. For purely negative reasons, this is a show—made possible, as they say, by grants from Vivitar, Inc. and the National Endowment for the Arts—that has to be seen to be believed.[5]

Although never commenting directly on his critics, Szarkowski is responsive to them. A certain part of this forebearance and self-confidence may be reminiscent in style of an acknowledged early inspiration, the architect Louis Sullivan. Szarkowski does appear, in fact, to build his ever stronger and more complex esthetic solidly upon the foundation of his early appreciations.

[SZARKOWSKI]: I think I was quite clear in my mind when I came here that whatever a curator's responsibilities were, one was not to lead artists. I've been a working photographer for twenty years. I knew how I felt about people in museums and people in magazines. Magazines aren't so bad; they've got their own commercial problems. Either they can use your stuff for grist for their mill or not. Museums are different. Museums using your stuff as grist for their mill is much worse and much more serious. It was very clear that my concerns as a photographer had nothing to do with my concerns as a curator: there, you've got to be a follower. You follow artists; obviously you have to make choices. You have to make some kind of judgement or guess as to what seems most vital, what has the most vitality in it. But you're counterpunching, you're after the fact, you're not a leader. It's immoral to try to be a leader.

If you start off with the assumption that there is, in fact, such a thing as photography that isn't just all in your mind, not just each individual's wholly personal and subjective, platonic notion of it in his head—if, instead of taking that position you take the position that there really is such a thing as photography that would exist even if both of us got run over by a bus, then it has a certain history. It has a certain life and that life has a certain lifeline and certain pictures at certain times have about them a vigor and vitality that has persuaded other photographers that there was something in that work that they could use, they could borrow from, they could steal and expand, use to their own advantages. And that's tradition, that's what I'm interested in. In this job that's all I'm interested in, tradition.

By which I don't mean old pictures, I mean that line which makes the job as curator rather similar to the job of a taxonomist in a natural history museum. You don't have to collect and stuff *every* song sparrow in the world, but you're especially interested in those that seem to be, in

Maren Stange

some way or another, a mutation, a little different. Then you ask whether or not the mutation is going to serve some interesting function in terms of survival capacity of that creature: whether it will be able to fly farther or sing more sweetly, or crack a bigger seed.

[LIEBLING]: Sing more sweetly.

[SZARKOWSKI]: Sing more sweetly. That's to do with abilities to attract mates and reproduce, because if the bird can fly farther and crack bigger seeds but nobody will get near it, it doesn't have anything to do with its survival capacity in terms of the future.

Such metaphors have a limited usage. But there is such a thing as photography, with a lifeline that continues, having to do with people adopting, and then adapting, stealing from. If new pictures come out of old pictures, which I think they do, then what you're concerned with at the moment is, in effect, where the point is from which one can move in any one of several directions to take a next logical step. It's not like a random sample; it has to do with a judgement about where the potential vitality lies and it doesn't have to be only in one area. It's not only proper, it's probably inevitable for the artist to take that position. Like, for instance, Walker Evans' marvelous definition of photography: never under any circumstance is it done anywhere near a beach. Perfect, you know, just perfect. Not true except for Walker, but it was absolutely true for him.

We do shows one at a time now because we've got a continual space [The Edward Steichen Galleries installed in 1967]. You don't have to do Chauncey Hare, or Helen Levitt or Michael Snow all at the same time, which would tend accidently to impose a kind of meaning on the group that you don't necessarily mean to impose on it. That's why that exhibition you were in was called "Five Unrelated Photographers" [held in the ground floor galleries in 1963]. I was trying to make it clear that it was five little one-man shows, that they weren't all related to Diogenes or any other Greek hero.

[LIEBLING]: How would you then describe some of the other work that you've shown here? Is there an idea of simplicity, or completeness, say, that you admire, in Gary Winogrand's work?

[SZARKOWSKI]: I actually think there is. But not so much as in the manner of working. And interestingly enough, also with Lee Friedlander, like the Monument book, which I think is just marvelous. He got the idea for that book looking through his recent work over the last four or five years and finding that he had been shooting a lot of monuments. He found, after the fact, that he'd been shooting a lot of this stuff, and then he got into the idea of the book. Whatever the orig-

70

inal seeds were, the very complicated process that came between the first monument picture and the final book is amazing. It's maybe the most patriotic thing to come out of the whole bicentennial.

I think the important thing is what is done and how well it's done and not what my secret personal prejudices are, that I might entertain in my dreams or late at night. I think that certainly it's true that everything we've done here has not been of equal personal interest to me in terms of my own most special personal perspectives. But it seems that anybody who's trying to do any kind of responsible job has got to recognize an obligation that goes beyond his most special personal concerns. He should be competent enough and have a broad enough knowledge and sense of the responsibility of his function to be able to report competently and critically and to recognize quality in work that is not necessarily involved with those issues that are of greatest personal concern.

One of the first shows that I really was intimately involved in from its inception was "Five Unrelated Photographers." That was not an accident, nor was the title an accident of that exhibition. I suppose, consciously or unconsciously, I wanted to make it clear that that show had no philosophical moral, it had no political moral, it had no stylistic moral, but everybody in it was doing work that I considered to be of intensity and quality, and that the attention would be directed toward the specific nature of the work that five people, that I considered to be of some interest as photographers, were doing—to the work, not to the people. I was certainly not trying to take the position that your innermost soul, and George Krause's, and Minor White's and Gary Winogrand's and Ken Heyman's was the subject of the show. It was the work that I considered the subject of the show. I suppose that, in a sense, is a prejudice, a position. But it's not a position which means that I should have excluded Minor, for example, who might himself have been interested in taking that position. And if his position is other than, say, *your* work, there it is.

The next show that was very important to me and that I think *was* a very important show that has got a great deal to do with what I've been trying to do here was the "Photographer and the American Landscape" show. That was the first large and difficult show that I did here. It did not have to do with American geography. It didn't have to do with amber waves of grain and purple mountains' majesty except that it had to do with the photographic tradition which is what I'm interested in. It had to do with tracing up to that time, including very recent work— Sinasbaugh, Porter, Currant, Washburn—and defining what was the current sense of the potentials of a line of picture-making possibilities and of picture-making tradition in photography. I think that was not necessarily in its subject matter but in its approach, and I think that possible distinction was pretty typical of what I've tried to do here. It had to

do with what I think is an objective issue and a traditional issue defined in terms of the work of individual photographers. But I think there certainly has been an emphasis on trying to preserve the integrity of particular people's work and certainly there's always been an emphasis on the idea of tradition in those terms. What is it that you start today know-

ing? And where did it come from? Because that is what I'm most interested in—the idea of tradition. Again, I don't mean old pictures, I mean what do we know, what do we remember? Including what do we remember of what was done yesterday. *The Photographer's Eye* [written by Szarkowski, published in 1966] was an attempt to try to define certain issues, certain fundamental issues, that might begin to offer the armature for a credible vocabulary that really has to do with photography and not with how Alfred Stieglitz felt about the smokestacks, or whatever else.

When we got our own small gallery along with our collection space, a lot of things that otherwise would have been done in bigger shows with some kind of philosophical rubric could then be done on the basis of a continuing effort, with small one-man shows seen in the context of the kind of background that the permanent collection provides. Where you don't necessarily need the more pretentious intellectual or philosophical framework. You know, you say: this is the work of so-and-so, who is age thirty-two. Or this is what so-and-so who is sixty-five has done in the last ten years, or a piece of it. But a show like "New Documents" [held on the first floor in 1967], for example: in one sense, we could regard it as a group of three little one-man shows. But it was three one-man shows that also had some degree, I think, of coherent meaning in regard to what was new in the mid-sixties, what was new and vital and most original in the mid-sixties.

We are doing a show in the summer [of 1978] about the American photography of the last twenty years ["Mirrors and Windows: American Photography Since 1960"]. Which, in a sense, I suppose, is a kind of a review to a considerable degree. By no means exclusively, but to some degree, it is what we've learned not only from those one-man shows but from more special shows. Like the shows that Peter Bunnell did on "Photography as Print-Making," and the sort of successor to that which was the "Photography on Sculpture" show and other kinds of project shows and survey shows and formal issue shows.

[LIEBLING]: I don't know the exact quote, but someone quotes you as saying, differently from some other people, that "photography relates to photography," which you have said here. Could you define that? Some of the work I see being done now by students refers back to photography. Is that what you mean, or is it something different?

72

Szarkowski at the Modern

[SZARKOWSKI]: In a sense that's what I mean. But students are different, students are students. If a student is making good use of his time as a student, it seems that it's almost inevitable that his stuff comes wholly out of photography or out of whatever art he's practicing. That's what they're there for. But forgetting those students, a very large impetus comes out of photography. But the issue for the individual person is how to understand that, make use of it, encompass it, and proceed from it.

[LIEBLING]: To accomplish what?

[SZARKOWSKI]: To push it, to advance it—the tradition, the line, the sense of the awareness of what is possible. The general generic problem of what is this funny medium and what can you do with it and what are its potentials. Obviously, in the process of doing that it would be exceedingly difficult, if not impossible, to expunge the personal perspectives and personality and particular talents and particular limitations of whoever it is that's doing the work. That you get free, in my view. But the center line of a problem and the most interesting part of it, you know, is not the question of what is unique to the individual, because, hell, we've all got that to begin with. But rather, it's how those energies are used to further explore the potentials of that line, that evolutionary line of the being.

[LIEBLING]: All right, now. You know what you're doing, John. If you had to, in two paragraphs, define that line, could we then think of someone else who would say the same thing?

[SZARKOWSKI]: My understanding of it may be imperfect, let us say. I'm not talking about my opinion; I'm talking about the truth. And I think the last time we talked I said it in words. I said, I think, that I really believe that there is such a thing as photography. If I did not believe that, I would find this an extremely boring job. All there would be is committee meetings, arguments, fundraising, all the crap. The reason it is still a very interesting job is because I think there actually is such a thing as photography that exists independently of what you think it is, or what I think it is, or anybody else. Something pretty close to an organic issue. I don't mean predetermined because an organic evolution isn't predetermined anyway. The thing that *is* determined is the genetic pool out of which the next experiment can be made. That is also what is determined in an art form—that's what the tradition is. It is the great genetic pool of possibilities out of which the next combinations can be made out of will, imagination, choice, etcetera, in part.

One thing that I think is a natural mistake for students, but certainly not for mature intellectuals, is to tend to judge a program on the basis of

73

the title of the show. Certain kinds of work—in the nature of that work—are going to produce much smaller bodies of work, and unless those pictures are unusually large physically, it is possible to deal with them in a group context and still show an equally large portion of that person's thought, concept, and so forth in a group context as opposed to a little third-floor one-man show. One of the problems that does, on occasion, aggravate me, although scarcely anything aggravates me anymore, is what I think especially—but not exclusively—of young people who have the notion that, for example, our exhibition program is determined as one would award medals in the Army or something like that. That the basic function is to award excellence. That is not its function at all. Or rather, any degree to which that might be its function is absolutely accidental and peripheral and is not the way one tries to design. Anybody approaching the issue responsibly would define an exhibition program; and you define an exhibition program in terms of how you can best act as a liaison between the photographic community, in the case of this department, but generally between the artist and his potential audience. I think in photography the formalist approach is not concerned with neatness, it's not concerned with parallel lines, it's not concerned with flat walls. It's concerned with trying to explore the intrinsic or prejudicial capacities of the medium as it is understood at that moment. Winogrand, for example, is perhaps the most outrageously thoroughgoing formalist that I know. What he is trying to figure out is what that machine will do by putting it to the most extreme tests under the greatest possible pressure. I sometimes think he's like a materials testing laboratory and he's trying to figure out at what point his theory will absolutely, totally, and finally fail. It's not neatness.

[LIEBLING]: I'm interested in how *you* respond, John, where that evolutionary line of photography developed for you. Had you remained in Wisconsin, what might the line be like? That's interesting.

[SZARKOWSKI]: But I'm not sure it's a very relevant question. If I was still working as a photographer in northern Wisconsin or anyplace else, I would certainly be able to enjoy much stronger and more irrational and unbalanced prejudices than I'm able to enjoy here. Which are absolutely proper and maybe essential for a working artist to have. What the hell does an artist need with distance, objectivity? A working artist's opinions about what part of the tradition is useful to him or to her are to do with what he can most profitably steal from for the good of his own work. So that's proper, and it's fruitful. I don't think I'll ever have that problem or opportunity, so I don't have to worry about it.

Szarkowski at the Modern

EFFORTS TO DISCOVER more about Szarkowski's idea of the "center line" of the problem of photography, and the meaning of his sense of a "great genetic pool of possibilities out of which the next combinations can be made," lead to consideration of some of the forces in American culture at large which have shaped both the man and the museum. Inquiry in this direction may help to define the concepts more sharply than he appears willing to do. Szarkowski is clear, if not particularly informative or critical, about the history of the museum and the Photography Department.

[SZARKOWSKI]: The reason this department is here, basically, or this program is here, is because of Alfred Barr. Before the museum was founded [in 1929], Alfred felt very strongly that a genuinely modern museum could not deal only with painting that's called pure, and with traditional graphics, but it also had to do with architecture and design, and photography and film. He made graphics with whatever the important artistic expressions of the will of the period produced.

The first photographs acquired by the museum for the collection were acquired in the spring of 1930, four or five months after the museum opened. They were Walker Evans photographs. In 1930, who was Walker Evans? He was just some penniless kid, nobody knew about him, he never had a one-man show at the Museum of Modern Art, nothing.

Then there were some really very interesting and important shows even before Beaumont came. Basically, there weren't departments then; I don't even know if there was a Department of Painting and Sculpture—it was just a museum. It was Alfred and a few people helping and a lot of bright, educated, eager, generally prosperous volunteers like Lincoln Kirstein and so forth. Beaumont came here as Librarian and Alfred found out that he was interested, very much interested, in photography and had done a good deal of studying on his own. So he said, "Do you want to do a history of photography show?" And Beaumont said he'd love to. So Alfred said here's some money, get out, go travel.

[LIEBLING]: That's the history of his book?

[SZARKOWSKI]: That's the history of his book. He's now working on the fifth edition. I think it was the very first coherent, disciplined, scholarly effort to try and figure out what the past had been about in this country from a disciplined art historical point of view.

Walker's "Victorian Houses" show was the first one-man show, in 1933, and Walker's "American Photographs" was in 1938, which I don't think Beaumont was involved in—I think that might have actually been when he was off doing research—but Lincoln Kirstein was. Kir-

75

stein was not on staff but was the Junior Counsel, something like that, and maybe Monroe Wheeler might have been here by then, probably head of Exhibitions and Publications. The department was formed in 1940, and when Beaumont went off to war, Nancy Newhall was acting curator and I think things didn't go altogether smoothly in those days. Then, briefly, Willard Morgan became Director of something called the Photography Center, which moved across the street to 54th Street; whether that's where the whole Department and collection moved, I don't know. Then the museum kept growing and getting more expensive and it got harder and harder to support as a hobby, even for well-to-do people. Then people began looking ahead, asking how is this thing going to be paid for, because obviously it's going to get more and more expensive. I think the combination of Beaumont's being away and things not going all that smoothly in his absence, and looking ahead to increasingly more ambitious and expensive programs—I think part of the notion was that Steichen was not only a great photographer and somebody who knew everything about what had gone on, practically, going back to the beginning of the medium, but also he would be a terrific person to help.

[LIEBLING]: Is there any relationship with Stieglitz during these early years?

[SZARKOWSKI]: Very little. Beaumont tried, I think, assiduously. Beaumont tried very hard first to enlist Stieglitz's help and then at least to preserve his goodwill. He was maybe a little bit successful in the first function. I think basically, maybe understandably, Stieglitz regarded the museum as a sort of Johnny-come-lately to the field of modern art. After all, he'd been doing it all these years, and who were these upstarts from Harvard who figured they could do it without even talking to him about it first, without getting his permission. I suspect he was, in those terms, kind of a difficult old crab. Basically I think he was unsympathetic to the whole idea of the museum, you know, from the first moment he thought about it or heard about it. I know that Beaumont tried to enlist his aid; whether Steichen even tried or not, I don't know. I think probably not too much except for the small things, particular, specific things, but by then I suspect that they'd known each other long enough to know that it probably wouldn't have been a very good idea on either side. Anyhow, Stieglitz was an old man; he was, in fact, dead.

MORE SPECIFICALLY, when Beaumont Newhall asked Stieglitz for help with his 1937 exhibition surveying the history of photography, Stieglitz refused. He wrote to a friend:

Szarkowski at the Modern

I have nothing against the Museum of Modern Art except
one thing and that is that the politics and the social set-up
come before all else. It may have to be that way in order to
run an institution. But I refuse to believe it. In short, the
Museum really has no standard whatever. No integrity of
any kind. Of course there is always a well-meaning "the
best we could do under the circumstances," etc., etc. . . . I
feared I could be of no use [to Newhall], as I felt that in
spite of its good intentions the Museum was doing more
harm than good. . . . The reason [for not supporting him]
was that I realized that the spirit of what he was doing was
absolutely contrary to all I have given my life to. In short,
that he was doing exactly what I felt was a falsification of
values—primarily because of ignorance.[6]

Stieglitz's remarks appear, from our present perspective, jarringly
heretical, the queer anachronism of a bygone age. The attitudes which
set him at such odds with the museum are, however, set forth quite
clearly in the collective book, *America and Alfred Stieglitz,* which me-
morialized him in 1934, five years after he opened his last gallery, An
American Place. The editors wrote that Stieglitz's

nearly fifty years of intricate creative action is, we feel, im-
portant in the precise sense that Man is important; in the
precise sense that the struggle toward truth is important; in
the sense that America, as a favored soil where truth may
be sought and where Man may live, is potentially
important.[7]

And Elizabeth McCausland wrote:

To be sure, Stieglitz derives from the American tradition, he
exemplifies the American character. These facts are true
enough; but they are unimportant except in relation to a
more basic and universal truth. In life it is evident that
there are forces for evil and forces for good, that life can only
be completely understood in terms of affirmative and
negative values, of creative and destructive energies. When
this is understood, one has no choice except to take his
stand on the side of good: certainly this is true of Stieglitz.
. . . Such integrity of the spirit one finds in earlier Americans:
Emerson, Whitman, Emily Dickinson. One finds it too in
Marin, O'Keefe, Dove. . . . in viewing their work, that work
which Stieglitz so passionately asserts must be permitted to

77

live without domination from the external world (the world of art dealers, collectors, museum directors, critics, and an indifferent public) one understands again how the American tradition operates[8]

And Stieglitz wrote, of himself, in 1921:

My ideal is to achieve the ability to produce numberless prints from each negative, prints all significantly alive, yet indistinguishably alike, and to be able to circulate them at a price not higher than that of a popular magazine or even a daily paper. To gain that ability there has been no choice but to follow the road I have chosen.[9]

Stieglitz's was, then, a highly-principled, carefully reasoned, and individualist enterprise. And, inevitably, despite his espousal of "America," Stieglitz experienced a detachment, a secession, from predominant aspects of American life and values. Such a projct as his was unprepared fully to encompass the realities of modern industrial capitalism—especially the forces of class antagonism and the diverse vernacular culture which was their product.

The museum which Stieglitz so opposed for lack of standards and integrity commissioned a progress report in 1935. It read in part:

The Museum of Modern Art is in a more strategic position than any other institution to lead the attack on the fundamental cultural question of our time: "How can Art be restored to a more healthy relationship to the life of the community?" . . . What we are really confronted with is the need for two quite consciously and deliberately different kinds of enterprise; on the one hand, the search for what is best in Art according to the highest standards of critical discrimination, and, on the other, the provision of facilities for popular instruction *in accordance with the public need.* (author's italics)[10]

This report became a statement of ideal purpose which has remained with the museum. Whatever else it has done, the museum has not seceded from the public, "external" world. In fact, it might be said that the sensibility exhibited by the museum can claim hegemony over advanced American taste and that the museum's discourse represents quite completely our educated vernacular in the arts.

Such great influence, like Szarkowski's own, is aptly called "unnatural." [11] But reasons for it, and historical causes, can be found.

Szarkowski at the Modern

The museum's idea of "the community" is inclusive, and the role it grants to the artist is large. In both these attitudes, the museum has been responsive to sentiments widely-held among educated Americans in the twentieth century. A similar purpose was, for example, articulated with painful clarity in *The Seven Arts* magazine, edited by the young cultural critics Randolph Bourne, Van Wyck Brooks and Waldo Frank, in 1917:

> It is our faith . . . that we are living in the first days of a renascent period. . . . In all such epochs the arts cease to be private matters; they become not only the expression of the national life but a means to its enhancement. . . . *The Seven Arts* is not a magazine for artists, but the expression of artists for the community.[12]

John Szarkowski describes this ideal relationship of artist and community well in his appreciation of Louis Sullivan: he "was what he built: a lyric poet by nature, an American pioneer in the strength of his desire, a cosmopolitan in breadth of mind; brilliant, outspoken, inventive: an American Master." [13] Szarkowski writes that Sullivan, like other American Masters before him, insisted on a democratized esthetic tradition:

> Sullivan had written: "This flow of building we call Historical Architecture: at no time and in no instance has it been other than an index of the flow of the thought of the people . . . an emanation from the inmost life of the people. . . ." [14]

And Szarkowski shows how Sullivan articulated and practiced an organic architecture, in which form followed function. Szarkowski quotes:

> Speaking generally, outward appearances resemble inner purposes. . . . the form, spider, resembles and is tangible evidence of the function, spider. Like sees and begets its like. That which exists in spirit ever seeks and finds its physical counterpart in form, its visible image. . . .[15]

Turning for the last time from the museum to the man, perhaps it is revealing enough for our purposes simply to suggest that the early hero, the American master, continues to inspire. Sullivan echoes in Szarkowski's description of the quintessential early American landscape photographer he exhibited in 1963:

Maren Stange

Simultaneously exploring a new subject and a new medium he made new pictures which were objective, non-anecdotal, and radically photographic. This work was the beginning of a continuing, inventive, indigenous tradition, a tradition motivated by the desire to explore and understand the natural site.[16]

And he continues to echo, fourteen years later, in Szarkowski's subtly constructed essay in *William Eggleston's Guide,* which so offended Hilton Kramer:

Form is perhaps the point of art. The goal is not to make something factually impeccable, but seamlessly persuasive. In photography the pursuit of form has taken an unexpected course. In this peculiar art, form and subject are defined simultaneously. Even more than in the traditional arts, the two are inextricably tangled. Indeed they are probably the same thing. Or, if they are different, one might say that a photograph's subject is not its starting point but its destination.[17]

Has the museum done well or ill in executing its self-appointed, paradoxical task, at once elitist and democratic? And Szarkowski's own work, whose principles he lovingly articulates for us but whose impulses and direction he keeps opaque—how does it stand in relation to the complex actualities of the photographic enterprise? The "great genetic pool of possibilities" may be, in fact, too great for any single person to comprehend. Perhaps this is what we mean by our insistence on knowing what Szarkowski's esthetic and historical "lifeline" actually represents. Suspecting distortion, we seek some corrective measure. But despite so many words, we are left in the end with clues, not answers. As is so often the case in discourse on photography, we are, most fundamentally, directed simply to look harder.

NOTES

[1] Alfred H. Barr, Jr., "Photography," *Art in Progress: A Survey Prepared for the Fifteenth Anniversary of the Museum of Modern Art* (New York: The Museum of Modern Art, 1944), p. 146.
[2] Minor White, "The Photographer and the American Landscape," *Aperture* (Vol. 11, #2, 1964), pp. 52, 55.
[3] A. D. Coleman, "Not Seeing Atget for the Trees," *Village Voice* (July 27, 1972), p. 23.
[4] Gene Thornton, "All of a Sudden Friedlander Seems Passé," *New York Times* (December 15, 1974), p. 39.
[5] Hilton Kramer, "Art: Focus on Photo Shows," *New York Times* (May 28, 1976).

80

Szarkowski at the Modern

[6] Russell Lynes, *Good Old Modern* (New York: Atheneum, 1973), pp. 156-7.

[7] Waldo Frank, Lewis Mumford, Dorothy Norman, Paul Rosenfeld, Harold Rugg, eds., *America and Alfred Stieglitz* (New York: The Literary Guild, 1934), p. 5.

[8] *Ibid.*, pp. 228-9.

[9] *Ibid.*, p. 116.

[10] Lynes, pp. 148, 161.

[11] Sean Callahan, "The First Viceroy of Photography," *American Photographer* (June, 1978), p. 29.

[12] Lillian Schlissel, ed., *The World of Randolph Bourne* (New York: Dutton & Co., 1965), p. xxxv.

[13] John Szarkowski, *The Idea of Louis Sullivan* (Minneapolis: University of Minnesota Press, 1956), p. 19.

[14] *Ibid.*, p. 27.

[15] *Ibid.*, p. 103.

[16] Szarkowski, quoted in Minor White, "The Photographer and the American Landscape," p. 55.

[17] John Szarkowski, *William Eggleston's Guide* (New York: The Museum of Modern Art, 1976), p. 7.

The Bus Show

There will be an exhibition of photographs in 500 New York City public buses in May of 1975. The purpose of the show is to present excellent photographs in a public space. All prints will appear with the photographer's name and the picture's title.

Photographs accepted for the exhibition will become part of the permanent collection of the Library of Congress. Send duplicate prints of each photograph you wish to submit; one print will go on a bus, the other to the Library of Congress. You must state what rights you grant to the Library of Congress with each photograph: loan, reproduction, or neither without your specific approval.

You may submit photographs to be considered for one person shows or as part of the group exhibit. Since the photographs will be placed in the interior advertising space of the buses there are certain size requirements, and in the case of one person shows, a specific number of photographs are needed to fill the available spaces. If you are submitting for group exhibition, send us any number of photographs in any of the size categories. For one person shows, you must submit the exact number of photographs needed to fill a bus, in each of the size categories. The size requirements and number of photographs for each bus is as follows: 14 photographs with an image height of 9 inches; one horizontal photograph with an image height of 13 inches; two verticals with an image height of 16 inches. Photographs not accepted for one person shows will automatically be juried as part of the group exhibition.

All work must be unmounted and untrimmed. Remember to submit duplicate prints of each photograph. Work not accepted will be returned if postage is included. On the back of each print write your name, the picture's title, and the rights you grant to the Library of Congress. Enclose a 3" x 5" file card with your name, address, and phone number. Mail prints to: Bus Show, Photography Department, Pratt Institute, Brooklyn, New York 11205. For information call (212) 636-3573. The deadline for submission is March 1, 1975.

This exhibition is made possible with support from the New York State Council on the Arts. Poster © 1975 by Pratt Institute. Photograph by Bill Arnold.

THE BUS SHOW

BILL ARNOLD & KATE CARLSON

IN FEBRUARY OF 1975, Bill Arnold, with help from colleagues at
Pratt Institute and friends, mailed copies of this poster to over
1200 addresses in the United States and Canada. It began: "There
will be an exhibit of photographs in 500 New York City buses in May,
1975. The purpose of the show is to present excellent photographs
in a public space . . ." The text explained that work could be submitted
for consideration as one-person shows or as part of the group exhibit.
Size requirements were specified since the prints would be mounted
in the panels usually occupied by advertisements. Finally, the poster
said that pending the consent of the photographers involved, their
duplicate prints would become part of the permanent collection of
the Library of Congress.

In the months that followed thousands of prints arrived at the Bus
Show office space at Pratt where Bill and a small staff reviewed,
sorted, dry-mounted, alphabetized, and shaped them into coherent,
individual shows. Besides being in abundance, they were beautiful
photographs, and they described an intricate and infinite variety of
people and scenes. There were ballet dancers and drive-ins, black and
white glossies and color prints, New Mexico and New York, prosti-
tutes and conceptual pieces, designs and Minamata, Hasidim and
snow. Confronting the rich and conscientious perspective of these
262 photographers made the staff feel as if they were tending an eager
and full garden. Very few of the prints submitted were rejected.
People who responded to the poster seemed to grasp immediately
the meaning of the Bus Show, and sent in imagery which was access-
ible, personal, and vivid. Most contributors realized that exhibiting
on buses was not going to advance their careers significantly because
the show was literally outside of the art world. They sent pictures
they liked and wanted to see on a bus. Most submitted 15-20 prints
and probably spent about $50.00 on materials and postage. In effect,
they were sending gifts to the people of New York.

The show actually opened on November 1, 1975, and ran for
two months. Four hundred buses in Manhattan and all of the bor-
oughs carried the 5,000 prints. One bus in every ten was a show.
None were marked on the outside, making it impossible for riders
to know if they were about to step into a gallery until the bus was
close enough to see inside. Passengers could then begin to notice

that the bands of competing ads had been replaced by quiet group-
ings of images which seemed to enlarge the interior space, which
asked nothing, and which invited as much, or, as little participation
as riders wished to grant. Once inside, people often changed seats
to get a better view, began talking to one another about the pictures,
and many drivers became enthusiastic gallery directors.

New York was the second mass transit exhibit that Bill Arnold
had imagined and brought into being. The first one opened three
years earlier on a snowy February afternoon in Boston's Copley
Square. Forty-four buses had become gallery space for over 1,000
of his own prints. (The New York show was funded by The N.Y. State
Council on the Arts. The Boston show was partially funded by The
Institute of Contemporary Art.) Since then the Bus Show idea had
developed its own momentum and eventually reached its vast
New York proportions, but the central motive behind placing original
prints on city buses was fundamentally unchanged. In one of the
early grant proposals for the Boston show Arnold explained: "People
who ride city buses are in an advertising term 'locked in.' Their
ride lasts an average of forty-three minutes. During that time adver-
tisements offer the primary source of visual material on which they
can focus. I would like to put personal and unpresuming photographs
into the normally commercial space inside city buses. . . . I believe
that the primary value of the photographic image lies in its ability
to communicate and be understood instantly, by anyone. Everyone
has taken a picture, so everyone can understand photographs. By
exhibiting photographs inside city buses a large segment of the popu-
lation will be able to view the work. The value of this kind of ex-
posure seems to me to be in the potential for the photograph to
humanize or soften the tension of urban life. . . ."

Approximately 1.6 million people in New York rode on Bus Show
buses and thousands saw the Boston exhibits. In both cases, pas-
sengers were invited to register their responses via an address listed
on every bus. The Boston show also had a phone number, and
over 100 people called in. The tapes of those phone calls convey
much of what the Bus Show meant to riders . . . The voices are
energized, congratulatory, warm.

Some of the people who wrote or called were worried about how
the pictures would be protected from graffiti and theft. But the show
was meant to be vulnerable. It was assumed that the photographs
would be taken down by the bus riders and eventually they were.
In both the Boston and New York Bus Shows there was very little
graffiti, or none at all.

Martha Hodes
175 Lexington Avenue
New York, NY 10016
December 1, 1975

Bus Show
Box 1747
General Post Office
New York, NY 10001

Dear Sir or Madam,

Ah, the wonder! As I entered the bus I tripped on
my own umbrella, my boots squelched and I felt just plain
wet and miserable on this just plain wet and miserable
Thursday evening. And then-! Rather then being bombarded
with numerous condescending, obscene or otherwise disturbing
advertisements, I saw many beautiful photographs that allowed
for peaceful contemplation.

My rush-hour growls ceased and when I exited the bus,
although the rain was still coming down, my spirits had
risen tremendously. Thank you.

Sincerely,

Martha Hodes

Martha Hodes

FRANCISCAN MISSIONARIES OF MARY
225 EAST 45TH STREET
NEW YORK, NEW YORK 10017

December 3, 1975

The Bus Show
G.P.O. Box 1747
NYC 10001

Dear People:

Thank you very much for the lovely photo
show now going on in the busses, in Manhattan
at least. Not only is it a fantastic change
from the usual ads, but it is really inspiring
art.

All the artists deserve congratulations -
Boxer, Belgrade, Tait and others I cannot
remember.

If I had to name one I most enjoyed, I
think it would be the remarkable Belgrade photo
of the black guy wearing the "Blue Boy" shirt.

Best wishes to you all - I am a Catholic
Sister and have no money to contribute but am
grateful to whoever paid for this show and am
sure that thousands who may not write in are
also appreciating it.

Sincerely,

Constance

Sr. Constance Peck

2/21/73

Dear Mr. Arnold,

I just rode in to work on a bus which displayed your pictures. It made a special event out of the usual routine. It gave it dignity & serenity; & it made me look outside the bus with a different attitude — how much beauty is going by which I just fail to see?

Your pictures are beautiful. Displaying them in public transportation is a superb idea — I wish it could be permanently done.

Thank you.

Linda Robeck

MRS. P. ROBECK
73 VIRGINIA RD
LINCOLN, MASS 01773

Mr. Richard Parks
4 Morton St., Apt. No. 1
New York, New York 10014

The Bus Show
P.O. Box 1747
General Post Office
New York, New York 10001 November 19, 1975

To The Creative People of The Bus Show:

What a pleasant surprize! I have had the pleasure of
seeing two buses with your photography show and I look
forward to seeing more.

I am so tired of looking at "stuffed nasal passage"
advertisements in both subways and buses. It really
is unfortunate that more people in New York City
do not have your creativity in bringing enjoyment
to people. I only wish your show could spread to
the subways.

This is the type of intelligent creativity that
makes New York City such a wonderful place. My
only suggestion is that you do more of this exhibit.

Very truly yours,

Rick Parks.

Rick Parks

 April 11, 1973
Dear Mr. Arnold,
 I'm thirteen, and I ride to
and from school everyday on the
M.B.T.A. I think the photographs
you take are really interesting.
Besides, they are much nicer
to look at then bank, and fun-
eral home advertisements. It's
nice to look up and see pictures
of people in the U.S.A. I
really hope these photographs
will be on all the buses
in the near future. Thank
you.
 Yours Very Truly,
 Stephanie
 Newburgh

THE CITY COLLEGE

OF

THE CITY UNIVERSITY OF NEW YORK

NEW YORK, N. Y. 10031

DEPARTMENT OF HISTORY

December 11, 1975

Dear Mr. Arnold:

I just rode on the 14th Street Crosstown
bus and saw the photography exhibition displayed
on it. What a marvelous idea, and what a boost
to the spirit! There is so much that is ugly
and depressing in the city right now, with the
garbage strike and all; and seeing the photos
posted in the bus just hit the spot, making me
feel good and expansive.

You are a good public servant, and I want
to thank you for reminding me that imagination
and resourcefulness are possible in a large
bureaucracy.

Do keep up the fine work.

With appreciation,

Aaron Noland

SENTIMENT, COMPASSION, STRAIGHT RECORD: THE MID-VICTORIANS

ELIZABETH LINDQUIST-COCK

IT DID NOT TAKE the mid-Victorians long to discover the fact that the photographic image is one of the most powerful instruments for arousing people's emotions and persuading them to ameliorate the ills of society. During the period from 1850 to 1880, many photographers seemed to be devoting their efforts to making strong social comments. On closer inspection, however, these comments fall into at least three major categories, not all of which reflect a genuine social commitment.

Some of these photographers, like Oscar Rejlander, managed to touch the heartstrings of the sentimental Victorians by posing models of "ragged slum children" against painted backdrops of London's East End. Others, like Thomas Annan, attempted to rouse the public to the horrible conditions in Glasgow's slums by presenting stark and truthful images of the downtrodden poor in the dark tenement canyons. Still others, like the popular Francis Frith, turned out picturesque picture postcards, by the thousands, of English fishing villages and factory towns with little or no emphasis on the human condition.

It is a fascinating comment on Victorian mores and morals that the photographers who aroused most emotion and gained the most notoriety seem to us today to be the most shallow and superficial. Quite obviously, the Victorians did not look at photographs in the same way that we do, and did not demand authenticity of documentary photographs. When we look at Rejlander's theatrical photograph of "Poor Jo" today,[1] we are more inclined to fits of laughter than the sea of tears which overwhelmed the Victorian viewers. In the same way, we cannot understand why so much emotion was aroused by Henry Peach Robinson's contrived and melodramatic photograph of a dying girl surrounded by her sorrowing family in "Fading Away."[2] The subject seems more appropriate to afternoon soap opera than to artistic photography. Today, accustomed as we are to the stark tragedy of, for example, a Nick Ut photograph of a Vietnamese child burned by napalm, and used to demanding truth and accuracy above all else, we have a well-developed awareness of the special abilities of photography to present the actual and tangible presence of reality.[3]

Elizabeth Lindquist-Cock

To understand why the Victorian audience did not detect the difference between contrived theatricality and reality, we have only to look at the general culture of Victorian society—its values, morals, sensibilities, and notions about art and photography. It is significant that the mid-Victorians could weep over the plight of Tiny Tim, Little Nell, and Little Dorrit, while they closed their eyes to the real tragedies of the poverty-stricken inhabitants of the London slums. It is also revealing that they could weep pious tears about the bathetic subject of Holman Hunt's painting, "The Awakening Conscience," in which a young woman, perched on her lover's lap, suddenly stops singing the hymn, "Rock of Ages," because she recognizes the evils of her past sinful life. While they were touched by the childlike innocence of Millais's "Blind Girl," or the melancholy couple setting off in "Last of England," the mid-Victorian hearts seemed to possess a Biblical hardness to the disease and wretchedness of the industrial wastelands of Liverpool or Birmingham.

The art criticism of the time was effetely arrogant in urging painters and photographers alike to avoid ugly truth and reality in favor of artifice: the academic painters continued the precepts laid down by Sir Joshua Reynolds in the 18th century, and critics advised artists to strive after "broad effects" over detail in imitation of the works of Raphael and Titian. Photographers were urged to "strive for loftier themes which would 'instruct, purify, and ennoble,' and to compose pictures worthy to be considered in the same class as paintings." [4] Instead of seeking new themes more suited to a new medium, photographers were encouraged to continue imitating the tiresome Madonnas, Nymphs, Venuses, and Vulcans of academic painting:

> For photography there are new secrets to conquer, new difficulties to overcome, new Madonnas to invent, new ideals to imagine. There will be perhaps photograph Raphaels, photograph Titians, founders of new empires and not subverters of the old. [5]

In his influential treatise, *Pictorial Effect in Photography* (1869), Henry Peach Robinson, the spokesman for the "art" photographers, urged practitioners to become familiar with the same rules of composition, balance, proportion and use of chiaroscuro which governed painters:

> Given a certain subject—for example, a ruined castle—to be photographed by several different operators . . . What will be the result? Say there are ten prints; one

90

will be so much superior to the others that you would fancy the producer had everything—wind, light, etc.— in his favor; while the others will appear to have suffered many disadvantages. This picture will be found to have been taken by the one in the ten who has been a student of art.[6]

Other critics, like Sir William Newton, Vice-President of the Royal Photographic Society and miniature painter to Queen Victoria, insisted that photographers seek artistic effects rather than truth and fidelity to nature. He declared that "if photographs were to take their place beside 'pictures and engravings, their appearance ought not to be so chemically beautiful, as artistically beautiful.'"[7] Photographs should not be left as represented in the camera, but negatives might be altered "in order to render them more like works of art."[8] Furthermore, "the whole subject might be a little out of focus, thereby giving a greater breadth of effect, and consequently more suggestive of the true character of Nature."[9]

Newton's opinions were buttressed by those of John Leighton, who believed that photographs were "too literal to compete with works of art."[10] Photographers could make artistic photographs by allowing them to be "out of focus, the distance fading away, the foreground indistinct, trees appearing in masses and figures obscured by shadows."[11] Furthermore, "Art cannot rival Nature, and should not attempt to compete with her. The marvelous detail of microscopic photographs defies human imitation; but these are not works of art. Only in the lowest walks of art is direct imitation attempted."[12]

Considering the popular idea of what photography should be, it is not surprising that the most widely accepted photographs were those which were most contrived and "artificial," not those which were authentic and real.

SENTIMENTAL PHOTOGRAPHS

In the work of Oscar Gustave Rejlander (1813-75), we can observe an ambivalence between his desire to imitate the Old Masters and a natural ability to record the lives of slum children with understanding and sympathy. Before becoming a professional photographer, Rejlander had started his career as a portrait painter and copyist. Challenged by a painter friend who told him he could never hope to equal the beauty and perfection of a Raphael in photography, he set out to prove that he could indeed produce a Sistine Madonna photographically. According to the newspaper critics, he succeeded fairly well. The *Irish Metropolitan Magazine* (Vol. II, 1858) reported that one of his studies for the Raphael was "testing Raphael by nature and beating him hollow."[13]

Not all critics were equally impressed:

> We admire a Madonna by Raphael not because he has
> faithfully copied a woman and child in a certain posi-
> tion, but because we see in its depth and purity of
> feeling a noble realization of an original and poetic
> idea. A photograph of the models Raphael used in the
> position he placed them, and surrounded by all the
> accessories he introduced, would no doubt form a val-
> uable study for a painter, but would be a sorry sub-
> stitute for his picture.[14]

For the Manchester Art Treasures Exhibition of 1857, Rej-
lander produced his most ambitious "artistic" photograph: *The Two
Ways of Life,* imitating Raphael's "The School of Athens," in which
Philosophy on one side is contrasted with Science on the other. In
the large print (31″ x 16″), Rejlander attempted to tell the story
of two youths who come to the city in the company of a philosopher.
One youth cannot resist the temptations and consequences of city
life—lust, drinking and gambling, and ultimate despair. The other
youth chooses the wiser path of industry, education and good works.
As it was technically impossible for Rejlander to photograph such an
elaborate group in one exposure, he had to construct his scene from
over thirty separate negatives of figures and background, then printed
them on a double sheet of paper. The production took the photog-
rapher and his wife more than six weeks to complete.

Today we consider such an elaborate allegorical subject absurdly
inappropriate for photography, but the work received Queen Vic-
toria's approval, and it was purchased for her collection. What seems
ironic is that the Victorian critics objected not so much to the
affectation of dressing up models in Roman togas but to the fact
that some of the figures were semi-nude. Rejlander was not allowed
to exhibit the photograph at the Photographic Society of Scotland
until this shocking subject-matter had been expunged. It is perhaps
because his vast and pretentious allegories were not so well received
by the public, and they were so very expensive to produce, that he
turned to more popular pictures.

It is in his genre scenes that Rejlander has preserved for us a
more sympathetic, if equally inauthentic, view of Victorian life. He
delighted in portraying the ragged street children of London, sub-
jects made popular by Dickens. Such scenes as "Tossing Chestnuts"
(1860)[15] reveal not only a reporter's sense of significant detail but
a real feeling for his subject, but this is quickly offset by the posturing
and prettiness of "The Milkmaid," with its goody-goody child and a

92

cat sipping milk from a bowl.[16] Rejlander's favorite street subject was the ragged urchin, whom he portrayed in "Homeless," "The Matchseller," "The Crossing Sweeper," and countless photographs of this street boy who lived by his wits, like Dickens's "Artful Dodger," sweeping streets, holding horses for the gentry, running errands, and amusing passersby with his antics until moved on by the police. In Rejlander's versions of this familiar mid-Victorian figure, we find the street boy turning handstands or jauntily posing, broom in hand. One such photograph which met spectacular success was "Poor Jo," a scene of a boy huddled on a doorstep, clothed in tattered rags, in an attitude of despair.[17] The popularity of such an exaggerated and theatrical image is proof of the Victorian public's inability to distinguish between arty contrivance and truthful reportage.

Another, and more extreme, example of the popularity of sentimental, staged imagery is the work of Dr. J. T. Barnardo. Barnardo was an Evangelical preacher who perceived the potential of photography for wringing the heartstrings and loosening the purse strings of the Victorian public. He posed children against backdrops representing urban decay, or with props of boxes, barrels, and litter; the models were dressed in carefully selected tatters and their faces meticulously smudged with soot. Barnardo relied upon one model in particular, a young girl named Katie Smith, who possessed the requisite doleful eyes and an appealing face. Broom in hand, she would pose wistfully against painted replicas of 19th-century London.[18] Barnardo also published "Before" and "After" photographs mounted on cards and sold in sets for five shillings a dozen: these portrayed miserably unkempt urchins before their rescue by the East End Juvenile Mission, and afterwards as they were spruced up and joyfully engaged in gainful employment.[19]

Interestingly enough, when Dr. Barnardo was finally accused of fraud, it was because Katie Smith, his favorite "Match Girl" model, had never actually sold matches. A court of inquiry, after ponderous consideration, agreed that "Photography implied actuality and Barnardo had been deceptive in creating 'artistic fictions'".[20] As a result of this court's verdict, Barnardo had to discontinue using "Before" and "After" photographs as a publicity trick for his philanthropic purposes. He then turned to photography as a means of simply documenting the condition of many of the children in his mission. When new charges arrived, he attached a photograph of each to their dossiers. Fortunately, hundreds of these photographs have survived in albums (now in the collection of the Photographic Department, Dr. Barnardo's, Tanner Lane, Barkinside), preserving forever aspects of Victorian London in the 1870's and 80's, without

the sentimental intervention of "arty" props.[21] We can forgive Dr. Barnardo's misuse of photography, for his purposes were good; Rejlander only wanted to sell pictures.

Another Victorian who represents the pull between arty, elaborate costume dramas and allegories, and sensitive, direct portraiture, is Julia Margaret Cameron (1815-79). Mrs. Cameron was strongly influenced by the painter, George Frederick Watts, who valued her imaginative compositions like "The Wise and Foolish Virgins," or "The Death of Arthur," more than straight portraiture. Watts advised her that "the noblest forms of art were symbolical, allegorical, literary and religious subjects which 'uplifted the mind to higher spheres of devotion and contemplation.'" [22] Many of Cameron's photographs embody Victorian sentimentality at its worst: "Pray God, Bring Father Safely Home," and "Seventy Years Ago." Watts and the Pre-Raphaelites were her mentors, but it was the poetry of Alfred Lord Tennyson which provided the inspiration for Mrs. Cameron's most famous photographs. Some of these were freely imaginative interpretations of Tennyson's poems. When she attempted to follow the text of *Idylls of the King* literally, the results became maudlin and absurd. In "The Passing of Arthur," [23] where an ordinary rowboat is used to portray the king's stately barge, the water is recreated by an awkward mass of muslin curtains. The wounded king was posed by a local porter, and the three queens seem uncomfortably crowded as they glide along under a fake moon scratched on the negative. Although the *Morning Post* of January 11, 1875, declared that this photograph would take rank among the finest achievements of the camera's art, most critics today agree that photography does not succeed in illustrating literary narrative or historical dramas. An artist like N. C. Wyeth could illustrate much more effectively the magical world of medieval knights.

Despite her overly sentimental costume dramas, Mrs. Cameron achieved some of the finest portraiture of the age. With large 12″ x 16″ glass plates, she captured superb likenesses of some of the great Victorians, among them Tennyson, Browning, Thomas Carlyle, Anthony Trollope, John Herschel, and the mother of Virginia Woolf.[24] Considered to be a pioneer in the art of portrait photography, with control of lighting her prime asset, she created a Rembrandtesque style of emphasizing the individual's features in a diffused haze. Unlike the mawkishness of the allegories, these portraits display great depths of feeling and empathy based on direct observation.

COMPASSION

While Rejlander's artifices probably would have been described by the mid-Victorians as evoking the sentiment of compassion, generally

they did little but stimulate gratifying and self-indulgent tears. It takes a 20th-century sensibility to see the difference. Alan Thomas notes that the documentary spirit seems first to emerge in a series of stark photographs taken by a group of largely unknown photographers during a slum clearance program in Birmingham. One 1870's picture from this series reveals a straightforward shot of what seems to be only a dingy, empty courtyard; gradually the eye recognizes a tiny group of huddled children against a wall, apparently deserted in a jungle of abandoned buildings.[25] This artless photograph reveals the impact of a ruthless urban environment in a way never conceived of by the Rejlanders and Camerons.

The despair and hopelessness of the London slums were directly recorded by John Thomson (1837-1921), whose avowed purpose was not to make artistic pictures, but to document the horrifying conditions and near starvation he saw everywhere in London. In his book, *Street Life in London* (1877), Thomson recorded the day-to-day life of the working people: street musicians, cabbies, vendors, porters, flower sellers, locksmiths, all in their real surroundings. Each picture was accompanied by an article on the life and conditions of the subject. Two of these are characteristic of Thomson's work: the first portrays a young mother holding an infant and staring at two bearded street vendors while her older daughter looks, one assumes, longingly at the contents of their pushcart. The sense of want, of dingy hopelessness, of grubbiness, is vivid.[26] Thomson's most famous picture is the second: called "Poor Woman with Baby" (1876), it is of a destitute woman, again with an infant, both covered by her wrinkled striped shawl as they sit together, wretched and abandoned by society, on the doorstep of some hovel. The weary, despairing posture of the woman, her grimace of defeat, the ludicrously inappropriate ruffles which adorn the bottom of her dress, the cup and teapot sitting behind her on the steps, testimony to her frugal repasts, all add up to a gut-wrenching indictment.[27] Pity, which might shed a few tears, is not evoked; compassion, which requests that we protect and defend this woman, is called forth almost instinctively.

Thomas Annan also used his camera as a social weapon against the miseries of the dark Glasgow slums of the 1860's. Commissioned by the Glasgow City Improvement Trust between 1868 and 1877, these grim photographs record life in the dank alleyways and dark courtyards of an industrial city. Although many of his photographs do not include people, some do, and these are unforgettable, like "No. 11, Bridgegate" (1867): a small girl peering out from a shadowy passageway,[28] or a woman against a background of dilapidated buildings, the washing hung out to dry in filthy canyons, piles of refuse

and garbage. As did Jacob Riis in New York City, Annan heightened dramatic effects in order to persuade people to take notice of the deplorable conditions of these forgotten inhabitants of the industrial desert.

Twenty years later, the London scenes were again recorded. By the 1890's, Paul Martin (1864-1942) had the advantage of a portable hand camera and roll film. He also had the advantage of living at a time when the public had become more accustomed to the idea of truth-to-life. Martin repeated many of the subjects of Thomson's photographs, but he also looked at life with more humor and gaiety than his predecessors. In Martin's photographs we find strollers watching a Punch and Judy show, children dancing at a street corner, couples flirting, and Cockney girls whirling to the music of a street organ. It may be that conditions had been improved; certainly the mood had changed. Martin was particularly successful in capturing the throb and movement of the city. In pictures like "Magazine Seller at Ludgate Circus," he contrasts a frontal shot of a woman selling newspapers with the blur of movement of horses and carts in the background.[29] (The woman's face seems to lead us directly to Paul Strand's "Blind Woman.") In "Billingsgate Porters" (1894), Martin captures the strength and independence of London workmen against a background of cast iron store fronts and market carts.[30] In a striking photograph of three Cockney street urchins, Martin records the mischievous and impudent spirit of the London street boys with truthfulness and good humor, a realistic portrayal as far from the bathos of Rejlander's "Poor Jo" as can be imagined.[31]

Martin, perhaps more detached than Thomson and Annan, seems nevertheless full of understanding and sympathy, neither tugging at heartstrings nor underestimating the severity of his subject's life experiences. While Thomson and Annan engage the viewer's wrath, Martin might be saying, "Look at the courage and stamina of the poor; they will survive come what may." No action seems necessary or demanded.

STRAIGHT RECORD

Not all social commentaries were made for the purpose of changing society or to reform social inequalities. Many mid-Victorian photographs were taken simply to record or preserve for posterity the photographer's idea of the daily life of workers and peasants, without commentary. In this category belong the work of Francis Frith (1822-98) and Frank Sutcliffe (1853-1941).

Frith had made his reputation by supplying the Victorian travelmania for mementos of far-off and exotic places like the Tomb of

The Mid-Victorians

Rameses the Great at Abu Simbel, or the glaciers of Mont Blanc. But his publishing company at Reigate, Surrey, also supplied the public with romantic views—either large 8" x 10" size or picture post-cards—of ruined abbeys, castles, and life in the rural towns of England.[32] Because most of these photographs were for the tourist industry, Frith's work covered the holiday areas of Britain, primarily Devon, Cornwall, the lake district and the coastal towns. Frith did not intend to alter social conditions, but merely acted as a modern travel magazine. Examples of this type of picture: "Hindhead, Old Broom Squire's Cottage" (Victorian Maritime Album),[33] which presents, in a matter-of-fact manner, a bearded rustic carrying milk pails through a setting of picturesque ivy-covered cottages, and "Clifton Hampton, the Barley Mow Inn,"[34] a typical romantic view of a half-timbered, thatched country inn, with tables set out for travelers.

Frith's photograph, "Street in Ayr, Scotland,"[35] can profitably be compared with Paul Martin's previously mentioned "Magazine Seller." Martin focused on the strong features of the street vendor against the traffic congestion of the city, while Frith emphasizes the line of Neo-classical facades and cast-iron fronts of buildings. The workman carrying his brush and pail, and the pedestrians, seem only incidental. Frith later advised his colleague, Frank Sutcliffe:

> "Never be tempted to include any figures in your land-scapes or architectural views." Sutcliffe asked why: I was told that no matter how good a photograph might otherwise be, it would not sell if there were any figures in it. Mr. Frith went on to tell me that they had scores of negatives which were useless because there were figures in them. "Just think," he added, "when anyone buys a photograph of Rievaulx Abbey or any other building, they don't want Tom, Dick, or Harry, people whom they have never seen in their lives, stuck in the foreground"[36]

Photography had clearly become big business. However, almost in spite of himself, Frith was sometimes not able to conceal the reality behind the romantic photographs of abandoned boats and fishnets on lonely beaches, or quaint stone cottages, all presented as "straight record." It did not take much thought to surmise the kind of dangerous lives these beach fisherman led, or the hardships of life in cottages without running water, sanitation or lighting other than candles or cheap oil lamps.

Elizabeth Lindquist-Cock

Frith's illustration for the *Guidebook to Flamborough Head*—"Here be boats and fishermen"[37] is typical of his work for travel folders. The photograph is packed with fascinating details of beach ponies, fishermen, tangles of ropes and canvas, and the small "cobles" of northeast coast fishing boats, against a background of dramatic white cliffs. The human beings are simply props for a picturesque view of the English coast.

Frank Sutcliffe's photographs of this same coast appear, at first glance, to be "straight record," but they are, in fact, idealized portraits of rural life. Sutcliffe's father was a painter in the English watercolor tradition, so it is understandable that the young Sutcliffe would approach his subjects with the painter's eye for romantic effects of light and atmosphere. Beginning his photographic career by taking pictures of Yorkshire abbeys and castles for Frith's collection of "beauty spots" of the British Isles, he represents a final stage in the cycle between Rejlander's and Robinson's contrived portraiture and the human commitment of Thomson, Annan, and Martin. He despised the artificial conventions of many of his contemporaries in photographing rustic and picturesque scenes by bringing models into a studio, creating harbor scenes out of yards of net and fish cut out of brown paper. He criticized Robinson for his practice of taking young ladies out to the country, there to pose them in faked genre scenes like "Miller's Daughters" or "Fisher Maids." Sutcliffe believed it was better to risk a little awkwardness by photographing local people in their own setting.[38]

We should not be fooled into thinking his work is "straight record," and, in fact, his work calls into question whether any of the picturesque photographs can be called "straight." Behind the simple surface of his photographs of milkmaids, farmers, and fishermen are the monumentality and calm poise of figures out of the paintings of Vermeer and Millet.

> In these two Millet-like photographs, the subject becomes—as in Millet's paintings—'the peasant of all times and all places'—both Millet and Sutcliffe worked hard to capture the feel of a country life which both suspected—quite rightly—could not survive for much longer. In both cases, their work stands as a testimony to a way of life which has been swept away by the advance of the world.[39]

Unlike Millet, however, the work of Sutcliffe contains few suggestions of the lives of endless toil, or the constant threat at sea. His children are rosy-faced and happy, his milkmaids smiling, his old

people serene. Even in his photograph of the jet factory at Whitby, there is little hint of the deplorable working conditions and the achingly long hours of toil for the working person in the Victorian age:

> Covered with dust from the grindstones, inhaling the grit from the stone and the fine dust from the ground jet, these men would spend ten hours a day at work, and think nothing of it. No part of jet manufacture was free from dust, but grinding was the worst of all. After being at work in the grinding shops an hour or so, you would hardly be able to distinguish one man from another, so dense was the dust.[40]

It is difficult to say whether Sutcliffe's apparent disregard of the realities of working conditions stems from his commercial outlook or from some other Victorian ideology which made him think that "All was well."

CONCLUSION

There are obviously many unresolved issues in any attempt to formulate categories or to assess true levels of human commitment in mid-Victorian photography. We are much too sophisticated today to be moved by Rejlander's theatrical portrayal of models posing as "the poor." We have been so inundated by documentary photography that it is not easy to respond compassionately to the stark realism of Thomson, Annan and Martin. Should this realism be called "straight record"? Probably not. Despite their optimistic, nostalgic approach, Frith and Sutcliffe do retain a degree of impersonality, an objectivity carefully arranged in the camera. Each of these photographers selected his subjects out of all the possible subjects available, and we know that the selection of subjects is crucial. We cannot always know, even from careful studying of a photographer's work, what his motives actually were; we therefore respond to the content of the photograph.

In the early days of photography it was believed that the camera could not lie. We now know that photography, like painting, does lie in that we always see, and we can only see, what the artist wants us to see.

Elizabeth Lindquist-Cock

NOTES

[1] Alan Thomas, *Time in a Frame; Photography and the 19th Century Mind,* New York, Schocken Books, 1977, p. 142.

[2] Beaumont Newhall, *History of Photography,* New York, Museum of Modern Art, 1964, p. 60.

[3] *Newsweek,* October 21st, 1974, p. 70.

[4] Helmut Gernsheim, *Creative Photography,* New York, Bonanza Books, 1974, p. 75.

[5] *The Photographic Journal,* February 21, 1857, p. 217.

[6] Henry Peach Robinson, *Pictorial Effect in Photography,* Pawlet, Vermont, Helios, 1971, reprint, pp. 13-14.

[7] James Borcoman, "Purism versus Pictorialism," in *An Inquiry into the Aesthetics of Photography,* Arts Canada, 1975, p. 74.

[8] Gernsheim, p. 74.

[9] *Ibid.*

[10] *Ibid.*

[11] *Ibid.*

[12] *Ibid.*

[13] *Ibid.,* p. 76.

[14] *Ibid.,* pp. 76-77.

[15] *Ibid.,* plate 75.

[16] *Ibid.,* plate 76.

[17] Thomas, p. 142.

[18] *Ibid.,* p. 143.

[19] *Ibid.,* p. 144.

[20] *Ibid.*

[21] Gail Buckland, *Reality Recorded; Early Documentary Photography,* New York Graphic Society, 1974, pp. 92-93.

[22] Gernsheim, p. 84.

[23] *Ibid.,* p. 88.

[24] Beaumont and Nancy Newhall, *Masters of Photography,* New York, Castle Books, 1958, pp. 48-53.

[25] Thomas, p. 141.

[26] *Ibid.,* p. 146.

[27] Gernsheim, plate 154.

[28] Buckland, pp. 79-80.

[29] Thomas, p. 149.

[30] Oliver Mathews, *Early Photographs and Early Photographers,* London, Reedminster, 1973, plate 184.

[31] *Ibid.,* plate 186.

[32] Bill Jay, *Victorian Cameraman,* London, Newton Abbot, 1973.

[33] *A Victorian Maritime Album,* Cambridge, P. Stephens, 1974, p. 59.

[34] *Ibid.,* p. 60.

[35] Thomas, p. 134.

[36] Michael Hiley, *Frank Sutcliffe, Photographer of Whitby,* Boston, Godine, 1974, p. 25.

[37] Thomas, p. 124.

[38] Hiley, p. 66.

[39] *Ibid.,* pp. 92-93.

[40] *Ibid.,* note to plate 47.

100

THE PHOTOGRAPHS OF HELEN LEVITT

ROBERTA HELLMAN
&
MARVIN HOSHINO

THE CAPACITY "to fix an image of visible objects," without human intervention "by employing the very light those objects reflect" [1] makes the camera the most radical of image-making devices for it erodes the ritual distinction between art and life. However, neither nineteenth-century photography because it simply adopted the traditional conventions of painting, nor the Photo-Secession because it deliberately suppressed the camera image, nor Straight Photography because it demanded the photographer's absolute control of the image, could fully accept the autographic nature of the camera the way the photography of the 1930s finally and systematically did.

Of this school, the quintessential photographers are Henri Cartier-Bresson and Walker Evans and with less purity of style but no less merit, Bill Brandt, Andre Kertesz, Brassai, and Ben Shahn. The earliest work of Helen Levitt (see Plate 1), their immediate successor, shows the marked influence of Shahn whose originality in seizing a gesture of facial expression is reminiscent of the mime of silent film acting. Levitt looked also to the somnambulistic eroticism of the movies of Cocteau (Plate 2). But it was her early friendships with Cartier-Bresson (Plate 3) and with Evans (Plate 4) and their lasting influence which make her the current practitioner of the style, having extended it into color beginning in the late 1960s, in its purest form (Plate 5).

The photographers of this style have all made pictures which blur the difference between people and things: a woman is equated with a corset ad on a poster, a couple in a bistro with a pair of glasses of wine, a reflection with its man, the likenesses of two women on two billboards with the facades of two houses, and, in the case of Levitt (Plate 6) the silhouette of the central figure's outstretched arm and right leg with a draped electrical wire attached to the wall. This irreverence toward subject matter is matched formally by a willful indifference to distinctions between stillness and stop-motion, flatness and depth, and negative and positive space. This first non-distinction is an indirect way of describing Cartier-Bresson's "decisive

101

moment." The second could be called Walker Evans's "decisive flatness." Evans's habit of photographing flat facades makes it impossible to tell whether the space in his pictures is flattened or highly illusionistic. In this context, it's easy to see the close stylistic connection between these two seemingly disparate photographers; one does in time what the other does in space. Either of these two stratagems is used in some measure by all of these photographers, as is the third, the use of negative and positive space. For example, the lower right corner of Levitt's photograph (Plate 7) with its light and dark outlines, some projected onto the sidewalk by the sun and some into the picture plane, is a baffling matrix of figures and grounds. Just as these seemingly anomalous shadows are too well integrated into the picture to be irrelevant, so too, the piece of paper on the sidewalk (Plate 8) looks like something someone ought to remove, until you notice that it matches up with a white sheet airing on the fire escape across the street. And how did it happen that the front paws of the cat mimic the legs of the woman walking while the cat's rear paws assume the pose of one of the young men? In this picture of black cats, did that hep cat, dressed half light and half dark, know when he dressed that morning of the shadow which would lie behind him?

Since most of us don't ordinarily see things this way, there must be some explanation. It's easy to assume that these happenings are projections of the photographer's imagination. Photography is taken to be self-expression and, accordingly, what the photographer is showing off is her skill in setting up these visual relationships. The other possibility has remained largely unimagined: the real world is constantly discharging its own clues and messages. These are its images. What's so unsettling and irrational, of course, is precisely that you can't tell where art ended and life began.

With all the talk in the twenties about the superiority of photography as "machine art," of the camera as "the new god," Straight Photography couldn't really deliver on its claim of an art of unprecedented realism because it couldn't see past self-expression. Simply wanting to be an "artist" was the limiting factor. Only by actively collaborating with chance, by doing less not more, could the photography of the thirties transcend the humanist limitations of traditional man-centered art. That's why the blurring of the distinction between people and things, and its formal equivalents, was so central to the thirties style. The photographer's job, as James Agee wrote, "is not to alter the world as the eye sees it into a world of aesthetic reality, but to perceive the aesthetic reality within the actual world." [2]

The very process of photography could bypass this distinction between the real and the esthetic which the Surrealists had so much wanted to destroy but couldn't, because even Duchamp's Readymades

were too quickly transformed into beautiful sculptures. Now with the style of the thirties, photography could satisfy Surrealism's fondest dreams. The result is a photography of near-perfect transparency—for art, at last, a "white style."

It's no wonder then that traditional criticism, which is used to separate form and content (always with the proviso that the two are inseparable), has been generally unable to grapple with autographic art—not only photography but movies and more recently the electronics media—where form and content aren't merely inseparable but identical. No analysis of painting ever had to deal with issues so specific and idiosyncratic—Garbo's smile or the color of Robert Redford's hair—as to seem not the stuff of valid criticism at all but of idol worship. For this reason the best film critics, Agee for one, have always seemed possessed, wayward, irrational, and *too* personal. Of course, the problem of the interrelationship between reality and art will eventually yield itself to analysis. When this happens what we now can only describe as "the irrational" in Levitt's photographs will no longer seem so. Just now, however, the tools for an understanding of structures of this subtlety, complexity, and specificity are not generally available.

It's no wonder, either, that the photography community's rebuttals to Susan Sontag's essays have been so feeble. Sontag believes that photography is estheticizing reality. In our view, the problem, if any, is that reality has fatally infected art. Because Sontag has this backwards, she blames photography for destroying the moral content of experience. But at least she understands what the issue is, something photography itself apparently doesn't. And it hasn't since the post-war years when the deliberate impersonality of thirties photography began to give way to a resurgence of self-expression both among photographers who can be seen as part of a reaction against the thirties school and, more peculiarly, among its supposed followers.

The first group has tried a retreat to the old humanist position which, after the felicity of the thirties style, seems pretentious, moralizing, and heavy-handed. The other group has gone back to a pre-Surrealist modernism, "art-for-art's-sake," which now seems precious, self-indulgent, and arbitrary. The current debate between those proponents who see photography as engaged exploration and those who see it as formalist invention amounts to nothing more than the dispute between ethics and esthetics, no more sophisticated now than it was a century ago when Peter Henry Emerson gave up photography altogether because he despaired of ever resolving the "contradiction" between truth and beauty.

Roberta Hellman & Marvin Hoshino

This dispute, under various aliases such as "documentary vs. pictorial," has gone on for years. Photographers such as Walker Evans have been needlessly shuffled from "concerned documentary photographer" (Genus FSA) to "Modern Artist" (albeit a devious one for having hidden his Art so long). Never having been subjected to such critical scrutiny, Levitt has been admired by both sides simultaneously—without anyone noting a contradiction. One group sees her as a social realist committed to the examination and documentation of urban life, especially among the minority poor with all its attendant liberalisms, and only incidentally interested in the beautiful photograph. The other sees her as a "photographer's photographer," astonishingly sophisticated about formal issues and only indirectly concerned with subject matter. Having produced some of the most complex pictures in all of photography, Levitt belongs to neither side. If you ask her about "social concerns" or about "self-expression," she would probably say she has never understood what they have to do with art. The "white style" has yet to yield its point of view.

NOTES

[1] Paul Valéry, "The Centenary of Photography," translation by Roger Shattuck, *Occasions* (Vol. Eleven, Collected Works), Princeton, N.J., Princeton University Press, 1970, p. 158.

[2] Helen Levitt and James Agee, *A Way of Seeing,* New York, Viking Press, 1965, p. 4.

Plate 1 HELEN LEVITT *New York ca. 1942*

Plate 2 HELEN LEVITT *New York ca. 1945*

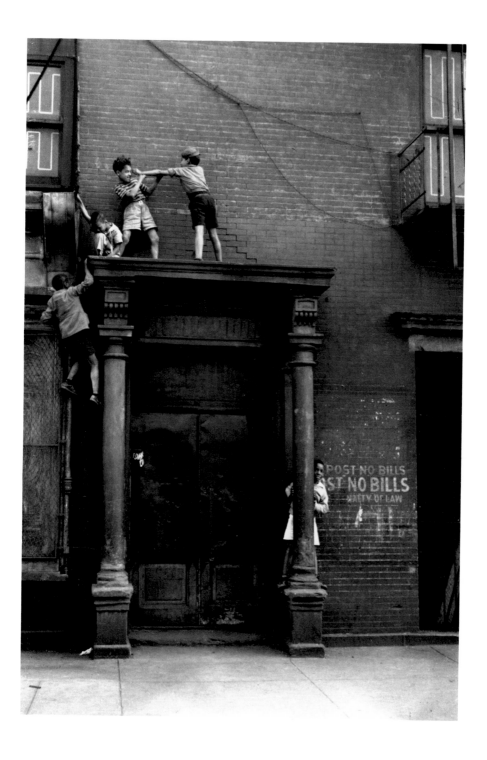

Plate 5 HELEN LEVITT *New York ca. 1945*

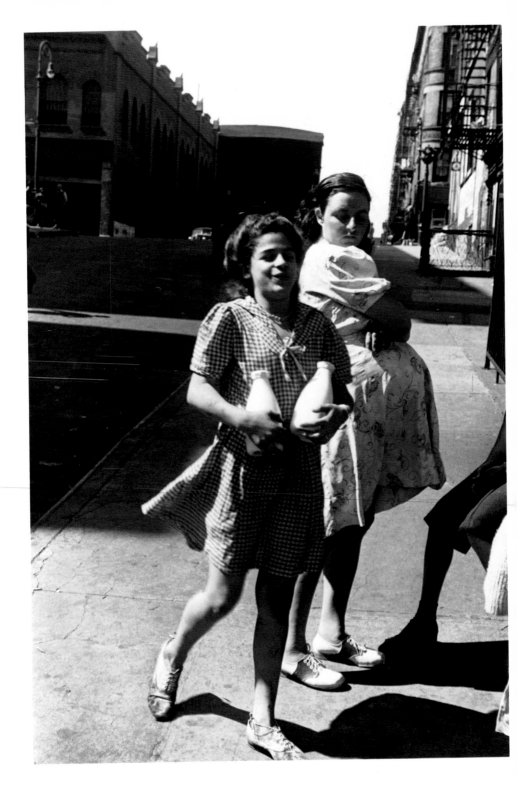

Plate 6 HELEN LEVITT *New York ca. 1948*

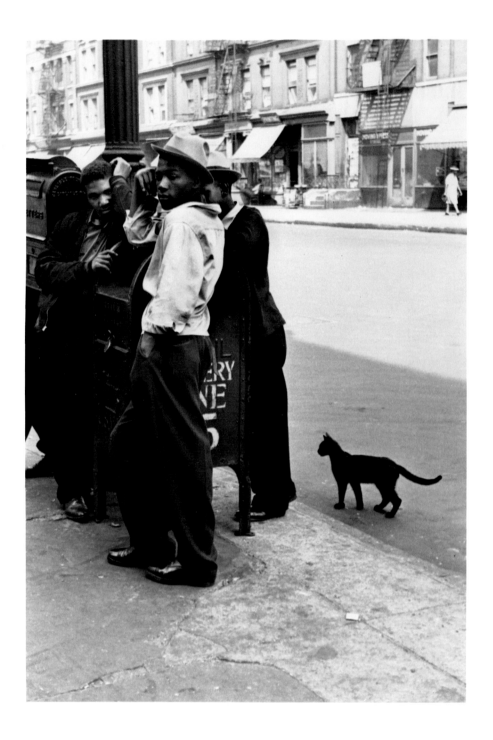

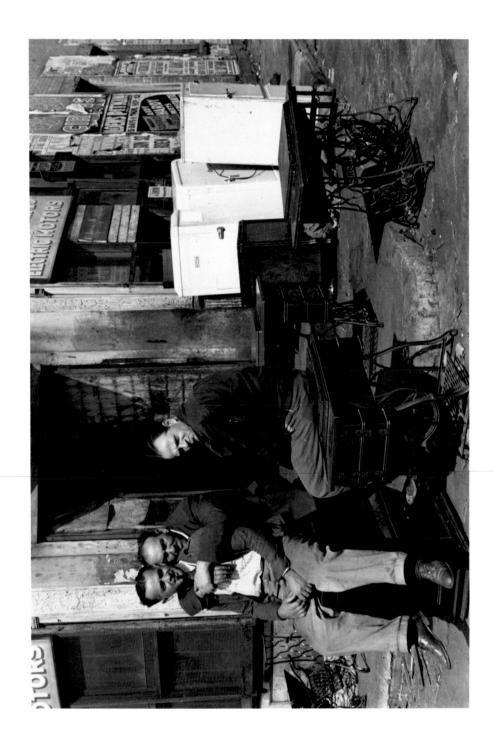

Plate 8 HELEN LEVITT *New York ca. 1948*

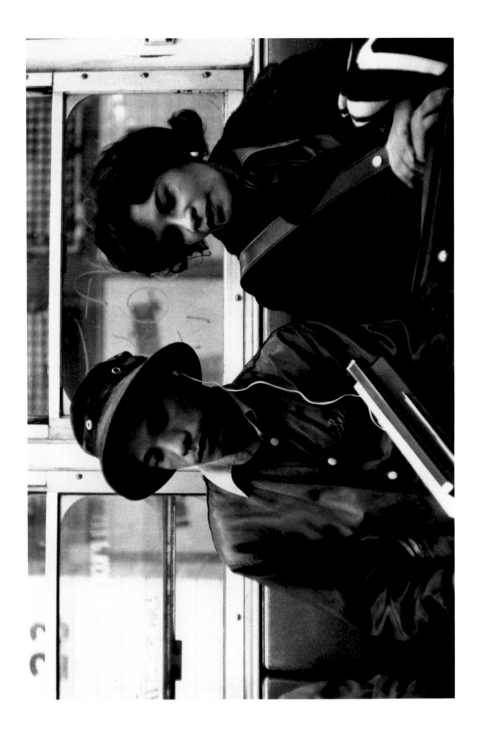

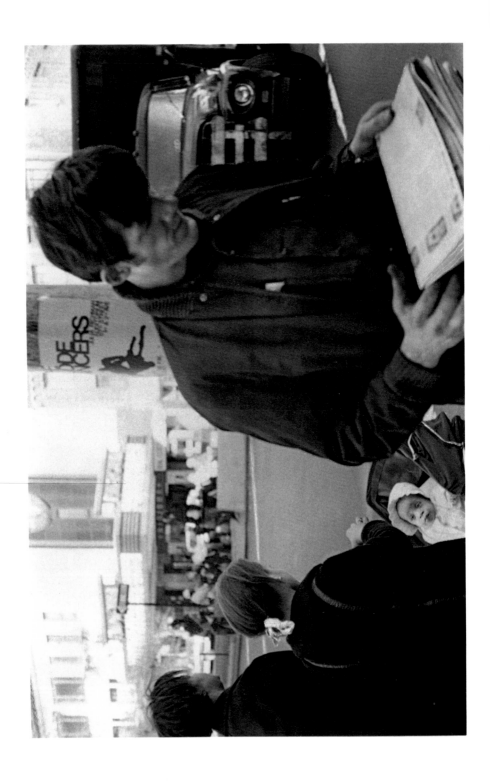

Plate 10 (from a color original) HELEN LEVITT *New York 1971*

WALKER EVANS
SUBWAY PHOTOGRAPHS

These photographs were made in the subway of New York City, during the late thirties and early forties of the twentieth century. The effort, always, has been to keep those who were being photographed as unaware of the camera as possible. To anyone who understands what a photograph can contain, not even that information is necessary, and any further words can only vitiate the record itself. Because so few people do understand what a photograph can contain, and because, of these, many might learn, a little more will, reluctantly, be risked.

Those who use the New York subways are several millions. The facts about them are so commonplace that they have become almost as meaningless, as impossible to realize, as death in war. These facts — who they are, and the particular thing that happens to them in a subway — need brief reviewing, and careful meditation.

They are members of every race and nation of the earth. They are of all ages, of all temperaments, of all classes, of almost every imaginable occupation. Each is incorporate in such an intense and various concentration of human beings as the world has never known before. Each, also, is an individual existence, as matchless as a thumbprint or a snowflake. Each wears garments which of themselves are exquisitely subtle uniforms and badges of their being. Each carries in the postures of his body, in his hands, in his face, in the eyes, the signatures of a time and a place in the world upon a creature for whom the name immortal soul is one mild and vulgar metaphor.

The simplest or the strongest of these beings has been so designed upon by his experience that he has a wound and nakedness to conceal, and guards and disguises by which he conceals it. Scarcely ever, in the whole of his living, are these guards down. Before every other human being, in no matter what intimate trust, in no matter what apathy, something of the mask is there; before every mirror it is hard at work, saving the creature who cringes behind it from the sight which might destroy it. Only in sleep (and not fully there), or only in certain waking moments of suspension, of quiet, of solitude, are these guards down; and these moments are only rarely to be seen by the person himself, or by any other human being. At the ending of *City Lights,* that was precisely what Chaplin was using, and doing. In that long moment in which, gently gnashing apart the petals of his flower, his soul, his offering, he perceives, in the scarcely pitying horror of the blind girl to whom he has given sight, himself as he is, he has made full and terrific use of this fact. But it has almost never been used in art; and it is almost never seen in life.

James Agee, NEW YORK, OCTOBER 1940

[*Walker Evans photographed in the New York subways in the late 1930's. He made hundreds of photographs with hidden 35mm camera and a long cable release extended down his sleeve. What is presented here are adjoining frames from Walker Evans's proof sheets. Evans selected a series of these photographs for the book* Many Are Called *published in 1966, sixteen years after they were taken, and with James Agee's introduction from 1940.*]

 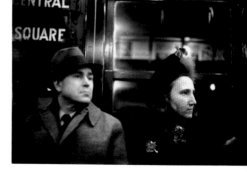

Plate 11 (Proofs) WALKER EVANS *New York ca. 19*

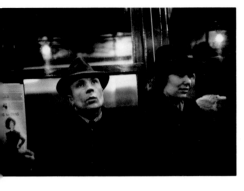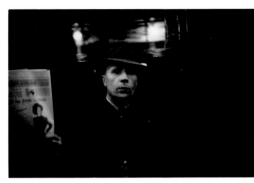

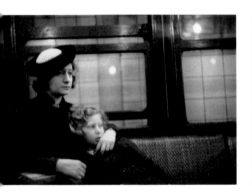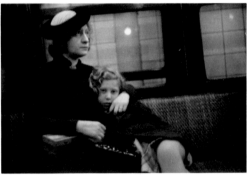

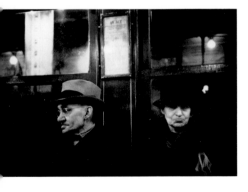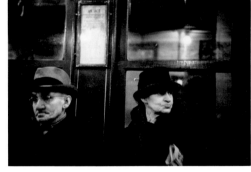

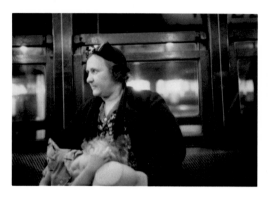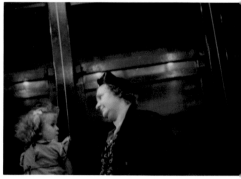

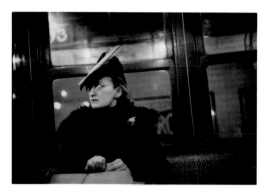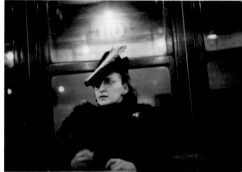

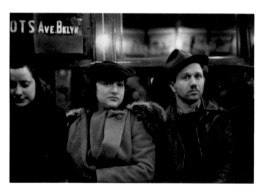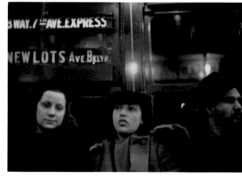

Plate 13 (Proofs) WALKER EVANS *New York ca. 19.*

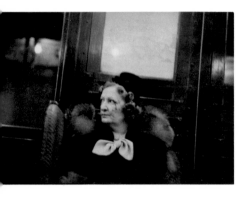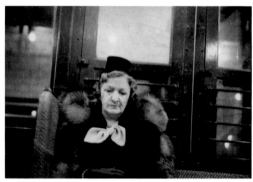

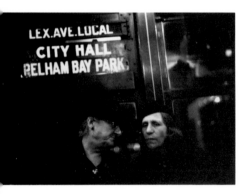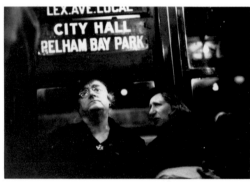

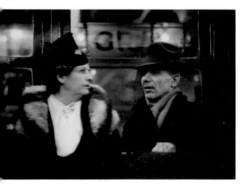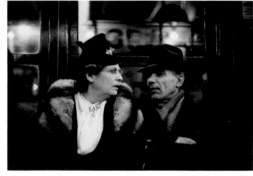

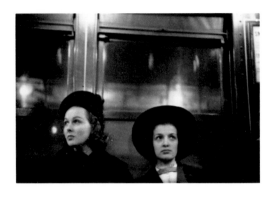
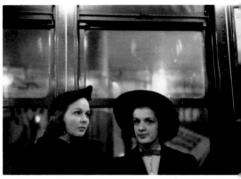
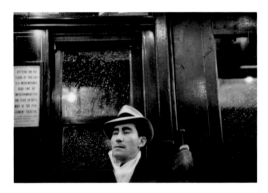
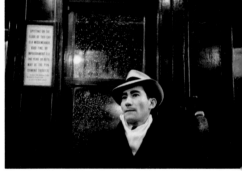
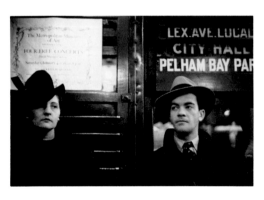
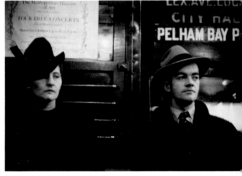

Plate 15 (Proofs) WALKER EVANS *New York ca. 19.*

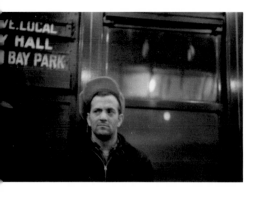 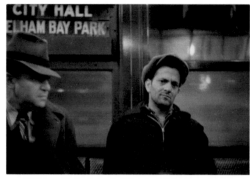

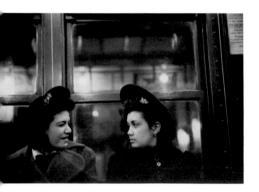 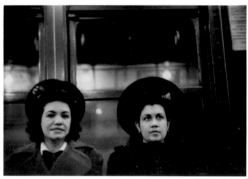

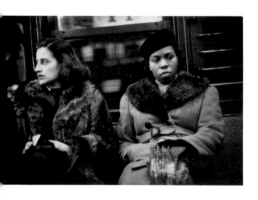 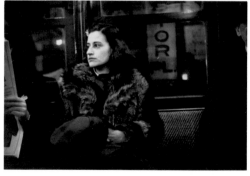

WALKER EVANS *New York ca. 1939*

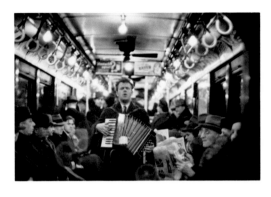
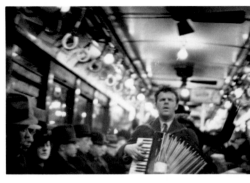
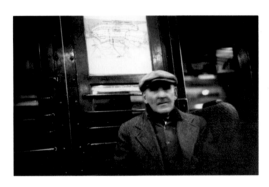
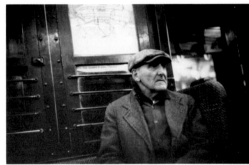
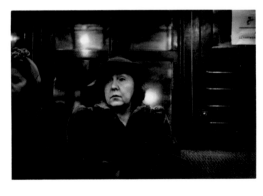
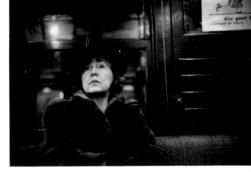

Plate 17 (Proofs) WALKER EVANS *New York ca. 193*

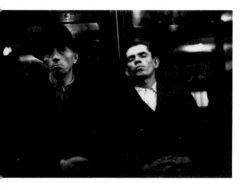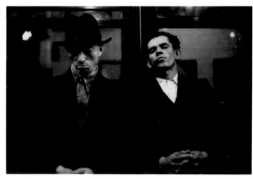

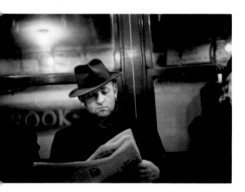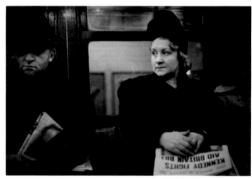

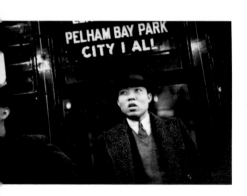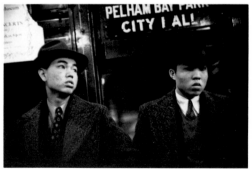

THE PHOTOGRAPHS OF ROBERT WILCOX

Robert Wilcox (1925-1970) was born in St. Paul, Minnesota. After service in the Navy during World War II he attended the University of Minnesota and graduated in 1956. He worked as a free lance photographer and then as an instructor of photography in the Art Department of the University of Minnesota.

The following photographs were part of an extensive project on the "Gateway Area" of Minnesota. The area was an early urban-renewal project, and much chrome, glass, concrete replaced the missions, old hotels, bars, alleys, peeling paint and the wandering men and women that were squeezed out of the center of the city.

Wilcox's photographs are presently in The Robert Wilcox Collection of The Minneapolis Institute of Art, Minneapolis, Minnesota.

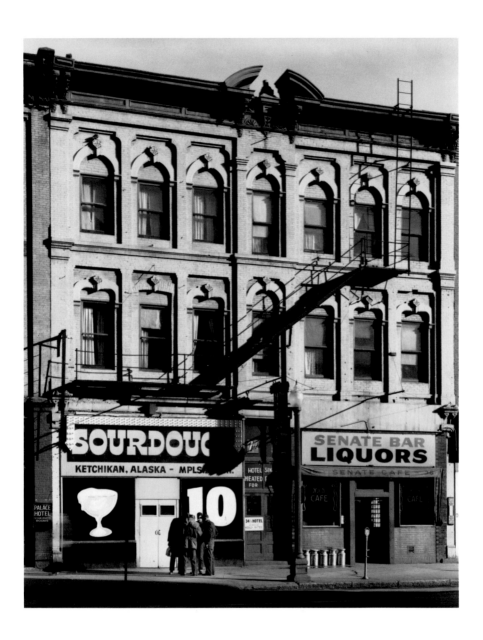

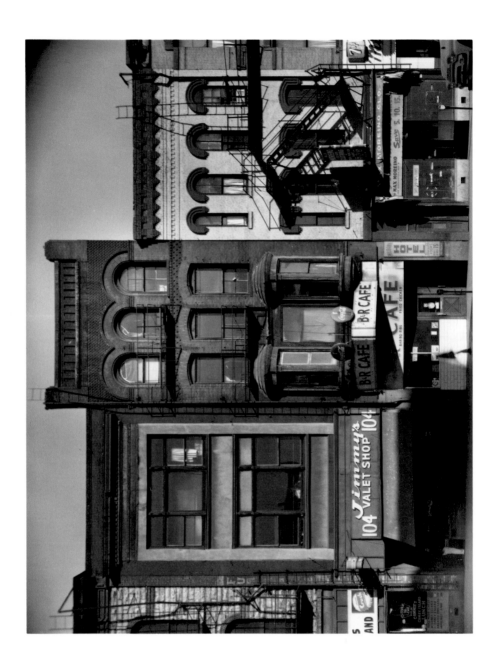

Plate 20 ROBERT WILCOX *Minneapolis ca. 1958*

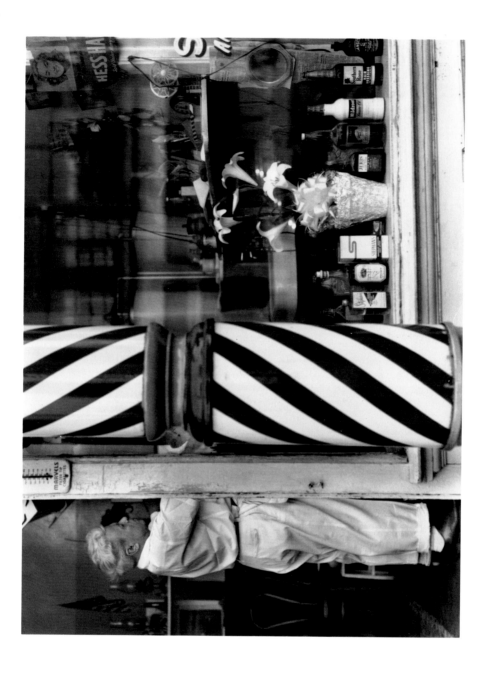

Plate 21 ROBERT WILCOX *Minneapolis ca. 1958*

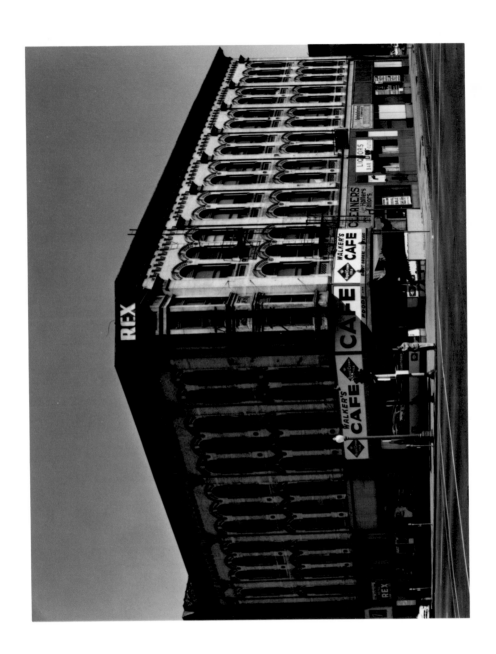

Plate 22 ROBERT WILCOX *Minneapolis ca. 1958*

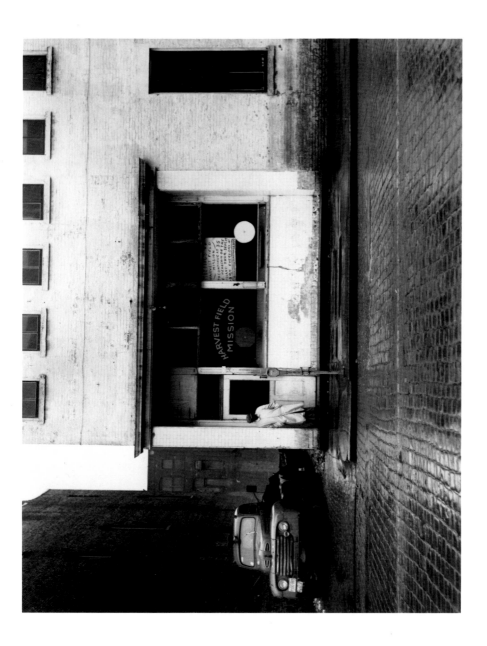

Plate 23 ROBERT WILCOX *Minneapolis ca. 1958*

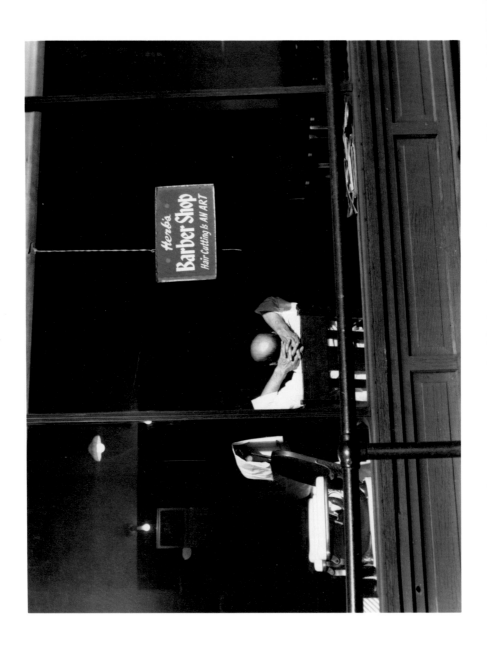

Plate 24 ROBERT WILCOX *Minneapolis ca. 1958*

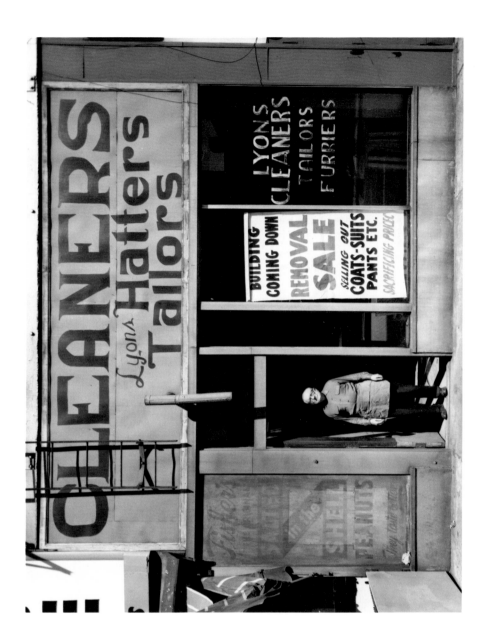

Plate 25 ROBERT WILCOX *Minneapolis ca. 1958*

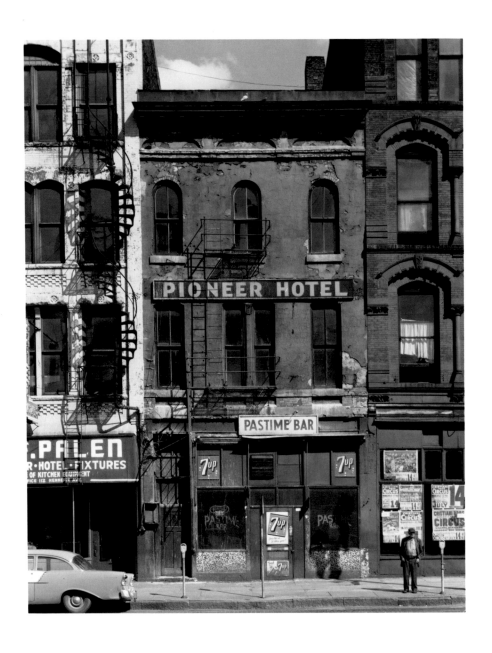

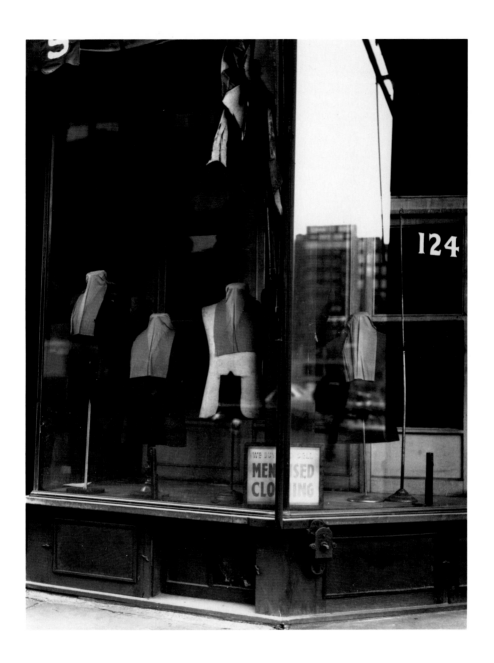

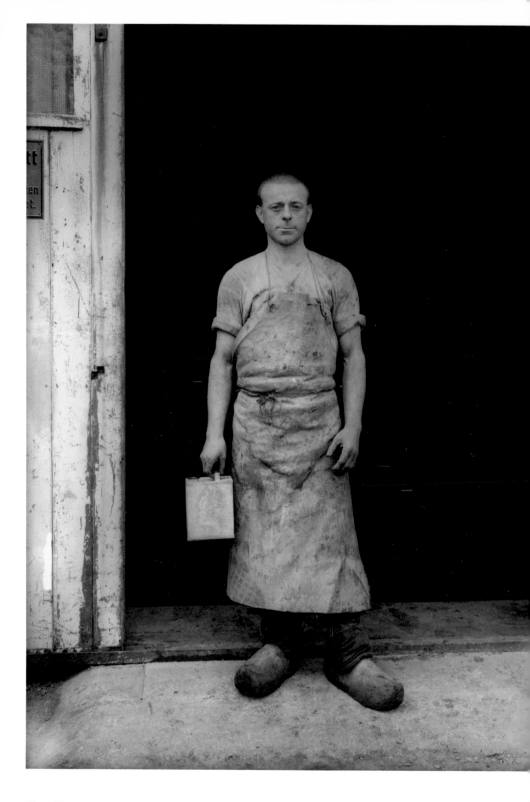

Plate 28　　　　　　　　AUGUST SANDER　　　　　　　*Cologne 19*

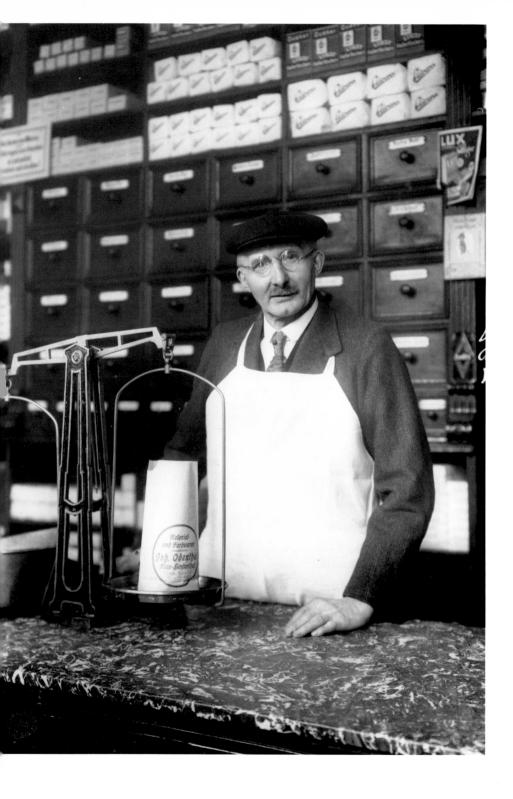

AUGUST SANDER

Cologne 1929

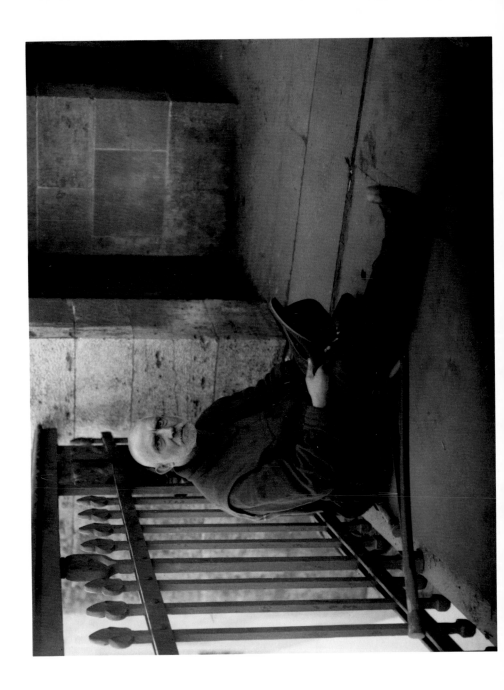

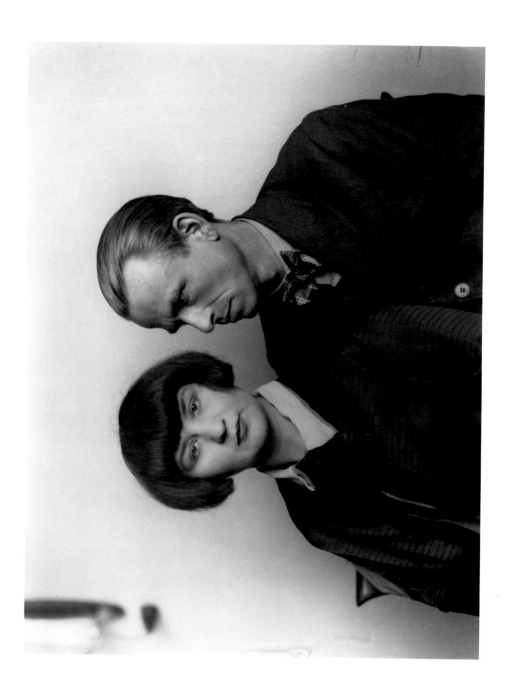

Plate 31

AUGUST SANDER

ROBERT FRANK

These photographs represent my last project in photography. When I selected the pictures and put them together I knew and I felt that I had come to the end of a chapter. And in it was the beginning of something new ...

New York City 1958

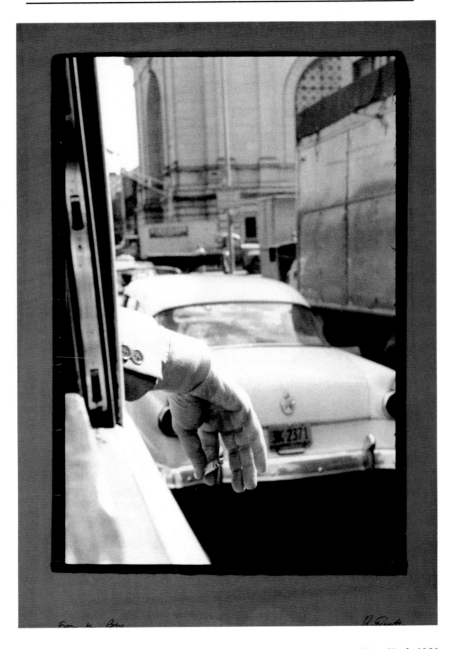

Plate 32　　　　　**ROBERT FRANK**　　　　　*New York 1958*

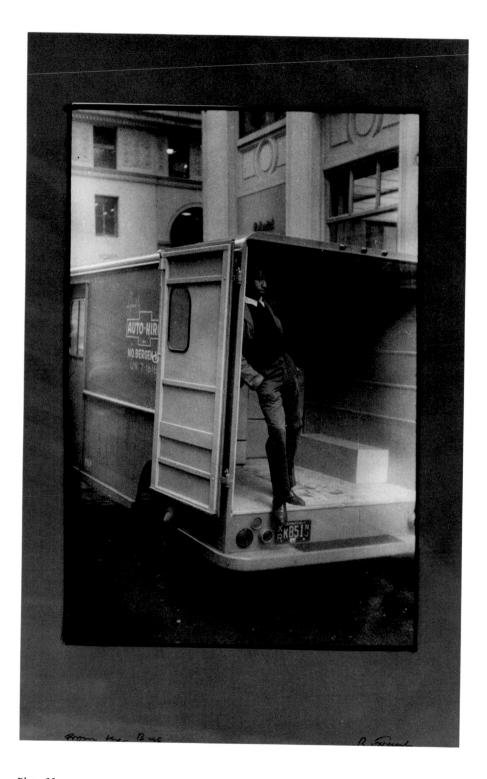

Plate 33 ROBERT FRANK *New York 1958*

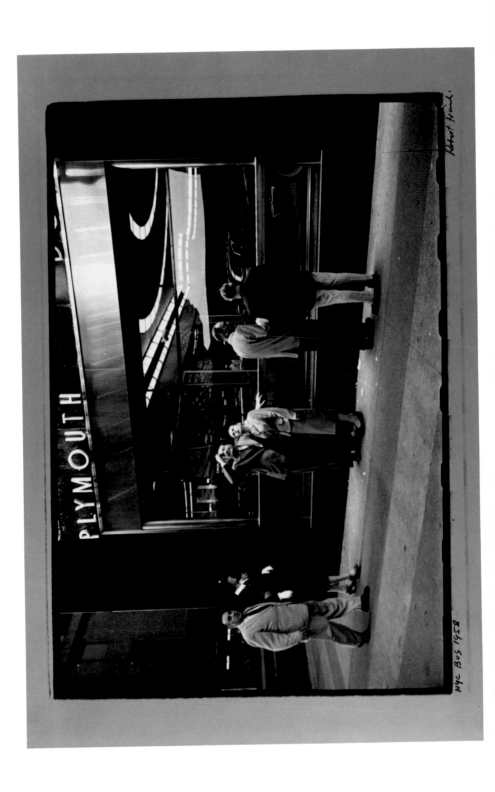

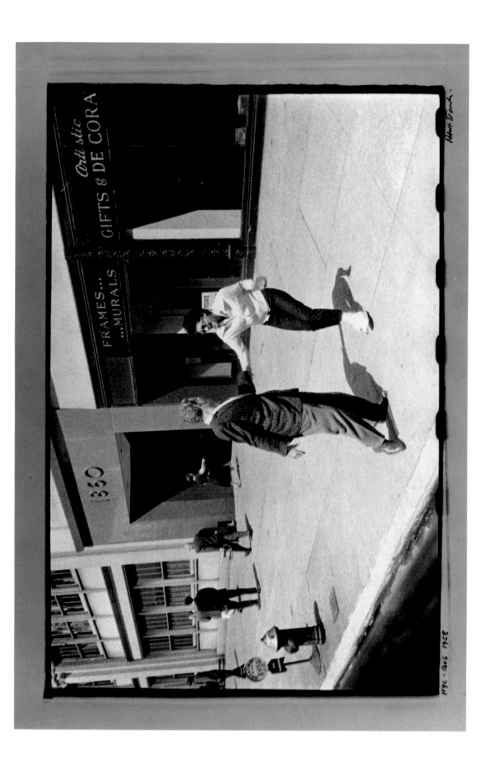

Plate 35 **ROBERT FRANK** *New York 1958*

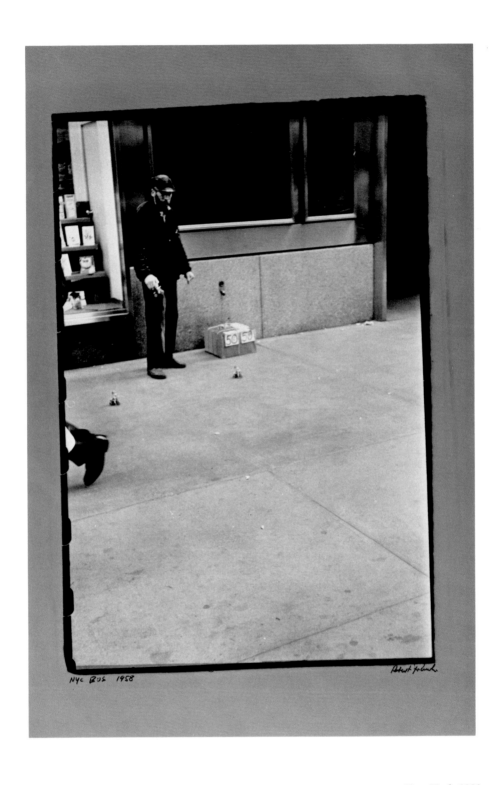

NYC Bus 1958

Plate 36 ROBERT FRANK New York 1958

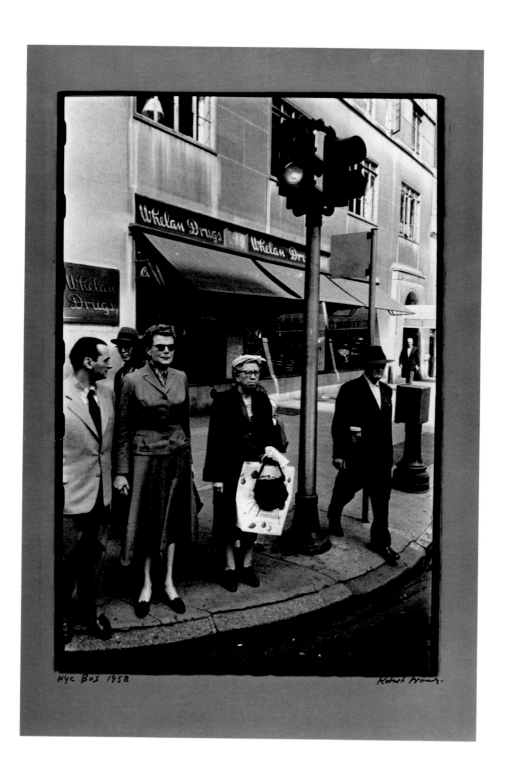

Plate 37 **ROBERT FRANK** *New York 1958*

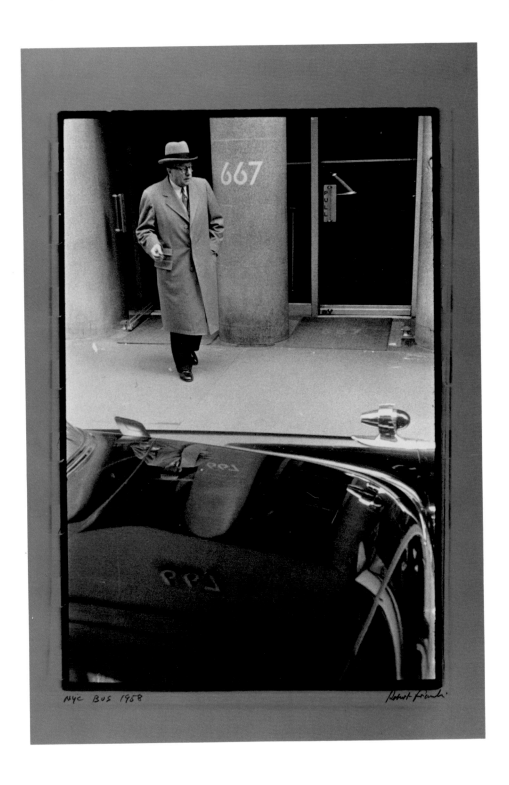

NYC BUS 1958

Plate 38 ROBERT FRANK *New York 1958*

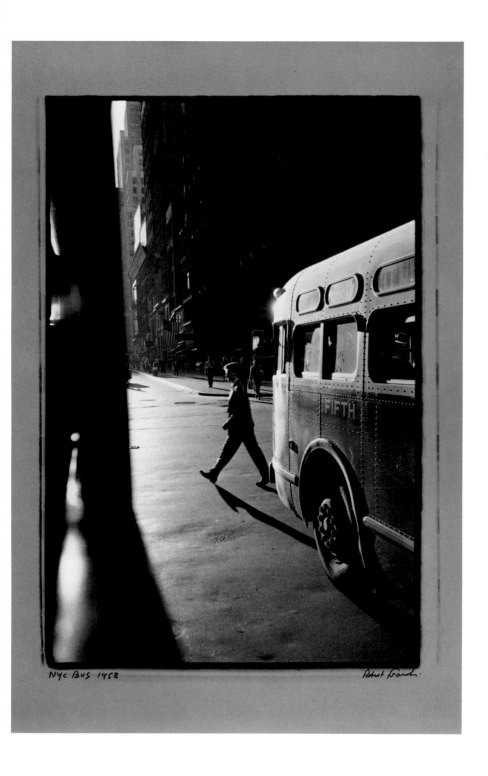

NYC BUS 1958

Robert Frank

Plate 39 ROBERT FRANK *New York 1958*

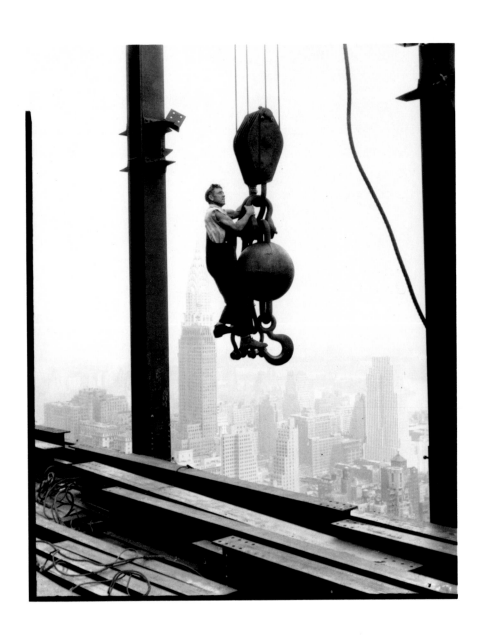

Plate 40 LEWIS HINE *Empire State Building ca. 1931*

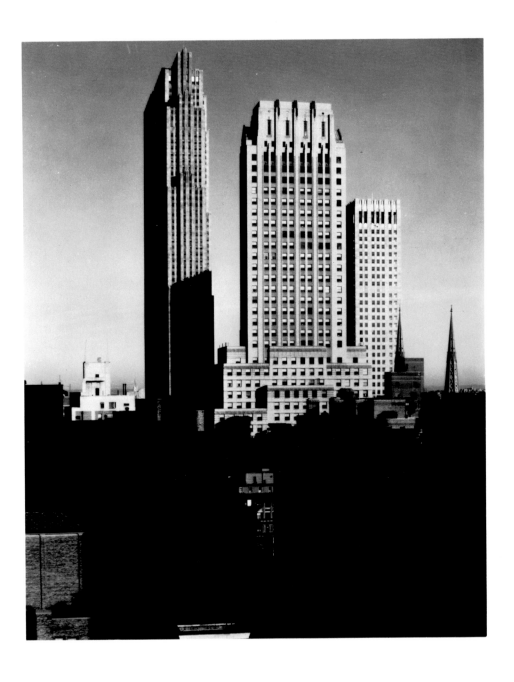

Plate 41 ALFRED STIEGLITZ *from* New York Series *1935.*
Collection of The Museum of Modern Art, New York. Gift Georgia O'Keeffe.

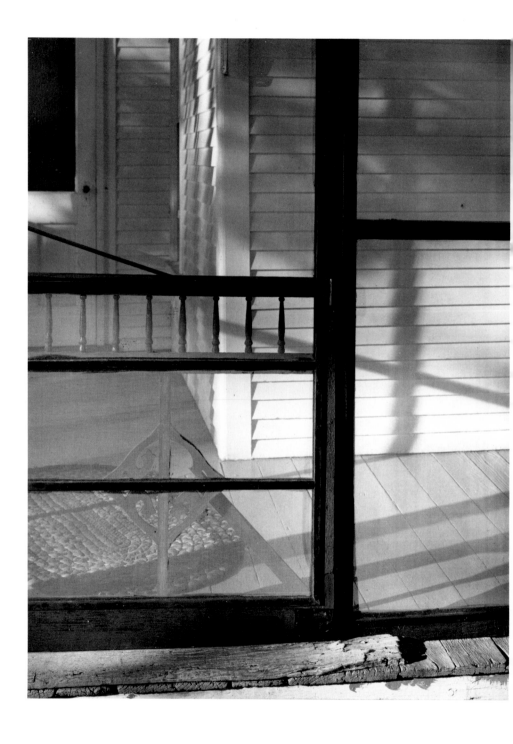

Plate 42 JOHN SZARKOWSKI *Stillwater, Wisconsin 1949*

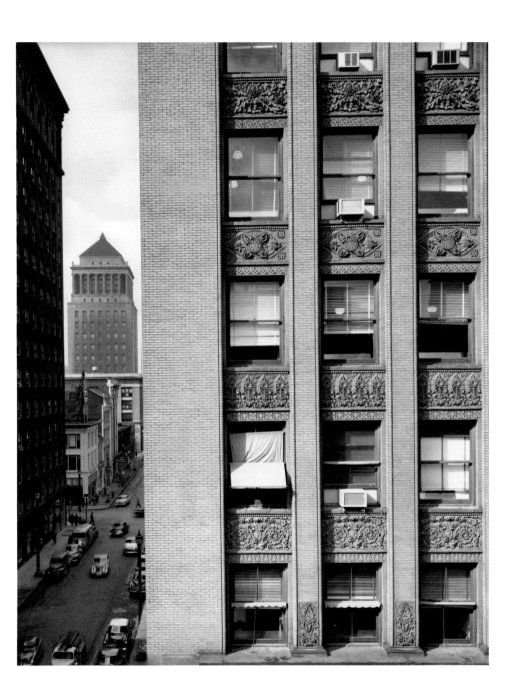

Plate 43 JOHN SZARKOWSKI The Wainwright Building *St. Louis 1954*

SUBWAY PHOTOGRAPHS
BY SALLY STEIN

I became interested in the subways when I left New York and moved to another city for a few years in the mid-seventies. During visits back to New York, the underground came to represent the City's most unique feature — embodying its peculiar energies and remarkable failure.

The subway photographs I was familiar with described an underlit situation but one in which personal boundaries were still maintained and respected. They lacked both the discomfort and humor of enforced intimacy. The graffiti began to suggest some of that, once I stopped trying to decipher words and began to take it in as visual analogue of gesture . . . and I wanted to see what photographs might express.

Although graffiti constitutes only background in my pictures, the idea of underground graffiti art remained in my mind while I worked with these photographs. As with those artists, my work lay outside acceptable social behavior in this highly circumscribed situation. The camera, like those rude markings, unquestionably added tension in a situation in which people already had good reason to be guarded.

The camera I generally use is a 2¼ twin lens reflex. Its cumbersomeness is often a limitation but here it seemed to work in my favor. In many ways it operated as a conversation piece for I would often hear comments that you didn't see cameras like that around any more. In comparison with smaller, faster, modern cameras, it provoked more curiosity than defensiveness. Used at waistlevel, the camera never hid my face, and the fact that I work slowly allowed people time to size up the situation and indicate possibly that they didn't want to be photographed. Surprisingly, most didn't react negatively, and whether this indicates a high degree of passivity in the subways or a general acceptance of cameras and the idea of being photographed is still not clear to me. Surely being a woman was a distinct advantage, since women photographers are still regarded more as a novelty than as official presence in a public situation.

After making a photograph, I would sometimes be approached either by those who had been in the picture or by other passenger-observers. Again, the questions were less hostile than I would have expected, and most often people seeemed satisfied with the explanation that the subways were a special feature of our lives for which few documents existed which described some of the content and contact of that experience.

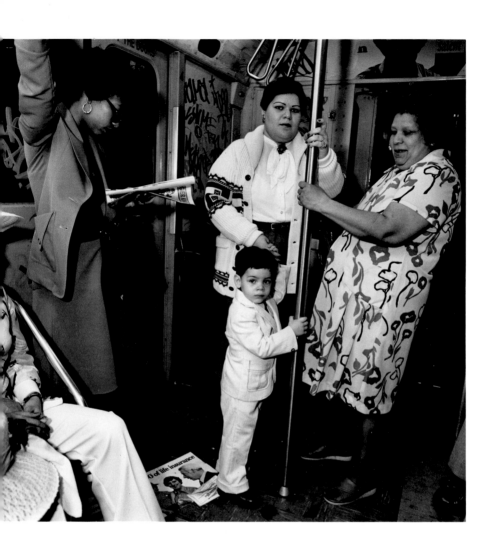

Plate 44 SALLY STEIN *New York 1976*

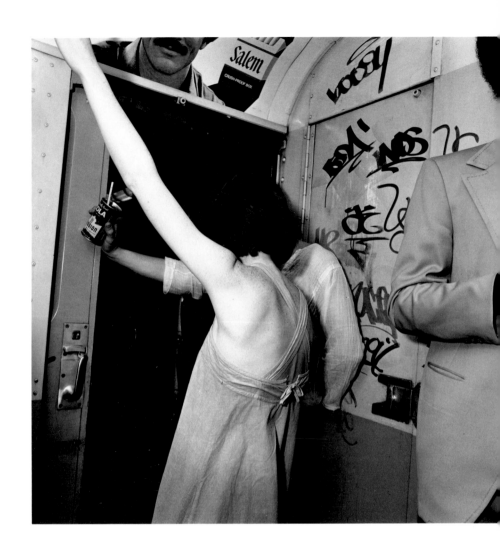

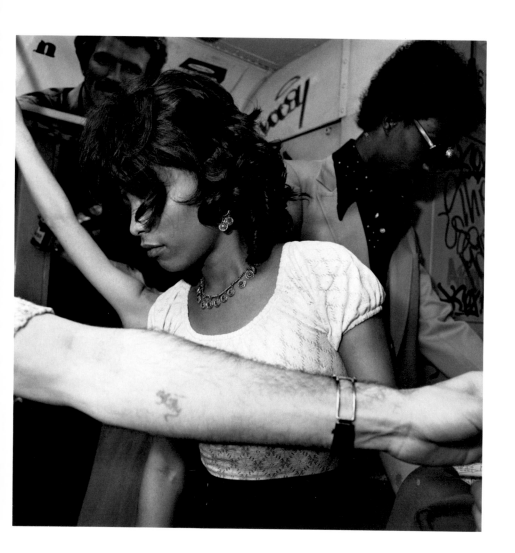

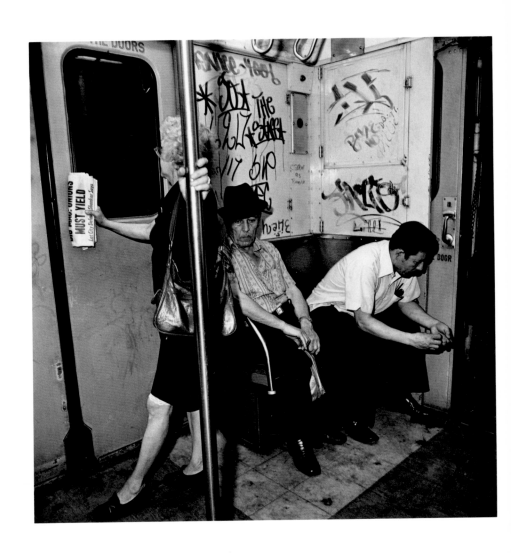

Plate 47

SALLY STEIN

New York 1976

JEROME LIEBLING
THE SOUTH BRONX

THE SOUTH BRONX PROJECT

Buildings and streets, bricks and rubble and trash, tell even more about the inner life of the community than about its daily life. Liebling's photographic revelations of this life open our eyes, not to a series of local disasters, in the Bronx or in Bushwick, in Detroit or Chicago, but to equally sinister urban destructions that have been going on all over the world from Warsaw and Rotterdam to London and Berlin. The empty spaces tell us more about the lives people have led than the solid walls that remain. Now that the ground has been cleared, even of decent durable buildings, we know the worst.

<div align="right">Lewis Mumford, 1977</div>

BRONX VIOLENCE CREATES SPECIAL PROBLEM FOR HOSPITAL

About half of the 500 brain and spinal injuries treated at the Bronx Municipal Hospital Center in the last six months were caused by violence, a ratio that hospital officials described as exceedingly high.

"We're looking at violence in the Bronx, an awful lot of it, and we have the statistics to prove it," said Dr. Elisabeth Frost, an anesthesiologist at the hospital.

Injuries caused by violence are defined as involving gunshot, stabbing, assault with deadly weapon, or by actions taken by the police. Most of them occur in the largely black and Hispanic sections of the South Bronx. The average age of the victims is 27.

"Nearly 40 percent of central nervous system injuries are gunshots," Dr. Frost said, "and only half survive. And many of them that do pull through are vegetables and it costs $600 a day to keep them alive in intensive-care units."

<div align="right">Ronald Sullivan, New York Times, May 18, 1978</div>

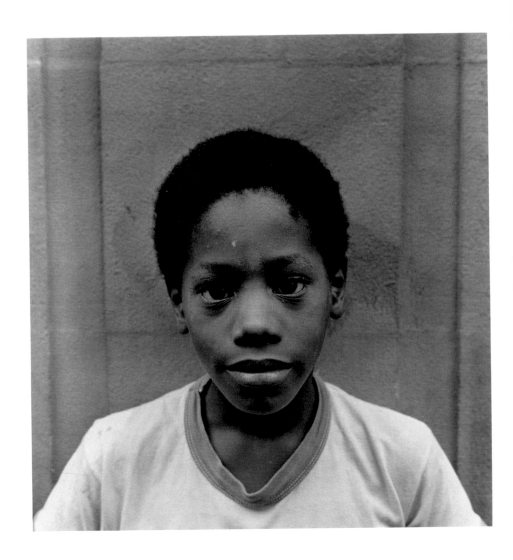

Plate 48 JEROME LIEBLING *New York City 1975*

Plate 49 JEROME LIEBLING *South Bronx, N.Y. 1977*

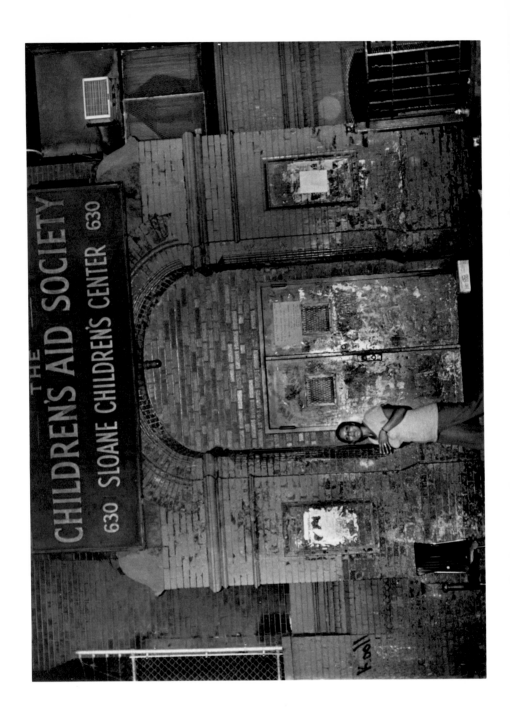

Plate 50 JEROME LIEBLING *New York City 1977*

Plate 51 JEROME LIEBLING *New York City 1977*

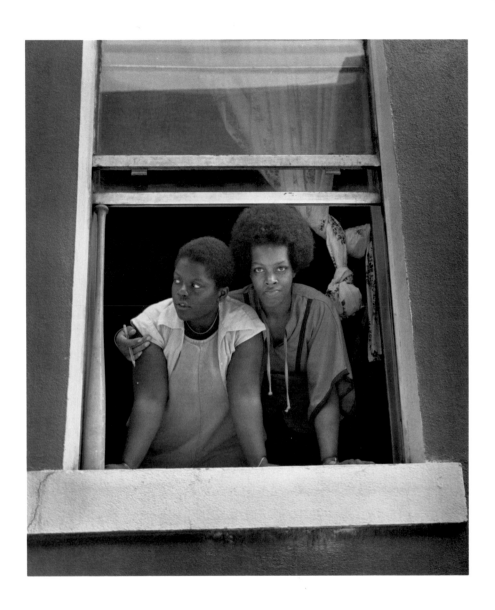

Plate 52 JEROME LIEBLING *New York City 1977*

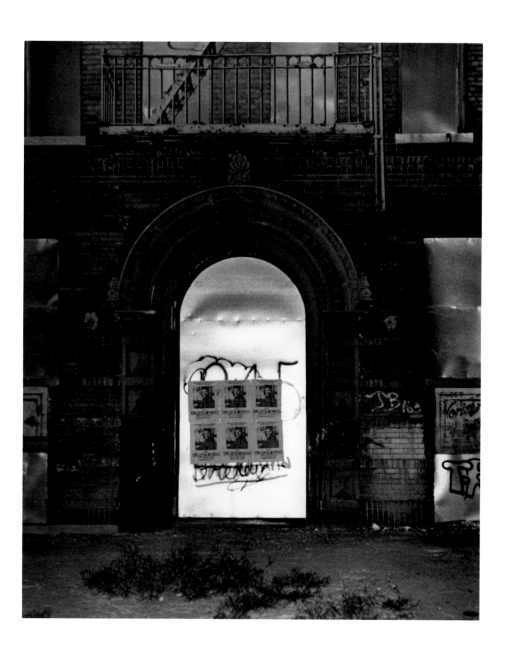

Plate 53 JEROME LIEBLING *South Bronx, N.Y. 1977*

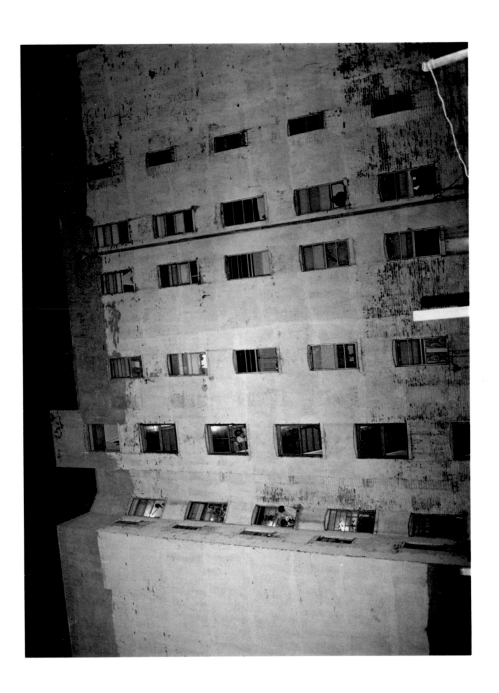

Plate 54 JEROME LIEBLING *New York City 1977*

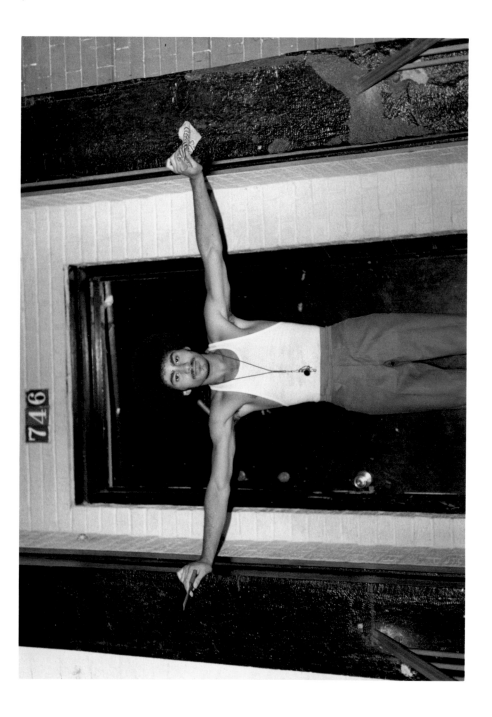

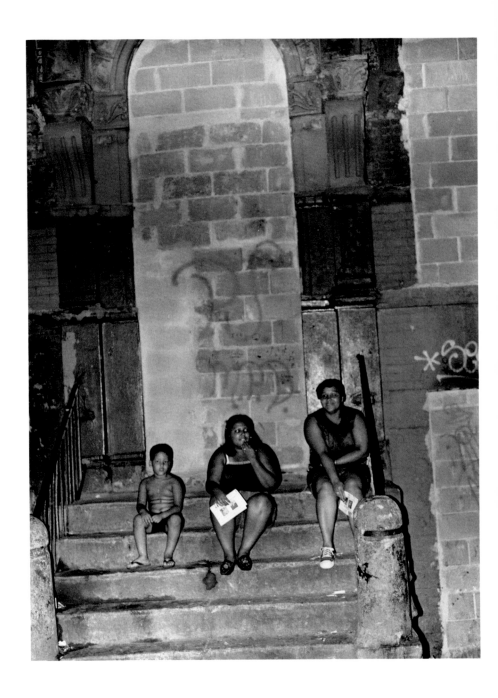

Plate 56 JEROME LIEBLING *New York City 1977*

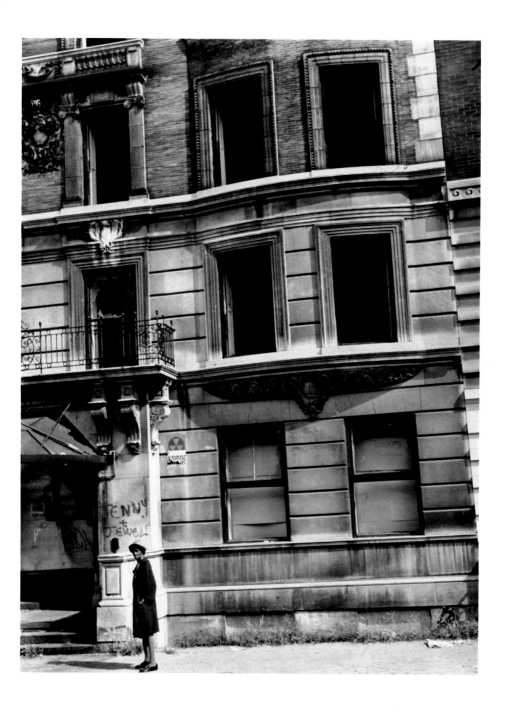

Plate 57 JEROME LIEBLING *New York City 1977*

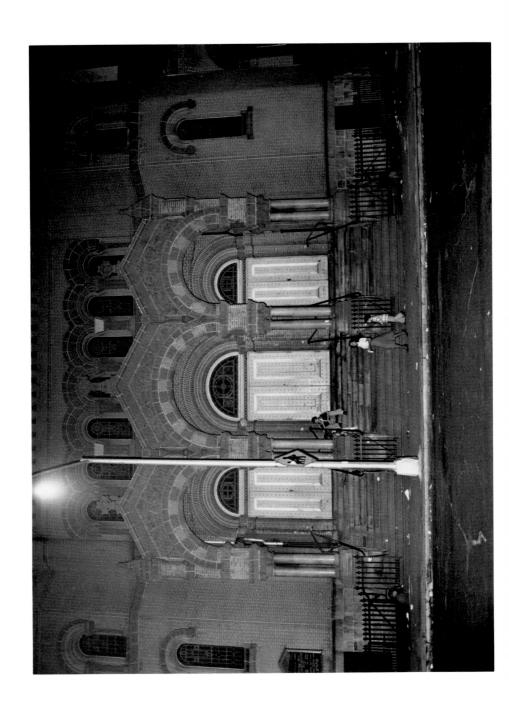

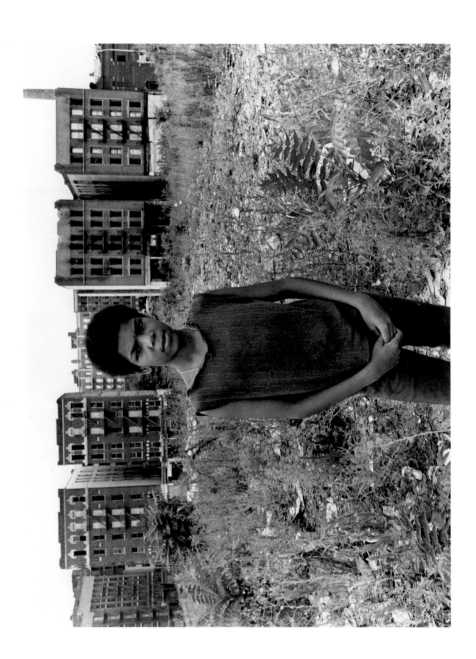

Plate 59 JEROME LIEBLING *South Bronx, N.Y. 1977*

Plate 60 JEROME LIEBLING *South Bronx, N.Y. 1977*

PHOTOGRAPHY AND THE WORLD'S BODY

ROGER COPELAND

IN HER BOOK *On Photography,* Susan Sontag offers a rather uncharitable explanation for the current level of interest in photography:

> The seemingly insatiable appetite for photography in the 1970's expresses more than the pleasure of discovering and exploring a relatively neglected art form . . . Paying more and more attention to photographs is a great relief to sensibilities tired of, or eager to avoid, the mental exertions demanded by abstract art. Classical modernist painting presupposes highly developed skills of looking, and a familiarity with other art and with certain notions about the history of art. Photography, like pop art, reassures viewers that art isn't hard; it seems to be more about subjects than about art.

I'd like to suggest that the photographic renaissance now taking place is evidence of something other than a growing perceptual and intellectual laziness, something much more positive (and necessary). True, we are at this moment experiencing a "backlash" against modernism (or more specifically, against two closely-related manifestations of "the modern": formalism and minimalism). And yes, photography has benefited substantially from this shift in sensibilities. But it's essential to recognize that this widespread dissatisfaction with two of the avant-garde's most celebrated projects was initiated in most instances by the artists themselves and not in response to a restless, fickle, and inattentive public.[1]

The fact of the matter is that art simply cannot pursue the goal of "self-purification" indefinitely. By "self-purification," I mean the two different varieties of radical surgery that the arts have performed on themselves in the last 100 years. First came the process that Ortega y Gasset called "dehumanization" in which the arts purged themselves of their "human content" or "lived reality." This resulted in a variety of "formalism." Art ceases to serve as a "criticism of life" (which Matthew Arnold thought art should be). Art turns its back on the world and refuses to "hold the mirror up to nature."

Subsequently, the separate arts underwent an even more impov-

erishing variety of "purification" that Clement Greenburg calls "self-criticism":

> What had to be exhibited and made explicit was that which was unique and irreducible not only in art in general but also in each particular art . . . The task of self-criticism became to eliminate from the effects of each art any and every effect that might conceivably be borrowed from or by the medium of any other art. Thereby each art would be rendered "pure." ("Modernist Painting")

Less, in other words, is more. But surely, at some point in time it becomes a purely practical, if not an ideological or spiritual necessity for art to re-establish relations with "the world," and to reclaim for itself those aspects of human experience once rigorously excised in the name of modernist purity.

Some of the various activities loosely referred to as "conceptual art" provide a case (perhaps *the* case) in point. Here, the quest for self-purification led art to divest itself of its every objecthood.[2] And significantly (at least for my purposes here), the only factor lending many such experiences a semblance of "materiality" was photographic documentation. Oftentimes, the photograph not only lent a touch of "permanence" to an otherwise ephemeral event, it also served to "situate" the event in the larger context of "the world" (the same world that the event itself—in its defiantly self-referential way—refused to acknowledge). The world, as it turns out, does not cease to exist because we refuse to acknowledge it.

And at approximately the same time (late '60s, early '70s), photography began to achieve widespread acceptance as an art in its own right. I don't think it's purely coincidental that the only other art to flourish so visibly in the '70s has been dance. Both photography and dance help restore to us what John Crowe Ransom called "the world's body" (which is precisely that aspect of life which modernism has so largely sacrificed). Ransom complained that science had robbed the world of its body by concerning itself only with the abstract principles which underlie experience, rather than with the concrete immediacy of experience itself. Siegfried Kracauer has written at great length about the extent to which the modernist arts unwittingly sustain this curse of scientific abstractness:[3] "Abstract painting," he writes, "is not so much an anti-realistic movement as a realistic revelation of the prevailing abstractness." Photography and the cinema, on the other hand, can help bring about what he calls "a redemption of physical reality" by "clinging to the surface of things" (rather than

extracting their skeletal substructure or interior meaning).[4] Clearly, for Kracauer, abstraction equals subtraction and entails a sense of loss.

But even the most abstract photograph is "connected" to the world beyond it in a way that a painting by, say, Ad Reinhardt or Frank Stella is not. Sontag makes this point deftly (even if she doesn't acknowledge its healthier implications):

> . . . the identification of the subject of a photograph always dominates our perception of it—as it does not, necessarily, in a painting. The subject of Weston's "Cabbage Leaf," taken in 1931, looks like a fall of gathered cloth; a title is needed to identify it. Thus, the image makes its point in two ways. The form is pleasing, and it is (surprise!) the form of a cabbage leaf. If it were gathered cloth, it wouldn't be so beautiful. We already know that beauty, from the fine arts. Hence . . . what a photograph is *of* is always of primary import-ance. The assumption underlying all uses of photog-raphy, that each photograph is a piece of the world, means that we don't know how to react to a photograph . . . until we know *what* piece of the world it is. What looks like a bare coronet—the famous photograph taken by Harold Edgerton in 1936—becomes far more interesting when we find out it is a splash of milk.

Kracauer makes the closely related argument that photography (and the cinema) are the only arts which continually re-direct the viewers' attention back to the pre-existing world.[5] The other arts—especially in their abstract, modernist phases—consume and transcend their raw materials.

Ultimately, photography (along with dance) offers at least a pro-visional solution to the problem Ortega y Gasset refers to as "the progressive dis-realization of the world":

> "The progressive dis-realization of the world," which began in the philosophy of the Renaissance, reaches its ex-treme consequences in the radical sensationalism of Avenarius and Mach. How can this continue? . . . A return to primitive realism is unthinkable; four centuries of criticism, of doubt, of suspicion have made this attitude forever untenable. To remain in our subjectivism is equally impossible. Where shall we find the material to reconstruct the world? ("On Point of View in the Arts")

Roger Copeland

Dance, almost by definition can never lose touch with the human form; and likewise photography invariably reveals some aspect of the material world. But at the same time, neither dance nor photography are in any danger of lapsing into the primitive realism which still characterizes so much of our popular culture. Dance is inherently "unrealistic" to the extent that the human figure is abstracted away from the world of speech. Analogously, photographic art (unlike cinematic art) remains for the most part uninterested in the "realism" of color. Despite the attention recently lavished on serious photographers who work in color (William Eggleston, for example), most photographic artists remain committed to the more "abstract" beauty of black and white (which is not to say that all color photography is necessarily "realistic").

Ortega thought that a formal appreciation of art was incompatible with a more directly empathetic involvement in "lived reality":

> Perception of lived reality and the perception of artistic form . . . are essentially incompatible because they call for a different adjustment of our perceptive apparatus.

Commenting on Titian's portrait of Charles the Fifth on horseback, Ortega argues that in order to appreciate the painting properly

> . . . we must forget that this is Charles the Fifth in person and see instead a portrait—that is, an image, a fiction. The portrayed person and his portrait are two entirely different things; we are interested in either one or the other. In the first case, we "live" with Charles the Fifth, in the second, we look at an object of art. ("The Dehumanization of Art")

But this is precisely the sort of either/or dichotomy that photography transcends. When we look at André Kertész's "Railroad Station" (1937), we see *both* an arrangement of forms and lines reminiscent of Cubist painting *and* a "human reality" we readily recognize from our own mundane experience.

To Ortega, the mutual exclusivity of "formalism" and "realism" mirrored the unbridgeable nature of the gap between the avant-garde artist and "the masses." But today, the desire to transcend the hermetic quality of formalism, and to reclaim for art some portion of the world's body, is part of a larger re-evaluation of the entire avant-garde ethos. Certainly, the aggressive desire to "épater le bourgeois" appears to be on the wane; and what Lionel Trilling once called "the adversary relationship" between the avant-garde artist and middle-class society has transformed into something more closely resem-

bling peaceful co-existence. This is the cultural ambience in which photography now thrives.

<center>II</center>

When Ortega talks about the "dis-realization of the world" he has in mind something much more serious than the decline of palpable physicality in our lives. He refers of course to the crisis of solipsism, of imprisonment in our own subjectivity. The "problem" of subjectivity first assumes "crisis" proportions when the romantics begin to stress the primacy of "imagination" over and above the world outside it. Consider Coleridge's eulogy to Hamlet (in his *Notes and Lectures* upon Shakespeare and the Old Dramatists):

> Hence it is that the sense of sublimity arises, not from the sight of an outward object, but from the beholder's reflection upon it; not from the sensuous impression, but from the imaginative reflex. Few have seen a celebrated waterfall without feeling something akin to disappointment; it is only subsequently that the image comes back full into the mind and brings with it a train of grand and beautiful associations. Hamlet feels this; his senses are in a state of trance, and he looks upon external things as hieroglyphics. His soliloquy, "Oh that this too, too solid flesh would melt . . ." springs from that craving after the indefinite—for that which is not—which most easily besets men of genius.

This retreat from the objectivity and materiality of the world is even more pronounced in the poetry and painting of the symbolists. Mallarmé, the high priest of this fin de siècle, neo-romantic movement once wrote,

> Truly it is when my friends have left that I begin to be with them, with their memory bordering my Dream, which their veritable apparition sometimes deranges a bit. . . .

On another occasion he commented "I hate London when there are no fogs; in its mists it is an incomparable city." This romantic and symbolist love affair with the desembodied and the ethereal was especially evident in the dance world. The romantic ballerina danced for the first time "on pointe"; and ballets such as "La Sylphide" and "Giselle" celebrated the impulse to transcend the constraints of earth and gravity. (Newton and his mechanical principles had of

<center>173</center>

course been chief villains in the intellectual life of romanticism since the time of Blake.) And Loie Fuller, a great favorite of Mallarmé's, virtually "vaporized" her body by covering herself with billowing silks which she swirled in shafts of brightly colored light.

Finally, this attenuated survey of the world's "progressive disrealization" culminates in the 7th of Rilke's "Duino Elegies":

> Nowhere, beloved, can world exist but within. . . . ever lessening, the outer world disappears. Where once there was a durable house pops up a fantastic image . . . as though it stood whole in the brain.

As T. E. Hulme was among the first to demonstrate (in his influential essay "Classicism and Romanticism"), both the artist and the world pay dearly when the subjective imagination is freed from the built-in restraints of the material world. Not only does the world recede into virtual oblivion; the disengaged imagination loses any objective criterion against which to assert or evaluate itself. By contrast, the classical artist, notes Hulme, "is always faithful to the conception of a limit . . . He always remembers that he is mixed up with earth. He may jump, but he always returns back; he never flies away into the circumambient gas."

Above all, the sort of classicism extolled by Hulme does not conceive of "creativity" as pure, unlimited invention, but views it rather as a form of "discovery" or excavation—a collaboration, in other words, between the subjectivity of the artist's shaping will (or imagination) and the objectivity of the world beyond it. I suspect that's what Michaelangelo had in mind when he described the sculptor as someone who "liberates the figure from the marble that imprisons it."

Compare that sort of equilibrium between "inner self" and "outer world" with Malraux's contention that "The modern artist's supreme aim is to subdue all things to his style." (Similarly, the Russian Formalists considered art to be the application of "organized violence.") Yet Hamlet's desire to see this "too, too solid flesh melt . . ." remains aesthetically vital only so long as "the world" offers some resistance. But in the 20th Century, we dominate—and are rarely dominated by—our environment. "Nature" is on the defensive. Paul Valéry foresaw this turn of events when he wrote that "The Modern world is being remade in the image of man's mind."

Kandinsky, upon learning that the atom could be "split," reacted as follows:

the collapse of the atom was the collapse of the whole world:
suddenly the stoutest walls fell. Everything turned un-
stable, insecure or soft. I would not have been surprised
if a stone had melted into thin air before my eyes.

Without the inherent "limits" provided by a solid and knowable
world, art runs the risk of drowning in a sea of subjectivity. (As Gide
once observed, art is born of constraints and dies of too much free-
dom.) One response to this dilemma is the Greenbergian concept
of "self-purification" I've already mentioned. In fact, Greenburg
addresses himself directly to this issue:

> . . . turning his attention away from the subject matter of
> common experience, the poet or artist turns it in upon
> the medium of his own craft. The nonrepresentational
> or "abstract," if it is to have aesthetic validity, cannot
> be arbitrary or accidental, but must stem from obedi-
> ence to some worthy constraint. ("Avant-Garde and
> Kitsch")

And according to Greenberg, modernist art finds that constraint by
identifying the underlying "nature" of its own medium and then
eliminating everything "extraneous" to it. Art, in other words, may
no longer be answerable to the world; but it is answerable to its own
medium.

So where does that leave art (and us)? Having helped usher in
the progressive dis-realization of the world, art now embarks on the
progressive dis-realization of itself.

III

Compare the following statements, the first by a minimalist painter,
the second by an early pioneer of photography:

> No accidents or automatism. . . . "One should never let
> the influence of evil demons gain control of the brush."
> . . . Everything, where to begin and where to end,
> should be worked out in the mind beforehand . . . The
> frame should isolate and protect the painting from its
> surroundings. (Ad Reinhardt, "Twelve Rules for a New
> Academy")

It frequently happens moreover—and this is one of the

175

charms of photography—that the operator himself discovers on examination, perhaps long afterwards, that he has depicted many things he had no notion of at the time. (William Henry Fox Talbot, *The Pencil of Nature*)

In his preface to *Paludes,* Gide maintains that creative work of the highest order always contains a dimension which the artist himself is unaware of: he calls this "God's share." Ad Reinhardt, with his excruciating self-consciousness and his desire to dominate chance and inspiration, is representative of the modernist desire to eliminate "God's share." Fox Talbot, by contrast, welcomes the intrusion of the unintended and the unexpected. (And, as Anatole France once wrote, "Chance is perhaps the pseudonym of God when He does not want to sign.")

Of course, there has always been an underside to modernism which has rejected the impulse to dominate and reshape the world, or to "compete" with God. The "chance" procedures of the Dadaists, the automatic writing of the surrealists, the "drip" paintings of the abstract expressionists are all attempts at self-effacement. But the end result in each of these cases is an even greater subjectivity— an exploration of deeper, more irrational impulses normally buried within the self.[6] Still, it makes little sense to say that the photographer approaches the world more "objectively" than other artists. Objectivity per se cannot of course be restored. But the peculiar genius of photography is its capacity for holding subjectivity in check. In a sense, the element of mechanical impersonality implicit in every photograph turns the Faustian impulse in on itself. Perhaps for the first time, technology operates so as to limit rather than extend the artist's control over his raw materials. (And perhaps a technologically imposed restraint is the only sort of limit a technologically-minded age will obey.)

No one understood this idea or expressed it more eloquently than André Bazin. In his classic essay, "The Ontology of the Photographic Image," he writes:

No matter how skillful the painter, his work was always in fee to an inescapable subjectivity. The fact that a human hand intervened cast a shadow of doubt over the image. . . . [But with photography] for the first time, between the originating object and its reproduction there intervenes only the instrumentality of a non-living agent. For the first time an image of the world is formed automatically . . . Although the final result may reflect something of his personality, this does

not play the same role as is played by that of the painter. All the arts are based on the presence of man, only photography derives an advantage from his absence.

Similarly, Siegfried Kracauer, speaking of both the still photographer and the filmmaker, insists that both are "much less independent of nature in the raw than the painter or poet; their creativity manifests itself in letting nature in and penetrating it." Or, as noted a bit more aphoristically by Helmet Gernsheim in *Creative Photography:* "The camera intercepts images, the paintbrush reconstructs them." [7]

By "intercepting" the image, the photographer re-establishes a connection with the world which is fundamentally different from that of every other form of reproduction or imitation. Bazin, again:

> Before the arrival of photography . . . the plastic arts (especially portraiture) were the only intermediaries between actual physical presence and absence. Their justification was their resemblance which stirs the imagination and helps the memory. But photography is something else again. In no sense is it the image of an object or person, more correctly it is its tracing. Its automatic genesis distinguishes it radically from the other techniques of reproduction. The photograph proceeds by means of the lens to the taking of a veritable luminous impression in light—to a mold. As such it carries with it more than mere resemblance, namely a kind of identity—the card we call by that name being only conceivable in an age of photography. ("Theatre and Cinema, Part II")

Reflected light, operating independently of human will, establishes a "mystical bond" between the photograph and the world. Beaumont Newhall has unearthed the following item from *The New York Times* of October 20, 1862, describing Brady's photographs of the battle at Antietam:

> Mr. Brady has done something to bring home to us the terrible reality and earnestness of war. If he has not brought bodies and laid them on our dooryards and along the streets, he has done something very like it . . . It seems somewhat singular that the same sun that looked down on the faces of the slain, blistering them,

blotting out from the bodies all semblance to humanity, and hastening corruption, should have thus caught their features upon canvas, and given them perpetuity for ever. But it is so.

Ironically, light—the least bodily of substances—helps restore to us "the world's body." Lamartine once described photography as a "solar phenomenon, in which the artist collaborates with the sun!"

The key word here is "collaborates." No doubt it's being more than a bit quixotic to argue, as Kracauer does, that photography and film can bring about "a redemption of physical reality," which will have the ultimate effect of deepening "our relation to this earth which is our habitat" (a notion Kracauer borrows from Gabriel Marcel). But at this point in our cultural history, photography appears to be leading the other arts back toward the world. (Certainly, the recent "realist" revival in painting owes an enormous debt to photography.) As Stanley Cavell notes in *The World Viewed:*

> So far as photography satisfied a wish, it satisfied a wish not confined to painters, but the human wish, intensifying in the West since the Reformation, to escape subjectivity and metaphysical isolation—a wish for the power to reach this world. . . .

Perhaps if Cartier-Bresson were not a photographer, the words I'm about to quote might not carry as much weight as they do:

> I believe that, through the act of living, the discovery of oneself is made concurrently with the discovery of the world around us . . . A balance must be established between these two worlds—the one inside us and the one outside us. As the result of a consistent reciprocal process, both these worlds come to form a single one.[8]
> (The Decisive Moment)

NOTES

[1] This desire to escape the minimalist cul-de-sac is evident in almost all of the arts, not just painting. In the mid-sixties, Twyla Tharp for example, was creating minimalist dances for performers who were rarely called upon to move, let alone "dance" in a virtuosic manner. Yet today, she choreographs for Baryshnikov. Composers like Steve Reich and Philip Glass have progressively "thickened" the textures of their once minimal music. And in the world of architecture, Robert Venturi has led the revolt against minimal "purity" by declaring "Less is a bore."

Photography and the World's Body

2 Of course, the conceptualists were motivated by other concerns as well, chief among them being the desire to create "non-buyable" artworks. Thus, photography, while re-locating the conceptual event in the world, also re-implicated it in the dynamics of the marketplace (because photographic documentation is collectable).

3 Ironically, Kracauer would dismiss as "abstract" the very sort of poetry that Ransom championed in his book *The World's Body*. Ransom felt that the poetic image (or "iconic sign") was more concrete than the abstract, scientific "concept" which gives us not the world's body, but the world's skeleton.

4 The word "redemption" betrays the essentially "spiritual" nature of Kracauer's argument. Like Bazin (whom he resembles in so many ways) Kracauer saw modernism as the creation of an alternative world which further estranges an already alienated species from our natural habitat. So perhaps I should make clear the extent to which I'm appropriating the work of Kracauer and Bazin for my own (purely secular) purposes. Both of them are just as opposed to formalist abstraction in the photographic arts as they are in the other arts (in fact, even more so). But *my* point is that even the most "abstract" photograph still demonstrates their essential ideas about the special relation between the photograph and its subject (even if that subject is "pre-stylized").

5 Furthermore, in *Theory of Film,* Kracauer insists that unlike painting, the frame of the photograph "is only a provisional limit, its content refers to other contents outside the frame." Stanley Cavell expands on this idea nicely in his book, *The World Viewed.* "You can always ask, pointing to an object in a photograph—a building, say—what lies behind it, totally obscured by it. This only accidentally makes sense when asked of an object in a painting. You can always ask, of an area photographed, what lies adjacent to that area, beyond the frame. This generally makes no sense asked of a painting. You can ask these questions of objects in photographs because they have answers in reality. The world of a painting is not continuous with the world of its frame; at its frame, a world finds its limits. We might say: A painting *is* a world; a photograph is *of* the world."

6 I'm not discounting those "anti-romantic" forms of self-effacement practiced by modernists: Barthes' "zero degree of writing," Robbe-Grillet's desire to recapture for objects their sense of "thingness" and "being-there," Cage's desire to "let sounds be themselves" or the "Neue Sachlichkeit" movement in the '20's. But with the exception of Courbet's realism and Zola's naturalism, almost all such attempts have been just as hermetic and rarified as the more purely "subjective" forms of modernist abstraction.

7 Note that for Sontag, this "interception" of the world is a "predatory" phenomenon. She argues that "print seems a less treacherous form of leaching out the world, of turning it into a mental object, than photographic images." But I would insist that photographs—because they're inherently less abstract than print—*preserve* a greater degree of the world's materiality.

8 Perhaps the closest that literature can come to fulfilling this ideal is a book like Mailer's *Armies of the Night* in which the author is giving us an unabashedly subjective account of an "objectively" public event.

179

FORM AND CONTENT
in the
EARLY WORK OF AARON SISKIND

CARL CHIARENZA

FOR AARON SISKIND, photography was never a detached art. It was and is, however, a symbolic and formalistic one. Siskind has had a fairly consistent "particular, humanistic, and engaged vision" of life (not of some conventionally accepted "objective world"). His purpose in making photographs has been, in his words, "to find a relation between an aesthetic and an idea." How could it have been otherwise for a man who spent a dozen years studying and practicing music and poetry before turning to photography? Siskind's work is the aesthetic result of a direct confrontation with life and a grappling with ideas about human destiny. His concern is with cause, not symptom. He learned very quickly that a photograph was no more objective an object than the worlds he experienced. A photograph was, for him, a set of relationships between shapes and tones. He discovered early on that he could control the kinds of relationships that occurred within the photographic frame. Whether he began with people (Illus. 1) or with a shredded broadside (Illus. 2) he could not separate form from content. The two people are two forms; the two forms are two people. The idea motivating both pictures is a major Siskind motif: that behind the surface imagery of conversations lies significant revelation of the complexity of human relationships. We may wish to argue that the "abstract" image is more general in terms of this idea, but that is because some 500 years of accepted conventions of pictorial representation convinces us that the photograph made in 1935 has a specific, identifiable content which is separable from its form, that it is "documentary evidence" of reality.

The often remarked change that occurred in Siskind's work in the years 1943-1945, was not a change from documentary to abstract. If it was a change at all, it was a change of referents. What happened to his work at that time was more in the nature of a clarification resulting from a long period of exploration of life as well as medium. During the dozen years preceding 1943 he tried to find in photography the visual equivalent of poetry, for it was in poetry that he first found a way to relate his own life's experience to what he believed was the major principle of life in the Western world. He

180

Early Work of Aaron Siskind

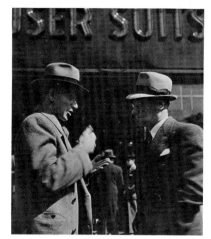

1 Broadway Ballyhoo c. 1935

2 New York, South Street 1947

called it the principle of duality, which, in its simplest form, is evidenced in the opposition of good and evil, but which can be seen everywhere, including the separation of mind from body, and of form from content. He found the separation of form and content a useful metaphorical tool, one that could best be used to advantage in photography, the medium most stereotypically associated with that separation. In order to understand this in his work, we must trace, if only briefly, some significant aspects of Siskind's life.

Siskind was born in 1903 in New York, the fifth of six children. His parents had emigrated from the Ukraine in 1893. His father and grandfather were tailors, the former operating a series of smaller and smaller neighborhood tailor shops, occasionally in the front room of the family's living quarters, always overcrowded because they boarded new immigrants. The elder Siskinds, poor and overworked, with little time for anything beyond survival, were stern and often irritable. Siskind found the atmosphere stifling; as far back as he can remember he was away from home as often as possible. He lived in the streets. Small and bright for his age, he recalls having to prove himself by beating or matching bigger kids. He quickly developed the necessary street savvy to be special. At school he was precocious, and invariably the teacher's pet.

Carl Chiarenza

By the age of twelve Siskind was listening to political speeches on Broadway; soon after he was making them himself. George Murray Hulbert, a member of the House of Representatives, was impressed with the boy's speeches decrying social injustice and promoting pacifism—this during World War I. Hulbert paid Aaron to speak for him from the back of a campaign truck. Speaking became a way to earn pocket money, and, more significantly, a way to gain a sense of importance. As speechmaker, he travelled to Harlem, witnessed more problems, became a junior member of the Young Peoples' Socialist League. The Junior YPSLs (pronounced yipsels) were messengers, running to polls, getting coffee, reporting problems. Siskind again became a leader of his group and a favorite of older members. He had found a measure of success and notoriety away from home—he was also attending weekly meetings of an Atheist Society —and he found adults who took an interest in him. He experienced as well some of the harsher, even brutal, realities of adult political life: Socialist meetings were raided by vigilante groups, the members beaten. And it was at a YPSL meeting that he met Sidonie (Sonia) Glatter, who became the sweetheart of his teen years and who would later become his wife.

At De Witt Clinton High School, Siskind's voracious reading ranged from Jack London to the Imagist poets. One of his teachers, Garibaldi Lapolla, encouraged his reading as well as his writing of poetry. Siskind's strong political and social concern very nearly resulted in his failure to graduate. After witnessing a riot instigated by vigilantes disrupting an open house at the new offices of the *New York Call,* a Socialist newspaper, Siskind wrote an angry letter to the editor pledging himself to the workers' cause. Siskind was reprimanded for this act by the high school disciplinarian. The principal informed Siskind that he could not vouch for his character—and therefore could not award him a diploma—unless Siskind would sign a document disavowing his political statements. Lapolla, Siskind's primary mentor during these years, and other teachers attempted to intercede with no effect. The situation was a traumatic one for Siskind who, after considerable discussion, signed.

At City College Siskind's political radicalism turned into a cultural radicalism. The center of his social and intellectual exchange was the college literary society, Clionia—a band of eager young intellectuals that included Barnett Newman (not yet a painter) and, though not enrolled in the college, Adolph Gottlieb, who had recently returned from Europe where he had studied painting. Many of the same people belonged to an independent writers' club. These groups replaced Siskind's politically-oriented organizations, and fulfilled his need to belong to an active cause.

182

Early Work of Aaron Siskind

Reflected in the poetry that Siskind wrote during this period was his growing attraction to things medieval. He regularly spent quiet hours in such churches as St. John the Divine and St. Thomas. He returned again and again to the Cloisters. In these environments he would read or, when possible, listen to religious music. He practiced, or fought with, the piano and with musical composition; he regularly attended concerts; he owned an enviable collection of records.

The poems that have survived contain many references to a god, either Christian or Jewish; to medieval thought, secular and religious; and to such polar concepts as good and evil. It was through literature and music that his spiritual needs were met at this period. Though he visited the churches—often with Sonia—and was strongly attracted to the rituals, he never participated or belonged. In college he concentrated on the study of Old and Middle English. He wrote several Middle English translations for *The Lavender,* the literary magazine published by Clionia. His medieval interests led him to the Metaphysical poets, although the major personal influences came from Blake and Proust. Siskind was awarded a medal for his poems, some of which were published in *The Lavender.* Despite all this, Siskind's self-esteem was low, and he gave up trying to be a musician; ultimately he also gave up writing.

But though he gave up poetry, his early writing contains themes that would haunt Siskind all his life. The imagery is often obscure, heavy, dark, slow-moving, mysterious. Like the late photographs, the poems deal continuously with opposing forces. Symbols and metaphors oscillate between the personal and the general. It is in this oscillation that Siskind seems to find a tentative meaning for his life. The poems reveal as well Siskind's struggle with the conflict between raw experience and elusive ideal. The reader is left, as the viewer of the photographs is left, with an image in which he must confront, again and again, the duality of life, what Siskind would later call "the terrors and pleasures of levitation." While some kind of faith in regeneration is expressed in the myriad examples of transformation through conflict, the poems persistently reveal his skepticism, his doubt, his bitter quest for answers.

By the time the poems cited here were written, Siskind had been for about thirteen years the steady companion of Sonia, the girl he had met at YPSL headquarters. The relationship caused significant effects on both. Sonia was mildly epileptic. She was deeply attached to her father, also named Aaron, who died when she was in her teens. Siskind filled the void. During Siskind's last year at CCNY, the couple had their first and only sexual union which resulted in pregnancy and a traumatic abortion. This highly-charged relationship found its way into much of the poetry Siskind wrote.

Carl Chiarenza

The incongruity of the real (Siskind's experience) and the ideal (his fantasy) is the theme of a considerable number of poems. It was concisely stated in *Song,* written about 1926:

> Pale man and paler maid;
> O which do I prefer?—
> Those seated on the bank
> Or the dream of him and her.

Siskind's desire, coupled with Sonia's increasing fear of sexuality, led him to write poems about temptation and agony, about desire and phobia. There are many, often quite lengthy. One short poem and an excerpt suggest the implications:

> *Sonia (Acrostic)*

> Sore did I yearn to bring you gifts: to place
> On your fair body royalty's robe, and grace
> Nine diamonds in your hair. As quick as thought
> I proffered these my glamorous gifts; but you
> (Alas) feared them—and since have feared me too.

> excerpt from *For Her Birthday*

> Walk lightly:
> Aye, shed your pall of flesh
> And go as spirit only.

The lines reflect the influence of Blake on Siskind's life and work. Siskind's early devotion to Socialism, his defense of the worker, his belief in an unfettered freedom for all men, his pessimism for all organized religion, his use of and feeling for Christian symbolism as relating to essential human qualities, his commitment to an intuitive experience of life without restriction, and perhaps most of all, his continuous attempt to unify the polarities of inherited doctrines, link Siskind to Blake. The need for a reconciliation between opposing forces guided them both. Here it is in Blake's *Auguries of Innocence:*

> Joy and Woe are woven fine,
> A clothing for the soul divine;
> Under every grief and pine
> Runs a joy with silken twine.

This theme is most directly drawn in Blake's *The Marriage of Heaven and Hell.*

184

Early Work of Aaron Siskind

After graduating from CCNY in 1926, Siskind considered a number of creative careers. Reluctantly he elected to teach in the public schools. It was a secure occupation at a time of economic distress. He taught seventh and eighth grade English until 1947 when he was transferred to a junior high school which he disliked intensely. He quit the public schools in 1949 to devote himself to photography. Though teaching and associated extra-curricular activities occupied much of his time, it was not an adequate replacement for the YPSLs or Clionia in terms of self-fulfillment.

In 1929, Siskind married Sonia. In 1930 they went to Bermuda on a belated honeymoon. As a going-away present for this trip Siskind received his first camera. Outwardly the marriage was compatible. Both taught school, haunted the concert halls, generally led a culturally rich life. But there were grave difficulties: Sonia's physical and mental problems grew. Epilepsy coupled with severe anxiety led to several attempts at suicide and other dangerous behavior. The marriage was literally painful to the couple. Sonia'a mental health took a drastic turn in 1937 which led to permanent hospitalization in 1938. From 1939 to 1943, Siskind's life was one of radical experimentation which fluctuated in tune with the dialectic of guilt and relief in his mind.

Siskind was twenty-six years old in 1930 when he received his first camera. The idea, of course, was to make snapshots, visual remembrances—documents. A few years ago, Siskind and I unearthed an album containing small prints made in the years 1930-32. There were very few snapshots. There were some composed portraits of Sonia. They show a woman, well dressed but somber, deeply introspective, whose eyes avoid the photographer. Others reveal Sonia's beauty in the nude. The rest of the prints are tightly composed pictures, somber in mood. Their structure is rigid: carefully balanced forms, often precisely symmetrical in composition, occasionally centrally organized with dark containing-areas on all four sides.

The New York skyscraper was an important subject for Siskind at this time, but the pictures are neither snapshots nor documents of the architecture. They present strong, mysterious, sometimes ominous presences. They stress the phallic nature of the skyscrapers. The buildings are usually dark silhouettes against menacing skies (Illus. 3). One of the prints (*The Daily News* Building) was made by precisely centering the camera very low and tipping it up at an extreme angle, turning the strongly contrasting light and dark verticals into a geometric abstraction of tense energy. Since all of these photographs were commercially-processed contact prints. Siskind

Carl Chiarenza

3 UNTITLED c. 1930-31

4 *Broadway Ballyhoo* c. 1935

was working under severe handicaps. He had had absolutely no training, no contact with serious photography of any kind. He had no darkroom. What he would later do in the darkroom, in terms of tonal control, he did to the extent possible without access to darkroom techniques. There are pictures of narrow empty streets with façades of buildings on one side which on the one hand recall the nostalgic romanticism of the streets of Atget and on the other hand have a terrible sense of claustrophobia. These are strong statements, they are very personal images. Structure and tonal arrangements are of primary concern. They are not social documents, they do not speak of classes, the poor, the deprived. It is significant that Siskind mounted these pictures in an album manufactured to hold family snapshots, since it is the only album he ever owned.

Others of these 2⅛ x 3⅛ inch prints further underline his earliest direction. Two of the prints, for example, are from the same negative. The "content" is a series of clotheslines stretched between buildings with a variety of hanging laundry. A dark coat, silhouetted and popping out of the picture plane, dominates the image. The second of the two prints was made by masking the negative so that the resulting print is 1⅜ x 2¼ inches. The negative was obviously made out of a window (probably in Siskind's apartment) which did not allow him to get close enough to compose the image as he wished, so he instructed the photofinisher to mask the tiny print to conform to the rectangle of related shapes, of lights and darks, that he had imagined. He was thinking formalistically and perhaps symbolically.[1] If the print also conveys overcrowded living conditions

186

Early Work of Aaron Siskind

(and that can be read into the image), it was not the dominant experience.

There are a number of still lifes from this period. Some are overtly formal exercises (a picture of opposing lights and darks, created by a tight framing of the forms of a multitude of barrel hoops, swirling this way and that, as if trying to burst out of the confining rectangle). Others are engaging exercises in symbolism (a picture in which the composition is awkward at best, but which depicts a bell, an open book, a lamp that is lit, and a provocatively positioned pair of scissors; on the wall above this array is a framed Dürer print of *Christ in the Garden of Gethsemane*). The latter photograph is clearly allegorical, an expression of Siskind's intense interest, at the time, in medieval literature, ritual and theology. The reference to "Bell, Book and Candle" is plain enough.

A less mystical still life from the same period is composed of two lemons and a banana, arranged with direct reference to genitalia. There are a few other prints in this very early group in which the eroticism is more subtly, more mysteriously, if more dramatically, communicated. One frames two pairs of women's legs curiously interleaved in fan-like form; another fills the right foreground plane with the head and shoulders of a woman whose pained and questioning expression unsettles the viewer caught by her direct gaze. In the distant background of the latter, the viewer catches sight of two other women embracing languidly on a couch. The two prints appear to be part of a series or sequence. In mood they relate to a poem-play Siskind had written in 1926, which, from its title (A Masque. Upon a Triple Occasion in Honour of the Misses Sonia and Cora, and Master Aaron, for June 26, Their Day), was obviously autobiographical. A brief section is quoted here as an example of the persistent mixture of metaphor, life experience (personal with general reference), and formal structure evident in all of Siskind's creative work. The following lines were spoken as a duet by two voices called "Virtue" and "Reward" (note the Judeo-Christian reference):

> We sought each other
> Sister, brother.
> Husband, lover,
> We sought each other
> And found us not about.
> We fled from meeting
> As from a plague;
> We had the ague
> And fled from meeting
> At last we found each other—out.

187

Carl Chiarenza

The range of the pictures from Siskind's first two years of independent involvement with photography reflects closely the subjects and concerns that begin to find strong and consistent maturity a dozen years later. He was, in effect, making sketches during these first two years—sketches which would form the basis of a lifelong career of picture-making in which form and content are one and the same in functional terms. These photographs were the visual equivalent of his early poetry and of his attempts at composing and playing music. Though he was at this stage consciously unconvinced of photography's potential for art, he just as consciously tested it, quietly, privately, hesitantly.

Two other pictures from 1930-32 ought to be mentioned. One is of a barren tree whose trunk splits into two limbs. The image is almost too obviously anthropomorphic. It is an important picture, for trees, either as isolated fragments or as anthropomorphic pairing of two or more trees interacting with one another—what he would call "Conversations"—are significant in his work throughout his career. The other of these tiny commercially-processed prints of major note is of a huge rock seemingly placed on a raised and groomed mound of earth. The totem quality, the sense of aura, are reminiscent of the great stones of England and Brittany. These and other early photographs prophesy the primitive anthropomorphism of Siskind's work in Gloucester in the mid-forties and the major pictures of fragments of stone fences on Martha's Vineyard from the early fifties and later. They also contain all the ingredients of the tragic images in Siskind's recent series on the trees of Corfu.

These early sketches show that Siskind was not interested in the photograph as a means of transporting the viewer to an event, place, or thing. For him the photograph was a visual construction equivalent to the verbal construction of poetry and the sound construction of music. His purpose was "to find a relation between an aesthetic and an idea." Not unlike the medieval poets he admired, he was interested in universal questions: the meaning of life, god, and the way life was played out within his own perception and experience. He had to rely on allusion, on symbol and metaphor, on the relations of shapes and of lights and darks, with which he would orchestrate the drama of his life's emotions from the lyrical to the violent.

In 1932, three years after the marriage and two years after the honeymoon and first pictures, Siskind purchased a better camera (a 9 x 12 cm. Voigtlander Avis). In that year he joined the Film and Photo League. Siskind had reached a stage in his solitary explora-

tion of photography where he was aware of his own accomplishment, the limitations of his equipment, and the limits of his knowledge.

Though details of the origin of the Film and Photo League in 1930 are obscure, its founding is similar to that of other artists' and writers' groups at the time, which had formal or informal connections with the Communist Party. It is certain that members of the League were committed to making pictures and films which carried the message of social reform, images which focused on the facts of poverty, illiteracy, and discrimination.

Why did Siskind, who had abandoned political involvement at the end of his high school years, join an activist group like the Film and Photo League? For one thing, he needed a group of people with whom he could talk and share ideas. Then, too, he had made a number of photographs of the disinherited and was certainly aware of the wretched social conditions born of the Depression. His own photography was at a critical point: quite simply, he needed technical advice. And finally, ever since his youth, he had needed a place away from the problems at home.

All of these needs were addressed when, walking down a New York street, Siskind noticed and was moved by a display of photographs in the windows of the League's headquarters. He went in and began to talk to a few older men who reminded him of the people to whom he had been attracted as a teen-aged Socialist. Several of the men at the League befriended him and gave him the advice he needed to set up a darkroom of his own. By 1933 he had obtained enough knowledge to build an enlarger and had mastered the necessary technology of the medium to be able to function with more concentration on the picture. In a number of ways the League was Siskind's avenue of entry into the photographic world.

In 1932, soon after Siskind joined the League, he attended a special meeting at which there were many people he had not seen before. One of the members, Izzie Lerner, who had recently returned from a trip to the USSR, had been accused of being critical of conditions in Russia. He was "tried" at the meeting, found guilty of being an enemy of the working class, expelled from the League and blackballed from further contact with members. This had a lasting effect on Siskind, who could hardly have failed to see the similarity to his own "trial" for speaking ill of the treatment received by the Socialists and working class just prior to his graduation from high school. Later, as chairman of the League's exhibition committee, Siskind found that he was expected to meet with a Communist Party "functionary" to plan what pictures should be made and which should be included in exhibitions. He discovered that the "party

line," and therefore the kinds of photographs requested, would change according to the international situation. This doctrinaire approach disturbed him and led to his resignation from the League in 1935. During those three years Siskind's feelings were in conflict.[2] He was upset about the "trial" and the authoritarian attitude of the party line, yet he worked hard for the exhibition committee. He believed in civil rights and social reform, and he made pictures for the cause. Siskind's pictures of the May Day Parade of 1932 were included in the League exhibition "America Today," which was produced in his first year of membership. Though interest in learning more about the medium was certainly a major factor in his decision to stay, it is difficult to see that as the only reason.

In 1936 Sid Grossman persuaded Siskind to rejoin. In that year the film group split off and the remaining members were reorganized as the Photo League under the direction of Grossman and Sol Libsohn. Soon after his return, Siskind gathered a handful of serious amateurs and formed the "Feature Group" which became the elite corps of the Photo League for the rest of the decade.

From 1936 to 1940, as founder, teacher, leader and working member of the "Feature Group," he would thoroughly explore, master and reject the documentary photo essay which we associate with the work of the federally-funded Farm Security Agency photographers who were working at the same time. The Feature Group had no funding; and, as was true of the League in general, its members were motivated by the appalling effects of the Depression on the lower strata of society in the major urban center of the world, New York City. Their work circulated largely through newspapers, magazines, and exhibition spaces underwritten by the Communist Party, labor unions and other liberal or radical groups friendly to the cause of reform. The work is only now beginning to be seen as important both socially and photographically to an understanding of the period.[3]

The group focused its attention on gaining total command of the medium while actively producing photo essays which would expose the conditions of the many disenfranchised citizens of New York. Siskind's personal conflicts continued. As he learned, and taught, more about the medium, he grew to be less convinced of the effectiveness of "documenting" the surface ills of society. This is most evident in the work he did independently of his League involvement, but is clear even in his work for the League.

The League itself changed and fluctuated during Siskind's second period. There was less overt political activity. Policy was no longer controlled by the Party. The membership expanded to include people of a variety of political persuasions. Most, however, were still com-

mitted to social reform. Pictures, including those produced by the Feature Group, continued to appear in the *Daily* and *Sunday Worker,* and in other Communist-sponsored publications. Siskind himself contributed to these publications and continued to work on exhibitions for workers' unions and schools. Of course, there were numerous political, ideological, aesthetic, and personal factions. The Feature Group was not immune.

By 1936 Siskind was thinking of ways to make pictures which would reveal the cause rather than the symptoms of social injustice. At the same time he continued to seek the limits of the expressive potential of photography as a medium. In the June-July 1940 issue of *Photo Notes* (the Photo League's newsletter), Siskind published a review of the Feature Group's evolution. In it he said:

> Instead of beginning with a study of critical statements on documentary photography by eminent moderns (Strand, for instance) and a review of its tradition (the procedure of Grossman's course . . .) we concern ourselves with the problem of how an idea comes to life in a photograph, and the special characteristics of that life. We start with the simplest ideas . . . The simplest ideas, because in examining the work we have done we can more easily relate the ideas to the elements of the picture and its total impact, and perhaps, in that way we can come to an agreement as to how and why it works—or doesn't.

Perhaps the most revealing section of that essay was this formalist statement:

> We learned a number of things about the form and continuity of a picture-story; but mostly, we came to see that the *literal representation of a fact* (or idea) can signify less than the fact or idea itself (is altogether dull), that a picture or a series of pictures must be informed with such things as order, rhythm, emphasis, etc.—qualities which result from the perception and feeling of the photographer, and are not necessarily (or apparently) the property of the subject.

It is significant that the moment when Siskind made his decision to commit himself to photography was during a talk about the relationship between photography and the workingman given by Paul

Strand at the League in 1934. Siskind has never been able to reconcile Strand's political stance (in word and picture) regarding the workingman, with his production of small, meticulous prints, carefully matted within thin wooden frames, priced so high that only the wealthy could afford them. While Siskind felt Strand's message was self-contradictory, he was moved by Strand's presence and passionate commitment to the medium. Strand's early flirtation with abstraction and the effect which that had on his later work is well known. Siskind's position, in terms of a political-aesthetic conflict, was not without similar characteristics at the time, though his presentation of work was at polar extremes to Strand's.

So, by the mid-to-late 1930s, Siskind found himself in an ambivalent position. He was growing more and more aware of the visual art world while he was deeply involved with the world of the social reformer. He was making photographs which can be called social-realist, pictures which emphasized an immediately recognizable visual message. Yet he never let go of his interest in joining metaphor, structure, and form. Even within the most "documentary" of his Photo League series there are outstanding examples of the recognizable overshadowed by metaphor built of symbol and form. Political dogma and the reformers' simplistic solutions to symptomatic injustice wore thin on Siskind. The Depression's effect on New York City, the growing threat of international war, and Siskind's own deteriorating marriage must have merged in his mind. Not unlike many of the major American painters of the time, Siskind turned more and more inward (as he had in his poetry of the 1920s, and in his first photographs of 1930-32). Siskind in the 1930s wanted to do the "right" thing at home, at school, and in the world. The "right" thing, however, seemed more and more futile, misguided, perhaps not right at all, and personally destructive as well. As the decade wore on, Siskind resorted to searching himself as a source of insight into the human condition. What he found were conflicts, dualities, myths in opposition to realities. And these became the form and content of his best work.

One needs, of course, to study the whole of Siskind's work from this period in order to see the consistency with which the important pictures lead to the breakthrough of 1943-45. Here we are restricted to a very few examples. Illus. 1 and 4 are from the series *Broadway Ballyhoo,* made c. 1935, ostensibly to show the vulgarity of the Broadway scene. Illus. 1 (and others from this and sub-series, of various people conversing before signs or billboards) may be the source of the important Siskind genre which he calls "Conversa-

Early Work of Aaron Siskind

5 *May Day Parade* 1936 6 UNTITLED Gloucester, 1944

tions." These "Conversations," which proliferated in the late 1940s (Illus. 2) and continue to the present, are generally considered abstract works in which form is dominant, metaphor is implied, and the source material is often a torn billboard. Siskind's interest, then and now, is in the revealing visual gestures, the visual closeness or separation, the visual evidence of human relationships.

Illus. 4 (also one of a sub-series) can be, as is often the case, read in a number of ways: it tells of the Broadway scene, of the trials of the handicapped, of the loneliness of individuals, of the concern of some for others. All of these interpretations are expressed as much by the shapes and tones, their contrasts and their carefully constructed relationships, as by the recognizable content. Illus. 5 is from a series on the May Day Parade of 1936. Note how little it tells us of the significance of the day or of the parade. It is in great contrast to the pictures Siskind made of the May Day Parade of 1932. In those he conveyed the specific messages of the parade. Indeed, many of them simply recorded the signs being carried by marchers. In Illus. 5, however, the form and content are powerfully blended into a message which is generalized and metaphorical. Note also the structural resemblance to Illus. 4, and, more importantly to Illus. 6 of 1944.

The more Siskind penetrated form in pictures, the more he consciously worked toward the incorporation of symbol. We have seen his very early interest in the Christian theme. The crucifixion, im-

Carl Chiarenza

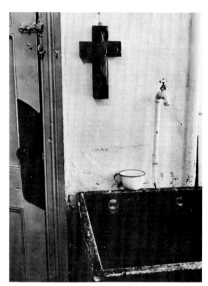

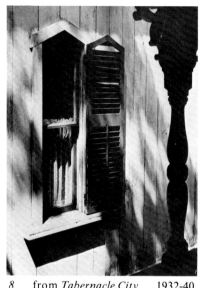

7 *The Catholic Worker Movement:* 8 from *Tabernacle City* 1932-40
 St. Joseph's House c. 1939-40

portant in all periods of Siskind's career, plays a primary role in
works of the Photo League period, such as the 1937 picture of the
monument to Father Francis Patrick Duffy. Siskind photographed
the monument before its unveiling so the figure of Duffy is wrapped
and tied like a corpse before the stone cross. The crucifix appears in
pictures from the *Portrait of a Tenement* series of 1936, in the series,
The Catholic Worker Movement: St. Joseph's House of 1939-40,
and in the series, *Dead End, The Bowery* of 1937-38. One example,
Illus. 7, demonstrates the direct symbolic use of the cross as well
as the abstract nature of the overall design of the rectangle, all of
which was planned to relate metaphorically to a Biblical phrase.
More familiar from this period are the numerous photographs in
various important series (particularly of Broadway, the Bowery, and
Harlem) which focus on painted and printed signs and billboards.
There is no need here to detail Siskind's ongoing interest in the
markings man leaves on walls and signs, and which he pointedly
refers to as "the writing on the wall." Many of these early "mark-
ings" pictures (especially those in the Broadway and Bowery series)
have the flatness and sense of collage more frequently associated
with the later work.

The most personal work of this period—that is, work done outside

194

Early Work of Aaron Siskind

of the Photo League—is largely architectural. There are three major series: *Tabernacle City*, 1932-40; *Bucks County Architecture*, 1935; and *End of the Civic Repertory Theatre*, 1938. It is significant, I think, that two of these series, *Tabernacle City* and *End of the Civic Repertory Theatre*, were exhibited at the Photo League and that in both instances they were poorly received. The former was condemned for not representing the worker's cause, the latter because the prints were "too dark." Both cases underline the growing antagonism between Siskind and the Photo League. Photo Leaguers were most interested in the political use (propaganda value) of photographs. Siskind was becoming most interested in pictures as expansive objects of formal and metaphorical contemplation. This is not to deny Siskind's genuine interest in the direct informational use of photography, most evident in the *Bucks County* series, nor his genuine interest in pictorial propaganda for social reform which is evident in the monumental *Harlem Document* project. Indeed, he was testing one kind of picture against the other in this period.

His abandonment of the propaganda picture was most closely related to his disillusion with the motivation of so-called reformers and with the effectiveness of the photograph as a means of activating reform. Though he still maintains respect for informational photographs, particularly in the case of architecture, he no longer produces them. In this period, however, the documentation of architecture served a variety of purposes: historical record (the primary purpose of the *Bucks County* series, which in its largely passive approach is the least effective in terms of its identity with Siskind);[4] exploration of form as structural order and as expressive of metaphorical meaning (*Tabernacle City* explores correspondence between architectural form and religious practice); and transformative possibilities (*Civic Repertory Theatre* reaches far beyond the general uses of the documentary and becomes a powerfully charged visual experience of decay and destruction which can be read generally or personally). Recall the importance of architecture as source material in the 1930-32 photographs and note the consistent use of architectural forms and fragments throughout Siskind's career. It is obvious that the geometry of most architecture (with or without organic decor) directly served Siskind's interest in positioning formal elements within the frame of the camera's ground glass. In other words, architecture was an opportune "subject matter" for the student interested in exploring the formal potential of the photographic medium. It follows that Siskind would use a tripod and a relatively large-format camera so that he would have optimum control over the composition of the negative.

195

Carl Chiarenza

9 from *Tabernacle City* 1932-40

10 *Ironwork, New York,* No. 1
1947-48

What Siskind calls *Tabernacle City* was actually a Methodist retreat community known as Cottage City on Martha's Vineyard. It consisted of numerous small cabins which were constructed around a large simple central tabernacle. Most of the cabins are individually and ornately decorated in the gingerbread manner. Thus the architecture symbolizes the idea and activity of the retreat: communal sharing and individual meditation. For Siskind, who has made an annual retreat to the Vineyard for most of his adult life, this community must have seemed an expression of his own lifestyle.

What attracted Siskind to this architecture, then, was again the melding of form and content. He researched the origin and development of the community—its people, its architecture, and the meaning of their annual retreat. He was originally drawn, however, to the shapes and ornamentation of the buildings, particularly the framing of the windows and the design of the ornamentation. He was taken, again and again, by the relationship of forms within isolated fragments of the cabins (Illus. 8 and 9). Very often there is in these semi-abstractions a suggestion of a "conversation" (often with sexual implications) between masculine and feminine shapes (Illus. 8).[5] And this too is characteristic, is an aspect which is developed in more sophisticated ways in later work. Compare for example Illus. 8 with Illus. 10 and 11, from 1947-48 and 1967 respectively.

Perhaps the most prophetic of the architectural series of this period was the *End of the Civic Repertory Theatre,* photographed in

196

Early Work of Aaron Siskind

11 Rome No. 30 1967

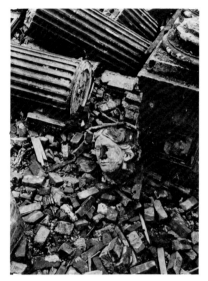

12 End of the Civic Repertory Theatre
1938

1938. When the prints exhibited at the Photo League were criticized as "too dark," Siskind's response was that he was interested in showing how decay breeds more decay and death.

That Sonia was permanently hospitalized in 1938 is very likely of significance in the making of these pictures. The photographs seem to be about more than the destruction of a venerable theatre building. They may refer to the decay of a culture, the death of a tradition, even of a civilization. That would not have been an unusual theme in the America of the 1930s. A number of photographs which depict broken classical columns or classical heads can be read as metaphors for such ideas. All show age, wear, and a general fatigue of materials. Many flatten space, use deep, somber, moody tonalities, and become literally abstractions which are heavy with the emotion of despair (Illus. 12). It is difficult not to see in these photographs Siskind's examination of his personal situation.

There are, too, photographs which symbolically depict the male/ female polarity; others imply the more generalized polarities of light and dark, angular and curvilinear (Illus. 13); still others suggest the ancient "writing on the wall." All are beautiful prints which display the most sensual of photographic tones. These, then, may be the most personal photographs of the Photo League period; they are, in photographic terms, most like Siskind's mature work.

197

Carl Chiarenza

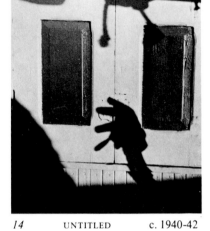

14　　UNTITLED　　c. 1940-42

13 End of the Civic Repertory Theatre
1938

Following Sonia's hospitalization, in 1938, Siskind underwent what we might today call a mid-life crisis. In 1940, he and Max Yavno, a Photo League photographer, rented two floors on Fourth Avenue and Eleventh Street, over the Corner Book Shop. Both men had recently separated from their wives. About these years, roughly 1939-1942, Siskind has said: "I had to get used to life again. Not having been able to make love for so many years, suddenly I was like an adolescent. . . ." This bohemian period was a time of confusion and ambivalence.

It was a critical time for Siskind's friends, and for his country, as well. In 1941 Siskind quit the League in response to criticism of the *Tabernacle City* exhibition. The political scene was confused; the party lines kept changing with the changing international scene. Siskind's own ambivalence over this is underlined by his attempt, in 1941, at the age of 37, to enlist in the Army's Officer Candidate School. He had been a pacifist all his life. He failed the written test and did poorly in the personal interview.

These years were very lean photographically. The pictures he made are generally aesthetically insignificant but personally poignant. They revert to an intimate symbolism, usually sexual (Illus. 14), often simply suggesting a general impotence and frustration (Illus. 15). All, however, are definitely a move away from the

198

Early Work of Aaron Siskind

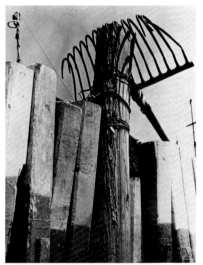

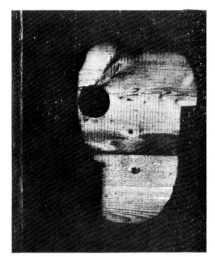

16 UNTITLED Gloucester, 1944

15 UNTITLED c. 1940-42

informational photographs of the Photo League, the Farm Security Administration, and *Life* magazine. They are in no sense social documentation.

By 1943 Siskind had moved to Ninth Street, east of University Place in Greenwich Village, where he would live until 1951. He renewed old friendships with Barnett Newman and Adolph Gottlieb, often summering with them on Martha's Vineyard or in Gloucester. In 1942 he met Ethel Jones, a young woman with whom he developed a serious and stable relationship of four or five years. Photography became even more important to him: he photographed every day during the summer, and printed during the school year.

Though Siskind had seen few art exhibitions in the 1930s—the first contemporary painting exhibition he saw was "The Ten Whitney Dissenters" in 1938, an exhibition which included Gottlieb and Rothko—now he began to visit shows regularly. He and Ethel visited Peggy Guggenheim's Art of This Century Gallery in 1942. They also met Mark Rothko in 1943 and became close friends: Rothko eventually married Ethel's closest friend. The four summered together in 1945, after Rothko's first major one-man exhibition at the Art of This Century. From 1945 on Siskind was a regular at the gatherings of artists at the Waldorf Cafeteria on Sixth Avenue and Eighth Street, and at the Cedar Bar. In 1944 Siskind photographed the pre-Columbian sculpture selected by Barnett Newman for exhibition at Betty Parson's Wakefield Gallery. In 1943 and 1944 a good part of Sis-

199

kind's summer was spent with either Newman or Gottlieb or both. Siskind was now back in an ambience that resembled that of his college years more than that of the Photo League years. In 1943 Newman was so excited by Siskind's new pictures that he brought Gottlieb over specifically to see them.

It was a period when Gottlieb and Rothko, as well as other American painters, were going through similar reappraisals of their work. Siskind's view of his and other artists' crises of the period is:

> It had to do with the concept of what art is and what it's for. And ours—we were all reacting very violently to what, during the thirties, was a very strong and dominating slogan: that art was a weapon of the working class—that it was something to use . . . a political arm . . . We were all disillusioned with that because we found that the very substance of art was corrupted by that attitude. So there was a withdrawal into the personal and a reexamination of the person in relation to the world.

This was often a topic of discussion among the New York artists of the 1940s. Most of them had had experiences with the Artists Union, the Artists Congress and the WPA Art Project which paralleled those Siskind had had with the Photo League. There was a general disillusion with social reform methods and particularly with the use of art in that connection. Most, too, were of similar backgrounds and ages. Gottlieb, Rothko and Siskind were born in 1903, Newman in 1905. Siskind's evolution parallels that of the major painters of the period. In 1969, Thomas B. Hess wrote of the Abstract Expressionists that "Instead of formulating a program for overthrowing the state, which had been at the heart of the earlier avant-garde thinking, they resolved to topple the government inside themselves." (*Barnett Newman,* New York, 1969, p. 31)

The change was a conscious one for most of the artists. Mark Rothko changed his name to underscore the break which he later described as going back to "symbols of man's primitive fears and motivations . . . changing only in detail but never in substance . . . And modern psychology finds them persisting still in our dreams, our vernacular and our art, for all the changes in the outward conditions of life." (Quoted in: M. Tuchman, ed., *New York School,* L.A. County Museum of Art, 1965, p. 29.)

Reactions to paintings by Gottlieb and Rothko exhibited at the Wildenstein Gallery in 1943 were not unlike those to Siskind's *Taber-*

Early Work of Aaron Siskind

nacle City exhibition at the Photo League in 1941. In response, Gottlieb and Rothko (with Newman's help) wrote a manifesto-letter to *The New York Times* which was published on June 13, 1943. Among the aesthetic beliefs they itemized was this: that the only subject matter that was valid was one which was "tragic and timeless."

> Consequently . . . our work . . . must insult anyone who is spiritually attuned to interior decoration; pictures for the home, pictures for over the mantel; pictures for the American scene; social pictures; purity in art; prizewinning pot-boilers; the National Academy

During an informal (taped) discussion with students at the Rhode Island School of Design in 1969, Siskind spoke of the "subject matter" of his work from the mid-1940s:

> When I found that [the pictures] were all organized the same way—though I was unaware of that when I made them—with organic shapes playing against geometric settings, it seemed very significant to me. The meaning of these pictures for me was that I was playing a game with the two forces of life; and I saw that it was the whole concept of Western civilization—the whole business of good and evil, matter and spirit, society and the individual, feeling and mind, and so forth. I realized that these were the things I had struggled with when I was writing poetry.

He went on to link the notion of this kind of duality to the Christian religion and Western culture. He called it "our problem," which he said was best expressed by photography, the "absolutely ideal medium" for the purpose,

> Because we're tied, in photography, to reality . . . and at the same time we're trying to do something about this reality . . . so in our pictures there's always this conflict . . . between the thing that's there and what we're trying to say about it.

In the summer of 1943 Siskind roamed the beaches of Martha's Vineyard. He photographed every morning, but without a feeling of accomplishment. He picked up objects, collected them, placed them in new situations which he photographed. In this way he fell on the

201

idea of the flat plane (by placing the camera parallel to the field he had created) and the elimination of the perspectival illusion of pictured spatial reality. Much of the work of this period resembles collage, both in terms of the constructed surface image and the tension between ordered but conflicting symbol-shapes. In 1955, he referred to this work and said it showed "order with the tensions continuing." ("The Essential Photographic Act," *Art News,* Vol. 54, No. 8, 1955, p. 36) More recently Siskind recalled a late 1940s discussion with a group of New York painters, including Rothko, Newman, and Motherwell, at which he talked about his 1943-44 experience:

> The thing that was driving me was a need for order. I felt so completely disturbed . . . so many conflicting forces were working within me, that the pleasure I got from making a picture, and the thing that was driving me to make the picture, was that that was the only way I could organize, could get a sense of order and relaxation. Therefore the object of the picture was something to contemplate—right from the beginning. It was the only sure way that I could remove myself from the battle and work in a kind of [confident] fashion.

The source material for the photographs of 1943-45 generally consisted of objects or substances (usually man-made) which were decaying, destroyed, or mutilated. Almost always the resulting pictures transformed these things anthropomorphically. The world of these pictures is ambiguous. Scale and space fluctuate: large/small, flat/deep. They are people with dismembered and headless bodies, ghosts and monsters without material substance. Other configurations suggest monk's clothes, the crucifixion, totemic or primitive icons, and ritual events. The mood is heavy, somber, cast in a low key with a preponderance of rich, deep greys and blacks. But it is all contained, controlled.

Illus. 16 is an example from the period which Siskind seems to have considered important since it was reproduced often on exhibition announcements and in such publications as *Art Photography* (June, 1954) where it was captioned: "the blank eye, the hard profile, in a time of violence." The primary image is of a menacing mask which sears the photographic paper. The stark contrasts of light and dark are violent and the circular eye is hypnotic. Most of the pictures of the period oppose organic and geometric elements. These oppositions range from simple "conversations" to such obviously symbolic suggestions as the male/female polarity.

Early Work of Aaron Siskind

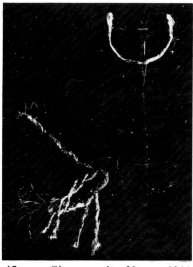

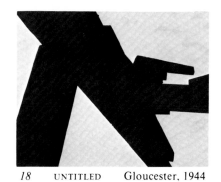

18 UNTITLED Gloucester, 1944

17 *Gloucester No. 28* 1944

Illus. 17 is one of the boldest, most powerful statements of the prolific year 1944. It can be seen as a "conversation," a weeping Magdalen at the foot of the crucifixion, as an isolation of the sexes, and so on. The rectangle is tension-filled but contained by a rigidly ordered construction. The flat plane is emphasized by the deep black field upon or in which the antagonistic figures gesticulate. One feels a great impending violence which is momentarily stilled by the formal placement of shapes.

Many of these pictures anticipate the later configurations of some of the Abstract Expressionist painters. One example, Illus. 18, must suffice to make the point here. The great clashing black forms on a white field suggest the later work of Franz Kline, who would a few years later become one of Siskind's closest friends and whose first one-man show would take place in 1950, three years after Siskind's first exhibition at the same gallery.[6]

That Siskind was aware of his breakthrough is made clear by the text of an essay which he wrote in the winter of 1944 and which was published in *Minicam Photography* (Vol. 8, No. 9) in June, 1945. After a lengthy discussion of his working habits, which he summed up as an "utterly personal" and "emotional" experience, he went on to say that

> . . . the picture that emerges is unique . . . the picture—and this is fundamental—has the unity of an organism. . . .

Pressed for the meaning of these pictures, I should answer, obliquely, that they are informed with animism— not so much that these inanimate objects resemble the creatures of the animal world . . . but rather that they suggest the energy we usually associate with them. Aesthetically, they pretend to the resolution of these sometimes fierce, sometimes gentle, but always conflicting forces.

. . . the potent fact is not any particular object; but rather that the meaning of these objects exists only in their relationship with other objects, or in their isolation (which comes to the same thing, for what we feel most about an isolated object is that it has been deprived of relationship).

These photographs appear to be a representation of a deep need for order. Time and again "live" forms play their little part against a backdrop of strict rectangular space—a flat, unyielding space. They cannot escape back into the depth of perspective. The four edges of the rectangle are absolute bounds . . .

Essentially, then, these photographs are psychological in character. [That] may or may not be a good thing. But it does seem to me that this kind of picture satisfies a need. I may be wrong, but the essentially illustrative nature of most documentary photography, and the worship of the object per se, in our best nature photography, is not enough to satisfy the man of today, compounded as he is of Christ, Freud, and Marx. The interior drama is the meaning of the exterior event. And each man is an essence and a symbol.

Siskind, therefore, did not exchange content for form in 1943. Nor did his work make the polar change usually associated with that period. What happened in the development of Siskind's photography is complicated. It is surely not *explained* in this essay. What we have shown, however, are three important factors: Siskind's creative production is intimately tied to his development as a person in New York City at a certain time and under certain circumstances. The essential elements of his photography were fully developed in his poetry of the 1920s. His involvement with what has been called content-oriented documentary photography in the 1930s was the result of complex factors stemming from his early life under immigrant and tenement conditions, the Socialist involvement of his teen years, his resulting high school conflict, his genuine interest in social justice and

civil rights, the psychological strain of his marriage and home life, his desire for knowledge and experience with a new medium, and his need for a supportive group and ambience.

Though the Photo League work may have delayed the evolution of Siskind's mature work, it also gave him an ideal opportunity to explore the "conflict of form and content" in a direct way for himself and for those members of the Feature Group who worked so closely with him. Indeed, the reason Siskind's pictures from this period, particularly the well-known work for *Harlem Document* and *The Most Crowded Block in the World,* are still so powerful is his insistence on the pictorial sense and structure of each photograph no matter what its ultimate purpose.

What is important to the success of Siskind's pictures is visual coherence (or visual meaning). His particular visual coherence is the result of the oneness of form and content—that is, the positioning of *all* elements into a meaningful whole which can be felt visually to be complete and to be continually intra-referential, even if it cannot be translated or articulated verbally.

NOTES

[1] See the related and somewhat similar photograph (*Rome No. 13,* 1963) made 33 years later.

[2] Concerning his feelings about Photo League politics when he first joined, Siskind said: "I went in there, I met up with it, I had to deal with it; but it was a kind of self-punishment because I always felt ill-at-ease. . . . By that time, everyone I met who talked politics to me immediately put me on guard. I looked at him and instead of hearing what he was saying, I was listening for his motivations, seeing his character. I was involved, not in what he was saying, but in how he was saying it, and wondering why he was saying it." This and all other quotations from Siskind are from taped interviews with the author over the last seven years, unless otherwise indicated.

[3] See Anne Tucker, "Photographic Crossroads: The Photo League," *Journal,* No. 25 (April 6, 1978), The National Gallery of Canada (Ottawa) and her forthcoming book of the same title to be published by Knopf.

[4] See C. Chiarenza, "Aaron Siskind's Photographs of Bucks County," *Afterimage,* Vol. 2, No. 8 (Feb., 1975), pp. 4-5.

[5] Compare Plate 8 with Stieglitz's, *Porch with Grape Vines,* Lake George, 1934, Plate 61 in *Alfred Stieglitz: Photographer,* Boston, Museum of Fine Arts, 1965.

[6] The gallery was the Charles Egan Gallery. The relationship between Siskind and Kline is more fully treated in: C. Chiarenza, "Aaron Siskind's Photographs in Homage to Franz Kline," *Afterimage,* Vol. 3, No. 6 (Dec., 1975), pp. 8-13.

CAMERA WORK: NOTES TOWARD
AN INVESTIGATION

ALAN TRACHTENBERG

THE NOTE OF WORRY that now shows up in discussions of photography—recovers an old idea under new conditions. The old fear appeared at the birth of the medium, and ranged from horror at the suspected demonism of using the sun to produce spectral images (Hawthorne hints at this in his picture of the otherwise sunny vocation of photographer in *The House of the Seven Gables)* to anger and disgust (in Baudelaire) with claims of the mechanical medium to a place of equality and honor among the fine arts. But the negative voice remained an undercurrent, soon drowned in the triumphant chorus of "progress."

The present worry, appearing unexpectedly at the very moment when the medium enjoys its widest legitimacy, now raises a new question, not of spirituality or authenticity of expression, but of ideology. In Sontag's words, photographs have achieved "virtually unlimited authority," and like all absolute authorities, bases its claims on a set of unexamined assumptions. These assumptions, which Sontag attributes to "the properties peculiar to images taken by the camera," include a pernicious displacement of reality on behalf of image: a depletion of the real, of its ability to arouse emotion and action, and a corresponding elevation of the image into a surrogate reality.[1]

The anxiety that our sense of reality proves vulnerable to ineluctable assault by chemically-made images may betray a buried wish for a restored and inviolate innocence: the innocence of a direct, unmediated experience: sensuous, active, pristine, and unfiltered by screen or image. What is especially curious, in fact paradoxical enough to register a major turn in avant-garde cultural criticism, is that the innocence that is now presumed to reside in a pre-photographic condition of pure being-in-the-world, was not very long ago hailed as a new and distinctively modern possibility within photography itself. "Open confidences are being made every day," wrote Man Ray in the preface to his book of photographs in 1934, "and it remains for the eye to train itself to see them without prejudice or restraint." The confidence that the eye can *train itself* to innocence ("without prejudice or restraint"), that seeing can become both means and end of being, exposes one of the tangled roots of connection between modernism (especially surrealism and its programmatic naivete of vision) and romanticism: a connection made clearer

206

and bolder in Man Ray's identification of pure seeing with unconventionality—and freedom: "Like the scientist . . . the creator dealing in human values allows the subconscious forces to filter through him, colored by his own selectivity, which is universal human desire, and exposes to the light, motives and instincts long repressed, which should form the basis of a confident fraternity. The intensity of this message can be disturbing only in proportion to the freedom that has been given to automatism or the subconscious self. The removal of inculcated modes of presentation, resulting in artificiality or strangeness, is a confirmation of the free functioning of the automatism and is to be welcome." [2]

What lay within the modernist program for photography, shared by such divergent programs as Strand's "straight photography," Moholy-Nagy's objectivism, and Man Ray's surrealist hope for a release of the free automatism—was a trust in the innocence-making capacities of the camera. Moholy-Nagy spoke for all currents of modernism when he said, "Thanks to the photographer, humanity has acquired the power of perceiving its surroundings, and its very existence, with new eyes." Of course the fact alone that such confidence welled into expression in the form of *programs* implied a worry that photography might not behave in the manner appropriate to it; all such programs included obligatory attacks on the false seeing of either timid or debased (imitative) photography. And common to such programs was an assurance that photography possessed certain *inherent* properties, which the artist need only obey in order to realize the "new vision."

The photographic community responded to Sontag as if a vile secret had been ferreted from the closet: that the capital of modernist notions of photography as a privileged source of new "truth," was itself tainted and poisoned by its complicity with the slick voyeurism, and the aggressive self-indulgence and narcissism engendered by consumer capitalism. What stung especially was Sontag's refusal to exempt any photographic practice from her characterization of the medium—that is, her refusal to allow any possibility of a recovered innocence from within photography itself. In this sense her argument is indeed anti-photography—or anti-photographic—for the only realm exempt from corruption seems to be a condition prior to, or outside the knowledge itself of photography: the response of savages who violently withhold themselves from the soul-snatching camera. She refused, in short, to allow photography a way out.

Responses to Sontag which angrily portray her as a detractor fail to engage the deeper issues which she herself glossed, and

expose a perilous condition within the photographic community itself: a paucity of vital ideas, of self-reflection, and of new programs. The anger, indignation, and complacency suggest that the success in the last decade—the success of individual practitioners in getting themselves recognized as artists—occurred without enhancement or refinement of understanding regarding the present work of photography, the very work that wins public acclaim. Sontag's critique seemed to catch unawares especially those who view photography as art: the category itself proving no defense against an assault on the medium as a medium in its own right. In the absence of a theory of the medium *as such,* the achievement of status as art rings hollow. Aesthetic definitions of photography provide, as Victor Burgin remarks, only a *"partial* account which leaves the social fact of photography largely untouched." [3] Accounting for the social fact is precisely the need exposed by Sontag's book, by the responses to it, and by the nagging worry of growing numbers of people made uneasy by the cult, the mystique of the photographic. A mystique by itself gives enough cause for worry; in this case worry compounds itself when we recognize that all around us a wholly mundane "photographic" performs its work toward ends only dimly comprehended.

II

Photography/work: the conjunction seems commonplace and untroubling. Did not the photograph attain its majority as a valued aesthetic object under the aegis of "camera work?" But the simple term work harbors nuances, shadowed regions of suppressed and repressed meanings, and the fundamental ambiguity of declaring at once an action and an object: the doing of something, and the something done. And there is the work of looking, viewing—or in the case of Stieglitz's journal, *tasting. Camera Work* left no stains of sweat; it was not industrial labor, the dirty making of something, but exactly the obverse (and deliberately so), a clean, white, tasteful space in a filthy, dark, sprawling age: the sprawl, the smoke and grime of daily life glimpsed fleetingly in pictures scattering among the nudes and genre scenes and landscapes and portraits which were the main fare of the magazine—random tokens of a contemporary world of work, distanced, aestheticized, and culminating in the very final pictures of the magazine in 1917, in Strand's abstractions. By its design (itself an icon of an idea of work as *hand*work, craft), the journal identified work with taste, and thus identified its true viewers as connoisseurs: as if aware of a destiny already implicit in its archaic idea of work, of becoming a collector's item.

Camera Work

The work of *Camera Work* included an obliteration of the kind of work practiced in the world around the journal. And by effacing its own physical labor of making, the journal thus confirmed the very system of ideas about the art-object (a finished, consummate event, with potential currency as precious coin) which photography as a medium had already begun to corrode. *Camera Work* preserved the doubled idea of art as privileged work and of the viewer of art as one who views from the outside, detached from the work of making.

Camera Work tended to remove its photo-objects from photography itself, from all other practices of the medium—and placed the object in an order or system of identification known as "art" (reinforced by the many pictures *of* hand-made artworks, portraits of artists, and eventually reproductions of graphic works themselves). The idea of "straight photography" formulated by Strand in his famous essay in the last issue in a way fulfills the entire *Camera Work* project; its core notion of "an absolute unqualified objectivity" as the "uniqueness of means" of photography speaks less about photography as a working medium than as an instrument "to an ever fuller and more intense self-realization." "Purity of its use" now appears as a repudiation of the "hand work and manipulation" of the early phases of the journal; but in fact the program calls for no more than *purification* in order to preserve the original practice: the production of images as pictures worthy of acceptance as traditional art. Dissociated from other practices of photography, the notion of "objectivity" translates into 1) an end to "the gum-print, oil-print, etc.," and 2) an openness to new devices for organizing pictorial space (close-up, abstraction) learned from and sanctioned by modern painting. The implicit idea of the camera *work* remains an exertion of individual vision and the presentation of the print as "picture." Apparently free to express its immediacy for any viewing eyes cast upon it, the *Camera Work* picture is already powerfully mediated, indeed over-determined, by the idea of the art-object inscribed in the artifact of the journal itself.

Photography/work: a doing and something already done. Lewis Hine, 1910: "I have had all along, as you know, a conviction that my demonstration of the value of the photographic appeal can find its real fruition best if it helps the workers to realize that they themselves can use it as a lever even tho it may not be the mainspring of the works." I have argued this point elsewhere—that taking work (visible acts of industrial labor) as his subject, Hine discovered a *work* of photography, photography as a specific practice, as a work-event.[4] Just as Strand's "straight photography" reflects upon the *Camera Work* practice, articulates and refines it, so Hine's "camera work" arises from and articulates an ideology—liberal (Progressive,

evangelical) social reform. Working consistently from the ideology he encountered an unexpected reversal: rather than illustrations of the reform ideology, photographs can *become* the ideology itself: not the statement of belief, but the occasion and the scene for the *work* of ideology. A struggle between opposing systems of value can be focused within the picture itself, making it not something depicted but something enacted.

Hine discovered for himself that the photographic picture, as a working image, *includes* a text: not so much to inform as to agitate. From the point of view of traditional aesthetics, which takes as picture-space the geometric planes formed and inhabited by the image, the text seems outside, a *caption:* a term which in law means the part of a legal document "which shows where, when, and by what authority" the document came into existence (retaining the original sense of seizure, capture). Not outside but *inside:* Hine discovered that the caption can be used as a way of seizing the image and returning it to an original authority, its origins in the very transaction of the camera, the camera *work.* Governed as it is by an explicit ideology, that original transaction performed the work of seeing for the sake of knowing again what was already known: the existence of child labor and its "look" to the reforming (which assumed itself to be the "natural") eye. Hine's "pictures" exist (or come into being) within the entire gestalt of image, text, layout. The montage poster is his heuristic example, an example deriving from the typical practice of layout and presentation in *Survey.*

The full range, power, and complexity of Hine's work still awaits rediscovery. The neglect of Hine is an episode that needs to be recited again and again: not simply because of the human disgrace (which is plentiful), but because of the problem it represents: the problem of the relation of the text to the image in the constitution of the photographic communication. In a manner of speaking Hine represented the repressed problematic of *Camera Work:* the problematic status of photographic (in relation to other) images. "Straight photography" made the romantic-modernist claim of a *purely-visual:* an unmediated vision empowered by its intensity to communicate itself wordlessly. Seeing sufficient to comprehending, without interference of words: this is the credo of a "new vision" photography. It aims at the production of images to silence speech.

The ideal discourse of *Camera Work* presumes the suppression of what, as *photograph,* the image merely denotes, what it signifies as a *trace,* an index to that whose reflected light left its mark upon the plate. This suppression of what is denoted, apparent in the "hand-work, manipulation," of the early phase of the journal, changes its form but remains essentially the same as the journal entered its

modernist phase and mixed photographs and reproductions of art-works in its pages: an event signifying the coming-of-age of photography within an already existing system of discourse. Photography earned its place within that system by showing itself capable of a process similar to that implied by abstract and cubist composition: the decomposition of traditional views of the world into "form," and the deconstruction of naturalistic perspectival space into pure pictorial space. Henceforth the "naturalism" of the photograph, which had seemed automatic (beyond control) reveals itself as inherently formal, capable of control and manipulation through strictly technical (as opposed to the earlier manual) means. In "straight photography," "naturalism" becomes a new formalism, retaining an old subjectivism: clouds become "songs of the sky," "equivalents."

Worry about the legitimacy of photography as art stimulated the culminating development of *Camera Work*. A quite different worry led Hine to his conception of camera work. If Strand felt the need to answer to the charge of photography's sheer mechanicalness of means, Hine felt compelled to answer the charge of unreliability of ends. The issue was "truth," and the worry that "photographs had been faked so much they were of no use to the work" of reform. Would they "stand as evidence in any court of law?" Issues of law—thus a literalization of "caption"—were at stake in Hine's "records" of violations of child labor regulations, but in the full defense of photography he developed in "Social Photography: How the Camera May Help in the Social Uplift" (a lecture illustrated with stereoptican slides) the legal allusions serve as an argument on way to a larger view of the work of the camera.[5] "Court" serves as a metaphor for viewer (just as "conflict," "battle," "campaign" metaphorize the mutual condition of photographer and viewer as one of war, class struggle), and as a metaphor it elicits an obligatory work for both the maker and viewer of images: to hold the image secure in its social concreteness, as a precise meaning. "With several hundred photos like those which I have shown, backed with records of observations, conversations, names and addresses, are we not better able to refute those who, either optimistically or hypocritically, spread the news that there is no child labor in New England?" Such images can declare what is *there*. A text confirms the social existence of what the image denotes, and authorizes its meaning.

But denotation by itself is neither adequate nor even possible. The confirmatory text confirms not only the existence of that which is denied (and thus fulfills a reformist campaign simply to prove the world different from how it is said to be by the ruling ideology), but also insinuates the notion that what exists ought not exist: that the *is* is a negation of the *ought*. The underlying ideological motive is to negate the negation, to cancel what exists on behalf of its

opposite. If *Camera Work* delivered its images over to the discourse of "art" and thus constrained their viewers to construe them as "pictures," Hine inserted his into a discourse of politics (broadly understood), where their work must be construed as ideological communication. The quite radically different structure of Hine's work resulted in a radically different camera work. The difference is decisive. Working in a structure which demanded not only an unambiguous but also a rhetorically pointed message, Hine came to understand the signifier—that part of the image which denoted real social fact—as inherently unstable *insofar as it remained purely visual.* In place of the claim of a purely visual, he asserted a priority to text, to language, to writing, conceiving writing not merely as appendage but as *the very image itself:* The dictum, then, of the social worker is " 'Let there be light'; and in this campaign for light we have for our advance agent the light writer—the photo-graph."

"The light writer—the photo-graph": Hine lurches toward a modernity beyond the early modernist "innocence" of "straight photography," of "objectivity." His practice ("campaign," "battle," "court") compelled him to define and justify his work precisely at the juncture of image and writing: at the crux where the picture is the scene of the production of a meaning. Hine may not be aware that he is treading a new theoretical terrain, but he is surely aware that he has entered the realm of theory. His illustrated lecture offers several modalities of joining image and text: images "backed with" confirmatory data (the typical *Survey* caption); an image "reinforced" by a generalizing passage on "the millstone of our social system" from Victor Hugo; and an image which invites a "pause" to consider the ground upon which it does its work. This latter passage itself gives pause. [See also illustration opposite.]

> Now, let us take a glance under Brooklyn Bridge at 3 a.m. on a cold, snowy night. While these boys we see there wait, huddled, yet alert, for a customer, we might pause to ask where lies the power in a picture. Whether it be a painting or a photograph, the picture is a symbol that brings one immediately into close touch with reality. It speaks a language learned early in the race and in the individual—witness the ancient picture writers and the child of today absorbed in his picture book. For us older children, the picture continues to tell a story packed into the most condensed and vital form. In fact, it is often more effective than the reality would have been, because, in the picture, the non-essential and conflicting interests have been eliminated.

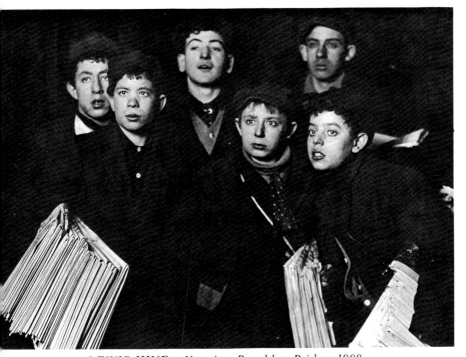

LEWIS HINE *Newsies, Brooklyn Bridge, 1908*

Alan Trachtenberg

An intriguing feature of this venture onto the ground of theory is that it occurs *while* the image confronts the audience: the question "where lies the power in a picture?" arises from the very power itself: the power to bring the viewer into a relation with a social fact (the newsboys waiting for a customer). By interposing a meta-language, Hine confronts the viewer with another social fact: the picture itself as a production. The picture is a *telling* of a story; its mode is symbolic: a condensation, a vitalizing of "reality" into a form. But the "reality" which the image brings the viewer "immediately into close touch with" is not wholly or simply the manifest visual image (the huddled boys), but also what that image itself tells: child labor, social millstone, deformation of human form by the system of production. And to these extended ranges of meaning Hine adds, as a direct hit at the inner work of the image, the *idea* itself of symbolic communication. Thus the image as symbol brings the viewer into "immediate" touch with the manifest content, its social specificity, its ideological meaning (deformation)—*and,* by raising into consciousness the theoretical power of the image as symbol, the viewer's own role as viewer, as *subject* to the picture.

Hine's thinking at this juncture—where image, form, symbol, and story cross and re-cross each other—can be put somewhat differently: taken by itself, as a purely visual, the manifest image is an opacity; it achieves transparency only by the viewer's successive recoveries of texts—the rings of connotation that layer the image and focus it as a viewer's experience; the recovered texts include a metatext which reflects upon the very process which is the work of the image: symbolic storytelling. The viewer, then—insofar as one enters into a fully conscious dialogue with the image—apprehends his or her own identity as subject. One finds oneself inside the image, a constituent of the process whereby the image coerces the world to a meaning. The picture is not a meaning already achieved, but a scene in which a meaning (and thus a subject) is produced.

III

Camera work seems so inevitably, so naturally the work of making pictures that our common language of analysis no longer registers the disturbance that Baudelaire felt: that photography *as such* is no more than a process for exact reproduction, and not, as such, a method of picture-making. Forgotten or repressed by critics is this simple distinction, between the process called photography (which can take place without a camera, as the experiments of Moholy-Nagy and Man Ray remind us), and the *photograph:* a particular instance of the process. If photograph means picture, then we must

recognize origins outside photography proper, in the pre-photographic, culturally-determined *idea* of picture. This is commonplace: it is through the camera, with its decisive frame, its borders, that the idea of picture attaches itself to the process of light-writing. Not only a faithful instrument of culture, the camera is itself a product of culture, a mode through which an enduringly potent idea gives shape and form to physical process. It is hardly strange that critics speak of photographs as only another kind of picture, an object offering itself for analysis of internal structure, disposal of space, tonal relations, and so on. But what is photographic *as such* remains problematic.

Taking a lead from Hine's idea of the work of photographic pictures as symbolic communication, we can begin to take the problem away from art-criticism proper, and from metaphysics, by locating it in *work,* in the viewer's experience. To think of the photograph as a place of a special kind of work, where a special kind of meaning gets produced, returns the question, "what is a photographic picture?" to the actual experience of a viewer, and through him or her back into the dense structures of thinking and feeling that make up the viewer's conceptual apparatus, his or her culture. We can begin to ask about the specific modes of production of meaning within photographs, and how they connect eventually with other modes of production and re-production within the culture.

Within the structure of culture whereby a photograph represents an instant, unmodified and unmediated re-play of lived experience, the photographic image seems to enjoy an unchallenged claim to "truth," to a privileged access to "reality." Sontag argues—and the point cannot be disputed—that this "myth" of photographic infallibility has been deployed in the service of a consumer capitalism: not only in commercial (advertising) practice, but also in amateur (family and touristic) and in "serious" photography—or wherever the photograph sets itself before the viewer as a surrogate reality. In fact that surrogate reality, she argues, projects an ideological version of time (history) as discontinuous, reality as real only in photographic fragments, and the viewer of the image as a passive consumer. With their mythic authority as tokens of reality, images tyrannize over subjects; they ready people for exploitation and manipulation.

Sontag argues from a presumed nature of the medium. But can we really speak of a *nature* of the medium outside specific practices? Are there no alternative practices, alternative *ideas* of photographic practice? The idea of photography as work—as both event and scene of event: a cross of the labor of the physical image (a holding in potential certain encoded signals) and the labor of a viewer—promises

Alan Trachtenberg

an alternative, for by replacing the image with the viewer at the center of criticism, it breaks the chain of authority. The authority which worries Sontag and others is, after all, conceded by viewers who are unaware of their own complicity in the work of the image. By shifting attention from the photograph to the act of viewing it, from the image-as-such to the work it implies, we can undermine authority. Conscious, knowing subjects can break the chain of command by recovering the working basis of the communication. This was Hine's intention in turning over the apparatus of photographic production to workers themselves (industrial workers and social workers); knowledge of the working of the image, and of the theory underlying the work, represented for him a certain power over history itself.

The project of counter-education simply overwhelms. In its pervasiveness and multiplicity, the photographic environment exerts a seemingly unshakable power. The pedagogy of a photograph is so simple as to lose itself in the experience of looking; viewers are normally unaware that they are also being directed how to look, what to see (and to cancel from sight), what to buy (either as tangible goods or as information)—and ultimately what to be. In the past twenty years or so McLuhan, Barthes and others have begun a training of viewers to recognize the pedagogy and to articulate the implicit text which makes images intelligible: a project aimed at inducing intelligent reading and sniffing out of covert ideological messages— but not resistance in the form of a counter-practice. The structuralist activity especially, of de-composing the elements of the photographic communication, identifying the operative codes within the image and those outside the image that impinge upon it, seems to assume a "free" viewer intent on defending his freedom, e.g., his or her ability to reject the message as a biased construction.

Sontag also assumes a "free" subject, glutted with someone else's images, and deceived (but capable of being undeceived) about his or her own "innocent" pleasure in taking pictures. All images, she seems to say, represent an excessive power of the Other over the ego. She calls for a moratorium, "a conservationist remedy," an ecology of images, to preserve what residue of "freedom" remains.

But it is possible to speak of an alternative practice—not a rejection or flight from the realm of the photographic, but a different engagement with it. I mean specifically the practice of the viewer, who by becoming aware of his or her activity at the site of the photograph can become a more knowing worker in the making of meaning. Critical reading of the image itself is one phase, a step toward what Hine recognized as an ultimate phase: the use of the photograph as a critical moment in a wider critique of the ideology (and social

216

practice hidden within it) through whose structures we encounter the image in the first place. The most eligible objects of such a critical reading are obviously those images most laden with ideological intent and implication—and these are usually also images in which the ideology is least overt as a sign: news and advertising images. To begin to dissolve these images, to de-compose them and submit their work to analysis, is already to oppose and resist them.

Another, perhaps more urgent because more difficult and less practiced, approach of critical reading concerns "serious" photographs—those we encounter by choice, not casually in the environment of everyday life, but in galleries and publications catering to the audience for photographic art. Art works seem to resist the semeiological reduction to message, except insofar as "art" is extricated as one signifying element in the communication, an element which predisposes the viewer to "aesthetic appreciation." The art practice that devolves from *Camera Work*, and Strand's later work is the strongest example, aims at a finish, a stillness and finality of representation, that is a compelling persuasion to the viewer to look at surface, tone, texture and composition, and less at the denotation/connotation dialectic more strikingly at work in images encountered in other contexts. Here the need for agitating the image is strongest, for only by resisting aesthetic claims can we recover what is most fully photographic in the image, what it shares with *all* photographs and thus what its authentic differences are. The critical viewing of "serious" images starts, then, with dismantling of a super-structure, a returning of the image to photography itself. A counter-education to the everyday photographic environment might, in fact, begin here, especially with those works of "serious" photography which make conscious and clarify communicative features of the medium itself.

Victor Burgin has written cogently about the role of the fixed lens point of view and of the frame in the photographic "structure of representation"—both features of the crude work of the camera which gives the viewer the illusion of a coherence originating from the site of viewing itself. "The characteristics of the photographic apparatus position the subject in such a way that the object photographed serves to conceal the textuality of the photograph itself—substituting passive receptivity for active (critical) reading." We can understand textuality both as Hine's "symbol" and "story," and as the semeiotic event of rendering the image intelligible by reference to the several codes or texts intersecting at the juncture of the image and the mind confronting it. Point of view and frame represent both the original and final arbitrariness of the camera image, and thus stand in potential contradiction to the interior claim of an "innocent" objectivity.

Alan Trachtenberg

The function of composition, Burgin adds, is to postpone "the subject's inevitable recognition of the *rule* of the frame"—a recognition that alienates the viewer from the authority of the image—and to prolong "our imaginary command of the point-of-view, our *self*-assertion." Composition is "a device for retarding recognition of the frame, and the authority of the *other* it signifies." [6]

The history of the role of composition in photography (and in the teaching of it) reveals at least this covert motive: to overcome the physical limitation of photography as a means toward "pure" images by transferring control from medium to master. What composition normally aims to suppress is the high degree of sensitivity of the photographic apparatus to accident, to contingency, to the sheer event of coincidence. The theory of the "decisive moment" in small format, rapid film/fast lens photography wishes precisely to exploit coincidence and transform it into intentional composition—a trick of language as much as a feat of eye and nerve. The notion of the "frozen moment," similarly, implies an intentional composition occupying the whole of the frame, thus expunging from the image anything not intended by the photographer. The rule of composition, then, is that frame needs to be converted from an arbitrary beginning/end, a seizure from the flux of time, to a necessary and fully intended coherence. The very idea of a photographic composition struggles to transform the camera frame (severing, fragmenting but leaving the flux intact) into a pictorial frame (beyond which exists only the *nothing* of uncreated space).

Accident, coincidence, the unexpected—these point to the major difficulty composition wishes to overcome: the fact that the photographic event occurs *in time.* Even the fraction of an instant necessary for exposure is long enough for something else to happen. Unexpected movements, resulting in blurs or disruptive gestures, are the marks of time—those very marks which composition wants to efface but which often remain as an inner resistance to composition. Any sign of that continuous flow, such as a blur, is a disruption of composition; it exposes composition as an arbitrariness attempting to cover up the prior arbitrariness (the camera's) of the frame.

These openings within the composed order of the picture are charms for the critical viewer; here is a point of entry into the image in its contingency, as the residue of an event, a work, which really took place: the placement of a camera before an object. If the photograph is an arbitrary work of composing a world, that world contains its own undoing, its own contradiction: its being the mark of a duration in which time does not cease but continues, in which movement and change continue to occur. If composition, apprehended as abstract form, signifies a maker's intentionality, what remains (or becomes)

218

uncomposed in the image represents an opposing energy: that of the recalcitrant world-as-such. It is the memory of its origins in this strata of unformed experience (so to speak) which the composed picture wishes to repress.

It was precisely the trace of the irrepressible that, early in the history of photography, amazed and enthralled practitioners and viewers. Often, wrote Fox-Talbot, the photographer will discover "on examination, perhaps long afterward, that he has depicted many things he had no notion of at the time. Sometimes inscriptions and dates found upon buildings, or printed placards most irrelevant, are discovered upon their walls: sometimes a distant dial-plate is seen, and upon it—unconsciously recorded—the hour of the day at which the view was taken."[7] One of the earliest and still one of the most acute writers on photography, Lady Eastlake, built upon this notion of an "unconsciously recorded" a theory of the uniqueness of the photographic report:

> No photographic picture that ever was taken, in heaven, or earth, or in the waters underneath the earth, of any thing, or scene, however defective when measured by an artistic scale, is destitute of a special, and what we may call an historic interest. Every form which is traced by light is the impress of one moment, or one hour, or one age in the great passage of time. Though the faces of our children may not be modelled and rounded with that truth and beauty which art attains, yet minor things—the very shoes of the one, the inseparable toy of the other—are given with a strength of identity which art does not even seek. Though the view of a city be deficient in those niceties of reflected lights and harmonious gradations which belong to the facts of which Art takes account, yet the facts of the age and of the hour are there, for we count the lines in that keen perspective of telegraphic wire, and read the characters on that playbill or manifesto, destined to be torn down on the morrow.[8]

Both Talbot and Eastlake, interestingly enough, speak of the unconscious inscriptions in a photograph as *writing:* texts to be read, pointing to events that lie outside the picture proper, and signifying a temporal frame invisible within the pictorial frame of the image. And light, as the measure of time, signifies the *passage* of time, and thus links the photograph in a unique way to the "great passage of time," or to temporality as such.

Such notions of the medium, derived from the practice of plate-cameras, slow lens and emulsions, and long exposures, virtually disappeared as a positive note in writings about photography, and re-surfaced in a startling way in the writings of Walter Benjamin, who introduced the notion of "the optical unconscious": the camera disclosure of what the eye sees but does not yet apprehend, such as "that fraction of a second when a person *starts to walk.*" Such moments are covert, must be won from the embrace of composition, and then seized as an opening into the inside, the unconscious, of the image:

> However skillful the photographer, however carefully he poses his model, the spectator feels an irresistable compulsion to look for the tiny spark of chance, of the here and now, with which reality has, as it were, seared the character in the picture; to find that imperceptible point at which, in the immediacy of that long-past moment, the future so persuasively inserts itself that, looking back, we may rediscover it. It is indeed a different nature that speaks to the camera from the one which addresses the eye; different above all in the sense that instead of a space worked through by a human consciousness there appears one which is affected unconsciously.[9]

The irrepressible mark of time hides in a recess of the image, and there too lurks the implicit text that needs to be written in order to secure the image—not only to free it from the "approximate," but to preserve it from the over-determinations of composition. In that recess is to be found the life of the image: the future that is its livingness now. Critical reading of photographs can find its Ursprung here, in locating the hidden, and returning it to the consciousness of the picture.

IV

A camera appears, takes up a place, and regards a scene. That regard, that gaze—the initiating event—disappears into the accomplished image. "The eye," writes Wittgenstein, "is not an object in its own visual field." But *not being there* is the absolute mark of a camera's having been there: the initial signification, as Barthes points out, of any photograph. By removing itself from the image, from the direct line of vision of a viewer, the gaze inscribes itself as a positive absence, a presence which takes the form of being absent.

Camera Work

The gazing eye withdraws so that the scene might appear, and the trace of its withdrawal is the sign of the photograph, of the image's origins in light-writing. The photographer's eye (sign of body and apparatus) is another repressed object within the image, deep within the recess guarding the covert marks of temporality. It too, the concreteness of the photographer as a positioned body and a knowing eye—must be recovered. By concreteness is meant, ultimately, ideology: where the photographer stands, places his apparatus; what he wants us to see, and why. These questions call to the viewer, interrupt his own gaze, break in upon it—and engender the work of critical reading.

Light, the measure of time, materializes itself through its opposite: shadow. Shadow is the darkness that signifies the existence *elsewhere* of light, darkness itself being no more than the abscence of light. The surface of the world is the sun's dial plate, and the photographer's shadowed body, camera, tripod and cable release in "Newsboy, Indianapolis, 1908" by Lewis Hine confirms not only a presence but a presence within concrete time and space: a specific thereness, unattainable as a sign in any other medium. Other shadows—the head at the bottom about to enter the scene, the poles at the right—reinforce the sense of particularity: all elements in the recorded scene occupying the same time-space continuum. The shadows give visible expression to a radical act of cutting, cropping, excluding from the image—they exclude any possibility of our seeing the frame as anything but arbitrary. Pressures exert themselves on both sides of the frame, the shadows reaching outward toward their bodily sources, which make themselves felt as presences: the presence of what the camera point of view and frame must reject and still acknowledge in order to make the image. [See illustration next page.]

The image is seized at a moment when shadows cohere to produce a space of intense, free-falling light, the realm within which the camera records itself in its work: confronting a young boy posing on a street-corner. Measurement is a defining activity in the image: as the shadows measure time, the boy's size, his smallness, is measured by the mailbox near his head. The image measures, too, the realm of light, where seeing occurs—the camera regarding the boy who returns its gaze, through the lens to us—against the realm (in shadow and light) of non-seeing, of disregard: the men in black crossing in the direction of the boy, the women in white crossing in the other direction, the "background" activity of daily doings in a commercial center (the street clock in the distance another measure, a sign of the rationalized structuring of life and work that governs that realm, e.g., a sign of its ideology). We confront two realms in a single image: the first realm decisively setting itself off (though remaining con-

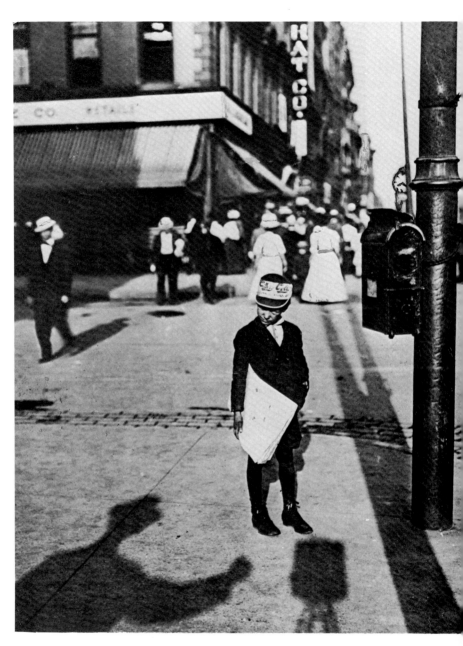

LEWIS HINE *Newsboy, Indianapolis, 1908*

nected) by the presence of the camera eye. Point of view and framing place the viewer directly within the first realm—the boy's shadowed eyes, one of the recesses of the image, themselves reaching through the picture plane toward the viewer—yet impose an awareness of the second realm. The clash is muted but pregnant: the boy as a subjectivity rescued by the camera from the ideology of the second realm, in which he exists only as an object of governing practices (and ideas) of work, time, identity. The critical, unconscious engagement lies between the camera and the clock: the camera permitting the boy (and the viewer) to step outside the time-scheme of the clock (also a scheme of identity), to defeat it momentarily, and enter a realm in which boy and viewer can become free subjects to each other, *in their humanness.* The unconscious recording of two times, then—one by shadow, the other by number (an ideological definition of being)—opens the image to its implicit text: the deformation of work represented by the "newsie"; the reformation represented by the camera.

Is such a text authentic, authorized by the image? "It is far from certain," wrote Paul Valery, "that objects close together on a photographic plate have anything in common beyond their nearness." [10] Rather than a latent certainty, meaning flows only from a construction, produced in the work of viewing, or re-viewing by the author-photographer. "At this point," writes Benjamin, "the caption must step in, thereby creating a photograph which literarizes the relationships of life and without such photographic construction would remain stuck in the approximate . . . must we not also count as illiterate the photographer who cannot read his own pictures? Will not the caption become the most important component of the shot?" [11] Authority for meaning resides in caption, itself a construction from out of the image, then returned to it as a "component." The caption Benjamin calls for takes Valery's caution into account: mere contiguity reveals nothing more than itself. The relations between parts need to be *literarized* before they can be grasped as authentic relations. The caption, then, authenticates the image—captures it for a specific revelation.

But need the caption be *literally* present, a distinct verbal presence? Another device for acknowledging the polysemic character of the image is a constructed setting of other images, a linear sequence or book. The sequence compels the viewer to read from image to image, watching for consistencies and transformations, repetitions which themselves take on the power of a matrix, an Ur-text. Speaking to a more restricted notion of an image-sequence of the same object, Moholy-Nagy formulated a principle the neglect of which indicates one of the crippling retardations of "serious" photography in the

Camera Work school (though Stieglitz's Equivalents and his composite portrait of Georgia O'Keefe fall roughly within range of the principle):

> There is no more surprising, yet, in its naturalness and organic sequence, simpler form than the photographic series. This is the logical culmination of photography. The series is no longer a "picture," and none of the canons of pictorial esthetics can be applied to it. Here the separate picture loses its identity as such and becomes a detail of assembly, an essential structural element of the whole which is the thing itself. In this concatenation of its separate but inseparable parts a photographic series inspired by a definite purpose can become at once the most potent weapon and the tenderest lyric.[12]

Although Moholy-Nagy has in mind sequences which disclose aspects of an object over time, such as his "Gypsy Dancing," or "Light Display, White, Black and Gray," each frame recording a minute variation from the preceding one, the principle of the sequence even in the realm of what he calls "normal fixation of the appearance of things" departs sharply from the presentation of the single image as "picture." Like the caption-text, a sequence of additional images resides like a germ within any single image; the photograph's special relation to temporality, the fact that it records a duration (however brief), accounts for this logical possibility. The logic of the sequence, moreover, dispels the claim of the single image to a truth beyond that of the instant of the photograph. In the sequence, in short, the single image invites the viewer to perform his or her work within a totality that already articulates the principle of camera work: that meaning is a production, the product of a subject's work, who thereby produces himself or herself as knowing subject.

The inherent incompleteness of the single image tells with remarkable force in two notable sequences, Walker Evans's subway series (see Plates 11-18), taken in the late '30s and early '40s — *Many Are Called* (1966), and Robert Frank's "The Bus Photographs, New York City, 1958" (see Plates 32-43). The point is particularly telling here because of the unmistakable strength of the individual pictures, a strength that qualifies any of the images for fine-art status and museum display. In sequence, however, each image becomes part of a chain, contributes to, and takes force from, the totality. Each is a moment toward the accomplishment of meaning, the fulfillment of the range of significance of each other. The totality serves

as a wordless caption, the source of authority—and the determining whole through which the viewer encounters the rich, irreducible specificity of each particular moment. Greater than the sum of its parts, the totality stands in an imaginary relation to an even greater whole: the invisible world of the city of which the underground subway and the surface bus represent subsidiary systems. Each series proposes a work of imaginative recovery, re-capture of the elusive forms of modern city experience, visible in details but invisible, in its wholeness. Quite dissimilar in most respects, the two series share as a covert text the passage from Sartre: "a *city* is a material and social organization which derives its reality from the ubiquity of its absence. It is present in each one of its streets *insofar as* it is always elsewhere." [13]

The *elsewhere* is one of the particular invisible vectors in both series, in that both depict events in or seen from vehicles of motion, mechanized instruments of passage from place to place (place as such remains one of the invisibilities). The moment of passage is especially prominent in the totality of Evans's images, where names of terminals and sections of subway maps (conventional signs of *elsewhere*) often appear. Frank's images are denoted by the series title as seen from a moving bus; they are glimpses constructed as revelations—and together as a single unified vision—of a world in which the moving vehicle determines perception and dominates space. *Placelessness* is a felt presence in each: not simply what is absent, but also the reality that leaves its mark on faces and bodies as they accommodate themselves to the non-place of subway or city street. While the Evans's series reads more as a study of *types*—face, attire, posture signifying a range of social life—Frank's sequence, less constrained by the fixed format of Evans's apparatus (hidden camera, uniform lighting), is a more selective, more severely edited study of isolating effects of street and machine. In each case, the totality brings the viewer into a relation (the substance of it is indeed the hidden text) with a machine for carrying people through city space, a machine which in turn declares itself as a proximate cause of the witnessed human effects. The denoted expressions are externally blank or bland in Frank, with signs of inner tautness, while greater variety shows in Evans's images, leavened by a good-humored and sympathetic wit. While Evans's images flow from page to page, disclosing subtle nuances of facial expression, posture, dress, Frank's images cut across each other abrasively, each a starkly different space, different configuration; the tempo of the movement might be likened to the jerking starting and stopping of a bus in traffic.

Like a verbal text these works exact an unaccustomed attention, precisely unlike the slackness of attention displayed by the repre-

Alan Trachtenberg

sented people to their surrounds. The sequences demand a reading attention, one by which the viewer comes to participate in the constructive process of assembling image and ensemble. The task requires more than recognition; it requires entering imaginatively into the photographic process itself, seeing the images as made of choices, of positionings of body and apparatus—and as radically disjunctive from normal vision. Rather than windows upon a recognizable world, they are fictions, imaginations, whose arbitrariness is declared by the very act of assembly into sequence. The reader begins by dissolving the pictorial and engaging the photographic: each image as the record of an event, initiated by a gaze, and culminating in a gaze returned from image to viewer. When one sees the image seeing oneself, calling the viewer to be the subject of the experience, expressing the viewer-as-subject, then camera work has been accomplished.

Attention in the Evans's series follows the nuanced variations from image to image, the deepening vision vouchsafed the attentive viewer of human variety under conditions—the subway ride—of deformation. Variations deepen; they do not transform. The sequence has no narrative, only repetition making difference emphatic within sameness of setting: metal window frames, reflective windows, light bulbs and their glare on metal and glass surfaces (this being a realm of artificial light, of *no time*), woven texture of benches. The critical eye follows the structure of representation imposed by the selective camera eye, a structure of self-presentation: artful or artless decor of coat, scarf, headdress constructing the public self; exquisitely unique structuring of face, mouth, jaw and cheek muscles—and especially eyes, exposing the infinitely more complex and richly inexpressible private self, the inner working its way toward open expression, and captured in its unconscious revelation. Eyes are the most decisive expression of difference; some inward-turning, others blank with the dull endurance of passage, many casting tentatively toward the hidden camera, engaged with the all-seeing (and now seen) body to which it is attached—and many roaming the space, gazing beyond the frame, creating a sense of a space beyond the frame: a space which opens like a detonation in the final image, looking up the aisle, of the blind musician, the Orpheus of this Hades, blind to where he is (though perhaps with a knowing blindness) as the passengers, engrossed in newspapers or idle looking, are blind to him and his urgency. The placement of this final image gathers accumulated implications of a limbo—many are called, few are chosen—and allows a literary closure to the reader's excursion in an underworld. The closure is accompanied by a caught breath: the revelation of the full space, and of the blind seer, a question mark above his head.

226

Camera Work

The literary note adds a metaphoric complexity—is the camera itself also a blind seer or "eyes for the blind"?—and by distancing the reader also brings him or her closer to the work he has just experienced: not the portraits themselves, but the camera's quest for a meaning.

While Evans's eye was fixed to his body, resulting in a pattern of difference within sameness, Frank's is mobile, swift, incisive as a razor; it intersects motion and carves into space. While the Evans's series connotes at a high literary level the mystery of being, of subjectivity, of difference within sameness, Frank's report brings us in touch with a deeper opacity of being: not only its mystery or hiddenness, but its deep deformation. Rather than eyes, the medium of subjectivity, he traces parts of bodies: the detached hand protruding from the armature of a bus window in the first image, marking a human gesture of boredom, resignation, against a space crammed with mechanized vehicles; the second image translating the fragmented hand into a fragmented foot just departing the frame on the left, leaving behind an unoccupied space of pavement in strict rectangular blocks, an empty white desolating even further the peddler and his mechanical toys. The hand thrust in pocket, or resting in pockets, the hands held by mother and two children, the folded arms of the sullen group under the Atlas figure at Rockefeller Center, the hand and arm clutching portfolio, the hand dropped in sloping resignation, or trailing behind the silhouetted figure crossing the blinding light of the street in the final image—these take the place of Evans's eyes, and indicate how much further the viewer is from access to a denoted meaning. Bodies differ in kind of motion—the apparent panic or sudden turn of the figure crossing the street, the heavy presence of the dark bulky figure wrenched into the same plane with the woman in light coat walking with apparent purposefulness, others crossing, waiting, lingering—discomfort with space, or at best slouched resigned, waiting within it: these are the cryptic modes of being represented in the series. These continuities unify the series, but they do not signify a demonstrable idea; within the continuous flow each image is also discontinuous from the rest, as patently isolated as the figures themselves: isolation, opacity, discontinuity emerging within the totality as the nature of the represented world. Only the mother and children holding hands portray a communication, though the mother shares the sullenness registered elsewhere in the series. One feels that meaning itself has withdrawn from the world; there are no reliable signs available for expressing or reading emotion, inner life, private existence. Human energy has been displaced by the machine, whose sign is detected in every image.

227

Alan Trachtenberg

There are few accounts of urban stupor and aloneness stronger, more original and affecting than these bus photographs. Yet the report is not quiescent. Opposite to the human depletion of the portrayed world is the energy and verve of the camera itself. Frank's camera is an antagonist. It makes itself felt in each image as the constructive force, registering coincidence, stopping action, condensing planes into single images. In each image we detect motion opposing motion—the camera struggling with the motion of the bus to arrest fleeing appearances into significant construction. Rather than efface its work Frank's camera insists upon its own role in the images it captures, and insists most subtly and actively in its use of the photographic tonal code of connotation: harshness of tone, sharp demarcations of black and white. Black and white, composed of a decidedly urban light, constitute a code of its own in these images, extremity of contrast appearing strongest in the concluding image, where light blazes like an acetylene torch in the opening between building and edge of bus, spilling into the street, etching the crossing figure as a silhouette, and glinting like sparks off the shadowed figures on the right. Each photographic tone reaches for an ultimate statement in this concluding image, and one cannot avoid the literary notion of a final judgment.

V

In photography we must learn to seek, not the "picture," not the esthetic of tradition, but the ideal instrument of expression, the self-sufficient vehicle of education.

—Moholy-Nagy

All questions of camera work resolve themselves finally to the work of the viewing-subject. On this figure—the everyman of our age—falls the burden of resolving the issue of humanism vs. formalism. The issue has less to do with photographs as content, than with photographs as the work of reading. Neither form nor humanness are abstract givens; they are activities performed in time and space, in historical place, and by real people. The primary circumstance which governs questions of photographic esthetics today remains what Hine perceived early in our era, and Evans and Frank re-discovered: the deformation of human form in modern society. Capitalism, industrialism, urbanism: photography appeared and developed in conditions engendered by modern history, and has been deployed by all contending forces. Photography by itself cannot discover or institute a humanism. It needs an idea of the human, and can find

the beginnings of such an idea by examining its own practices, its own work. In camera work the human takes the form of the subject, who can be active or passive, a participant or a victim. Literate photographers, who can read their own works, will discover ways, like Hine, Evans and Frank, of compelling their viewers toward critical reading, and thus toward active self-discovery as human subjects. The quarrel is not between a picture that is formalist and a picture that is humanist, but between a viewing which is passive, and a reading that is active and reflective.

A camera appears—and at once appears a difference: the world duplicates itself, reproduces itself no longer as undifferentiated experience but as image, as idea. The camera eye looks, and elicits a gaze in return: things look back at themselves. The feat is swift as light and as irreversible. The camera achieves the mirror held up to nature. All things now double their inscriptions, once in the bare eye, and again in the camera. But mirrors are illusionary, return only images: otherness becomes the Other, the necessary difference against which the self can see what it is in itself. Critical reading brings that useful difference into focus. Against that image, that past living forth into this now, a future becomes possible. The rupture in time represented by the fixed image calls me into being in relation to itself—a relation which in turn mirrors or *imagines* my relation to the world at large.

Photography is a specular activity; its images are speculations in the double sense of visions and propositions, appearances and thoughts. The photograph is an imaged and imagined relation to a real object, and re-places the viewer toward the object now caught up in a net of new relations—the intricate web of imagination. The image imagines its viewer-subject into being, gives him or her a place, a set of borders. The act of the camera is perforce fictive, perforce ideological. The viewer's work is to grasp the imagined relation to the world as an idea, and to play over it the critical light of his or her own desires, and not to flinch from withdrawing, from denying power to images whose ideas debase and deform. Criticism is the health of photography. "The critical gaze (Skepsis: view)," writes André Glucksman (citing Heiddeger), "is the gaze that tries to catch apparition in its appearing 'so that it ceases to be a simple entrance on to the stage.' " [14] From photographers who are also critics (skeptics) in this sense, their own readers and perhaps writers, can spring a truly speculative photography.

229

Alan Trachtenberg

NOTES

[1] Susan Sontag, *On Photography* (New York 1977), *passim*.

[2] Man Ray, *Photographs* (Paris 1934), n.p.

[3] "Looking at Photographs," *Tracks,* Vol. 3, No. 3 (Fall 1977), p. 36.

[4] *América & Lewis Hine* (Millerton, New York 1977), pp. 118-137.

[5] *Proceedings,* National Conference of Charities and Correction (June 1909), pp. 50-54.

[6] Burgin, "Looking at Photographs," p. 44.

[7] *The Pencil of Nature* (London 1844), Plate XIII.

[8] *London Quarterly Review,* CI (1857), pp. 465-466.

[9] "A Short History of Photography," *Screen* (Spring 1972), p. 7.

[10] "The Centenary of Photography," *The Collected Works of Paul Valéry,* ed., Jackson Mathews (Princeton, 1956-75), Vol. 11, *Occasions,* 162.

[11] Benjamin, "A Short History," p. 25.

[12] "A New Instrument of Vision," in *Moholy-Nagy,* ed., Richard Kostelanetz (New York 1970), p. 54.

[13] *Search for a Method* (New York 1963), p. 80.

[14] *New Left Review,* 72 (March-April 1972), p. 92.

DISMANTLING MODERNISM, REINVENTING DOCUMENTARY (NOTES ON THE POLITICS OF REPRESENTATION)

ALLAN SEKULA

S UPPOSE WE REGARD art as a mode of human communication, as a discourse anchored in concrete social relations, rather than as a mystified, vaporous, and ahistorical realm of purely affective expression and experience. Art, like speech, is both symbolic exchange and material practice, involving the production of both meaning and physical presence. Meaning, as an understanding of that presence, emerges from an interpretive act. Interpretation is ideologically constrained. Our readings of past culture are subject to the covert demands of the historical present. Mystified interpretation universalizes the act of reading, lifting it above history.

The meaning of an artwork ought to be regarded, then, as *contingent*, rather than as immanent, universally given, or fixed. The Kantian separation of cognitive and affective faculties, which provided the philosophical basis for Romanticism, must likewise be critically superseded. This argument, then, calls for a fundamental break with idealist esthetics, a break with the notion of genius both in its original form and in its debased neo-romantic appearance at the center of the mythology of mass culture, where "genius" assumes the trappings of a charismatic stardom.

I'm not suggesting that we ignore or suppress the creative, affective, and expressive aspects of cultural activity, to do so would be to play into the hands of the ongoing technocratic obliteration of human creativity. What I am arguing is that we understand the extent to which art *redeems* a repressive social order by offering a wholly imaginary transcendence, a false harmony, to docile and isolated spectators. The cult of private experience, of the entirely affective relation to culture demanded by a consumerist economy, serves to obliterate momentarily, on weekends, knowledge of the fragmentation, boredom, and routinization of labor, knowledge of the self as a commodity.

In capitalist society, artists are represented as possessing a privileged subjectivity, gifted with an uncommon unity of self and labor. Artists are the bearers of an autonomy that is systematically and

covertly denied the economically objectified mass spectator, the wage-worker and the woman who works without wages in the home. Even the apparatus of mass culture itself can be bent to this elitist logic. "Artists" are the people who stare out, accusingly and seductively, from billboards and magazine advertisements. A glamorous young couple can be seen lounging in what looks like a Soho loft; they tell us of the secret of white rum, effortlessly gleaned from Liza Minnelli at an Andy Warhol party. Richard Avedon is offered to us as an almost impossible ideal: bohemian as well as his "own Guggenheim Foundation." Artist and patron coalesce in a petit-bourgeois dream fleshed-out in the realm of a self-valorizing mass culture. Further, the recent efforts to elevate photography to the status of high art by transforming the photographic print into a privileged commodity, and the photographer, regardless of working context, into an autonomous *auteur* with a capacity for genius, have the effect of restoring the "aura," to use Walter Benjamin's term, to a mass-communications technology. At the same time, the camera hobbyist, the consumer of leisure technology, is invited to participate in a delimited and therefore illusory and pathetic creativity, in an advertising induced fantasy of self-authorship fed by power over the image machine, and through it, over its prey.

The crisis of contemporary art involves more than a lack of "unifying" metacritical thought, nor can it be resolved by expensive "interdisciplinary" organ transplants. The problems of art are refractions of a larger cultural and ideological crisis, stemming from the declining legitimacy of the liberal capitalist world view. Putting it bluntly, these crises are rooted in the materially dictated inequalities of advanced capitalism and will only be resolved *practically,* by the struggle for an authentic socialism.

Artists and writers who move toward an openly political cultural practice need to educate themselves out of their own professional elitism and narrowness of concern. A theoretical grasp of modernism and its pitfalls might be useful in this regard. The problem of modernist closure, of an "immanent critique" which, failing logically to overcome the paradigm within which it begins, ultimately reduces every practice to a formalism, is larger than any one intellectual discipline and yet infects them all. Modernist practice is organized professionally and shielded by a bogus ideology of neutrality. (Even academic thuggeries like Dr. Milton Friedman's overtly instrumentalist "free market" economics employ the neutrality gambit.) In political-economic terms, modernism stems from the fundamental division of "mental" and "manual" labor under advanced capitalism. The former is further specialized and accorded certain privileges, as well as a managerial relation to the latter, which is fragmented and degraded.

An ideology of separation, of petit-bourgeois upward aspiration, induces the intellectual worker to view the "working class" with superiority, cynicism, contempt, and glimmers of fear. Artists, despite their romanticism and their slumming, are no exception.

The ideological confusions of current art, euphemistically labeled a "healthy pluralism" by art promoters, stem from the collapsed authority of the modernist paradigm. "Pure" artistic modernism collapses because it is ultimately a self-annihilating project, narrowing the field of art's concerns with scientistic rigor, dead-ending in alternating appeals to taste, science and metaphysics. Over the past five years, a rather cynical and self-referential mannerism, partially based on Pop art, has rolled out of this cul-de-sac. Some people call this phenomenon "postmodernism." (Already, a so-called "political art" has been used as an end-game modernist bludgeon, as a chic vanguardism, by artists who suffer from a very real isolation from larger social issues. This would be bad enough if it weren't for the fact that the art-promotional system converts everything it handles into "fashion," while dishing out a good quantity of liberal obfuscation.) These developments demonstrate that the only necessary rigor in a commodified cultural environment is that of incessant artistic self-promotion. Here elite culture becomes a parasitical "mannerist" representation of mass culture, a private-party sideshow, with its own photojournalism, gossip column reviews, promoters, celebrity pantheon, and narcissistic stellar-bound performers. The charisma of the art star is subject to an overdeveloped bureaucratism. Careers are "managed." Innovation is regularized, adjusted to the demands of the market. Modernism, per se (as well as the lingering ghost of bohemianism), is transformed into farce, into a professionalism based on academic appointments, periodic exposure, lofty real estate speculation in the former factory districts of decaying cities, massive state funding, jet travel, and increasingly ostentatious corporate patronage of the arts. This last development represents an attempt by monopoly capital to "humanize" its image for the middle-managerial and professional subclasses (the vicarious consumers of high culture, the museum audience) in the face of an escalating legitimation crisis. High art is rapidly becoming a specialized colony of the monopoly capitalist media.

Political domination, especially in the advanced capitalist countries and the more developed neo-colonies, depends on an exaggerated symbolic apparatus, on pedagogy and spectacle, on the authoritarian monologues of school and mass media. These are the main agents of working class obedience and docility; these are the main promoters of phony consumer options, of "lifestyle," and increasingly, of political reaction, nihilism, and sadomasochism. Any effective political

art will have to be grounded in work *against* these institutions. We need a political economy, a sociology, and a nonformalist semiotics of media. We need to comprehend advertising as the fundamental discourse of capitalism, exposing the link between the language of manufactured needs and commodity fetishism. From this basis, a critical representational art, an art that points openly to the social world and to possibilities of concrete social transformation, could develop. But we will also have to work toward a redefined *pragmatics,* toward modes of address based on a dialogical pedagogy, and toward a different and significantly wider notion of audience, one that engages with ongoing progressive struggles against the established order. Without a coherent oppositional politics, though, an oppositional culture remains tentative and isolated. Obviously, a great deal needs to be done.

II

A SMALL GROUP of contemporary artists is working on an art that deals with the social ordering of people's lives. Most of their work involves still photography and video; most relies heavily on written or spoken language. I'm talking about a representational art, an art that refers to something beyond itself. Form and mannerism are not ends in themselves. These works might be about any number of things, ranging from the material and ideological space of the "self" to the dominant social realities of corporate spectacle and corporate power. The initial questions are these: How do we invent our lives out of a limited range of possibilities, and how are our lives invented for us by those in power? As I've already suggested, if these questions are asked only within the institutional boundaries of elite culture, only within the "art world," then the answers will be academic. Given a certain poverty of means, this art aims toward a wider audience, and toward considerations of concrete social transformation.

We might be tempted to think of this work as a variety of documentary. That's all right as long as we expose the myth that accompanies the label, the folklore of photographic truth. This preliminary detour seems necessary. The rhetorical strength of documentary is imagined to reside in the unequivocal character of the camera's evidence, in an essential realism. The theory of photographic realism emerges historically as both product and handmaiden of positivism. Vision, itself unimplicated in the world it encounters, is subjected to a mechanical idealization. Paradoxically, the camera serves to ideologically *naturalize* the eye of the observer. Photography, according to this belief, reproduces the visible world: the camera is an engine of fact, the generator of a duplicate world of fetishized

appearances, independently of human practice. Photographs, always the product of socially-specific *encounters* between human-and-human or human-and-nature, become repositories of dead facts, reified objects torn from their social origins.

I shouldn't have to argue that photographic meaning is relatively indeterminate; the same picture can convey a variety of messages under differing presentational circumstances. Consider the evidence offered by bank holdup cameras. Taken automatically, these pictures could be said to be unpolluted by sensibility, an extreme form of documentary. If the surveillance engineers who developed these cameras have an esthetic, it's one of raw, technological instrumentality. "Just the facts, ma'am." But a courtroom is a battleground of fictions. What is it that a photograph points to? A young white woman holds a submachine gun. The gun is handled confidently, aggressively. The gun is almost dropped out of fear. A fugitive heiress. A kidnap victim. An urban guerrilla. A willing participant. A case of brainwashing. A case of rebellion. A case of schizophrenia. The outcome, based on the "true" reading of the evidence, is a function less of "objectivity" than of political maneuvering. Reproduced in the mass media, this picture might attest to the omniscience of the state within a glamorized and mystifying spectacle of revolution and counter-revolution. But any police photography that is publicly displayed is both a specific attempt at identification and a reminder of police power over "criminal elements." The only "objective" truth that photographs offer is the assertion that somebody or something—in this case, an automated camera—was somewhere and took a picture. Everything else, everything beyond the imprinting of a trace, is up for grabs.

Walter Benjamin recalled the remark that Eugène Atget depicted the streets of Paris as though they were the scene of a crime. That remark serves to poeticize a rather deadpan, nonexpressionist style, to conflate nostalgia and the affectless instrumentality of the detective. Crime here becomes as matter of the heart as well as a matter of fact. Looking backward, through Benjamin to Atget, we see the loss of the past through the continual disruptions of the urban present as a form of violence against memory, resisted by the nostalgic bohemian through acts of solipsistic, passive acquisition. Baudelaire's "Le Cygne" articulates much of that sense of loss, a sense of the impending disappearance of the familiar, that Benjamin attributes indirectly to Atget. I cite this example merely to raise the question of the *affective* character of documentary. Documentary photography has amassed mountains of evidence. And yet, in this pictorial presentation of scientific and legalistic "fact," the genre has simultaneously contributed much to spectacle, to retinal excitation, to

235

voyeurism, to terror, envy and nostalgia, and only a little to the critical understanding of the social world.

A truly critical social documentary will frame the crime, the trial, and the system of justice and its official myths. Artists working toward this end may or may not produce images that are theatrical and overtly contrived, they may or may not present texts that read like fiction. Social truth is something other than a matter of convincing style. I need only cite John Heartfield's overtly *constructed* images, images in which the formal device is absolutely naked, as examples of an early attempt to go beyond the phenomenal and ideological surface of the social realm. In his best work, Heartfield brings the base to the surface through the simplest of devices, often through punning on a fascist slogan ("Millions stand behind me"). Here, construction passes into a critical *deconstruction*.

A political critique of the documentary genre is sorely needed. Socially conscious American artists have much to learn from both the successes *and* the mistakes, compromises, and collaborations of their Progressive Era and New Deal predecessors. How do we assess the close historical partnership of documentary artists and social demo-crats? How do we assess the relation between form *and* politics in the work of a more progressive Worker's Film and Photo League? How do we avoid a kind of estheticized political nostalgia in viewing the work of the Thirties? And how about the co-optation of the docu-mentary style by corporate capitalism (notably the oil companies and the television networks) in the late 1940's? How do we dis-entangle ourselves from the authoritarian and bureaucratic aspects of the genre, from its implicit positivism? (All of this is evidenced in any one second of an Edward R. Murrow or a Walter Cronkite telecast.) How do we produce an art that elicits dialogue rather than uncritical, pseudo-political affirmation?

Looking backward, at the art-world hubbub about "photography as a fine art," we find a near-pathological avoidance of any such questioning. A curious thing happens when documentary is offi-cially recognized as art. Suddenly the hermeneutic pendulum careens from the objectivist end of its arc to the opposite, subjectivist end. Positivism yields to a subjective metaphysics, technologism gives way to auteurism. Suddenly the audience's attention is directed toward mannerism, toward sensibility, toward the physical and emo-tional risks taken by the artist. Documentary is thought to be art when it transcends its reference to the world, when the work can be regarded, first and foremost, as an act of self-expression on the part of the artist. To use Roman Jakobson's categories, the referential function collapses into the expressive function. A cult of authorship, an auteurism, takes hold of the image, separating it from the social conditions of its making and elevating it above the multitude of

lowly and mundane uses to which photography is commonly put. The culture journalists' myth of Diane Arbus is interesting in this regard. Most readings of her work careen along an axis between opposing poles of realism and expressionism. On the one hand, her portraits are seen as transparent, metonymic vehicles for the social or psychological truth of her subjects; Arbus elicits meaning from their persons. At the other extreme is a metaphoric projection. The work is thought to express her tragic vision (a vision confirmed by her suicide); each image is nothing so much as a contribution to the artist's self-portrait. These readings coexist, they enhance one another despite their mutual contradiction. I think that a good deal of the generalized esthetic appeal of Arbus's work, along with that of most art photography, has to do with this indeterminacy of reading, this sense of being cast adrift between profound social insight and refined solipsism. At the heart of this fetishistic cultivation and promotion of the artist's humanity is a certain disdain for the "ordinary" humanity of those who have been photographed. They become the "other," exotic creatures, objects of contemplation. Perhaps this wouldn't be so suspect if it weren't for the tendency of professional documentary photographers to aim their cameras downward, toward those with little power or prestige. (The obverse is the cult of celebrity, the organized production of envy in a mass audience.) The most intimate, human-scale relationship to suffer mystification in all this is the specific social engagement that results in the image; the negotiation between photographer and subject in the making of a portrait, the seduction, coercion, collaboration, or rip-off. But if we widen the angle of our view, we find that the broader institutional politics of elite and "popular" culture are also being obscured in the romance of the photographer as artist.

The promotion of Diane Arbus (along with a host of other essentially mannerist artists) as a "documentary" photographer, as well as the generalized promotion of introspective, privatistic, and often narcissistic uses of photographic technology both in the arena of art photography and that of the mass consumer market, can be regarded as a symptom of two countervailing but related tendencies of advanced capitalist society. On the one hand, subjectivity is threatened by the increasingly sophisticated administration of daily life. Culture, sexuality, and family life are refuges for the private, feeling self in a world of rationalized performance demands. At the same time, the public realm is "depoliticized" to use Jurgen Habermas's term; a passive audience of citizen-consumers is led to see political action as the prerogative of celebrities. Consider the fact that the major television networks, led by ABC, no longer even pretend to honor the hallowed separation demanded by liberal ideology

Allan Sekula

between "public affairs" and "entertainment." News reporting is now *openly,* rather than covertly, stylized. The mass media portray a wholly *spectacular* political realm, and increasingly provide the ground for a charismatically directed, expressionist politics of the right. Television has never been a realist medium, nor has it been capable of narrative in the sense of a logical, coherent account of cause and effect. But now, television is an openly *symbolist* enterprise, revolving entirely around the metaphoric poetry of the commodity. With the triumph of exchange value over use value, all meanings, all lies, become possible. The commodity exists in a gigantic substitution set; cut loose from its original context, it is metaphorically equivalent to all other commodities.

The high culture of the late capitalist period is subject to the unifying semantic regime of formalism. Formalism neutralizes and renders equivalent, it is a universalizing system of reading. Only formalism can unite all the photographs in the world in one room, mount them behind glass, and *sell* them. As a privileged commodity fetish, as an object of connoisseurship, the photograph achieves its ultimate semantic poverty. But this poverty has haunted photographic practice from the very beginning.

III

I'D LIKE, FINALLY, to discuss some alternative ways of working with photographs. A small number of contemporary photographers have set out deliberately to work against the strategies that have succeeded in making photography a high art. I've already outlined the general political nature of their intentions. Their work begins with the recognition that photography is operative at every level of our culture. That is, they insist on treating photographs not as privileged objects but as common cultural artifacts. The solitary, sparely captioned photograph on the gallery wall is a sign, above all, of an aspiration toward the esthetic and market conditions of modernist painting and sculpture. In this white void, meaning is thought to emerge entirely from within the artwork. The importance of the framing discourse is masked, context is hidden. These artists, on the other hand, openly bracket their photographs with language, using texts to anchor, contradict, reinforce, subvert, complement, particularize, or go beyond the meanings offered by the images themselves. These pictures are often located within an extended narrative structure. I'm not talking about "photo essays," a cliché-ridden form that is the noncommercial counterpart to the photographic advertisement. Photo essays are an outcome of a mass-circulation picture-magazine esthetic, the esthetic of the merchandisable column-inch

and rapid, excited reading, reading made subservient to visual titil-lation. I'm also not talking about the "conceptual" and "post conceptual" art use of photography, since most such work unequivocally accepts the bounds of an existing art world.

Of the work I'm dealing with here, Martha Rosler's *The Bowery in two inadequate descriptive systems* (1975) comes the closest to having an unrelentingly *metacritical* relation to the documentary genre. The title not only raises the question of representation, but suggests its fundamentally flawed, distorted character. The object of the work, its referent, is not the Bowery per se, but the "Bowery" as a socially mediated, ideological construction. Rosler couples twenty-four photos to a near-equal number of texts. The photographs are frontal views of Bowery storefronts and walls, taken with a normal lens from the edge of the street. The sequence of street numbers suggests a walk downtown, from Houston toward Canal on the west side of the avenue, past anonymous grates, abandoned shopfronts, flop house entrances, restaurant supply houses, discreetly labeled doors to artists' lofts. No people are visible. Most of the photos have the careful geometric elegance—they seem to be deliberate quotations —of Walker Evans. The last two photographs are close-ups of a litter of cheap rosé and white port bottles, again not unlike Evans's 1968 picture of a discarded pine deodorant can in a trash barrel. The cool, deadpan mannerism works against the often expressionist liberal-ism of the find-a-bum school of concerned photography. This anti-"humanist" distance is reinforced by the text, which consists of a series of lists of words and phrases, an immense slang lexicon of alcoholism. This simple listing of names for drunks and drunkenness suggests both the signifying richness of metaphor as well as its referential poverty, the failure of metaphor to "encompass," to explain adequately, the material reality to which it refers.

We have nautical and astronomical themes: "deck's awash" and "moon-eyed." The variety and "wealth" of the language suggests the fundamental aim of drunkenness, the attempted escape from a painful reality. The photographs consistently pull us back to the street, to the terrain from which this pathetic flight is attempted. Rosler's found poetry begins with the most transcendental of metaphors, "aglow, illuminated" and progresses ultimately, through numerous categories of symbolic escape mingled with blunt recognition, to the slang terms for empty bottles: "dead soldiers" and "dead marines." The pool of language that Rosler has tapped is largely the socio-linguistic "property" of the working class and the poor. This language attempts to handle a irreconcilable tension between bliss and self-destruction in a society of closed options.

The attention to language cuts against the pornography of the

```
lush     wino      rubbydub
      inebriate
            alcoholic
barrelhouse bum
```

From MARTHA ROSLER, *The Bowery in two inadequate descriptive systems,* 1975, photographs and text

"direct" representation of misery. A text, analogous formally to our own ideological index of names-for-the-world, interposes itself between us and "visual experience."

Most of Rosler's other work deals with the internalization of oppressive namings, usually with the structuring of women's consciousness by the material demands of sex and class. Her videotape, *Vital Statistics of a Citizen, Simply Obtained* (1976) portrays documentation as the clinical, brutal instrumentality of a ruling elite bent on the total administration of all aspects of social life: reproduction, child-rearing, education, labor and consumption. A woman is slowly stripped by white-coated technicians, who measure and evaluate every *component* of her body. A voice-over meditates on violence as a mode of social control, on positivism, on the triumph of quantity, on the master's voice from within. Rosler refers to the body as the fundamental battleground of bourgeois culture.

Since I've mentioned video, I ought to point out that the most developed critiques of the illusory facticity of photographic media have been cinematic, stemming from outside the tradition of still photography. With film and video, sound and image, or sound, image, and text, can be worked *over* and *against* each other, leading to the possibility of negation and metacommentary. An image can be offered as evidence, and then subverted. Photography remains a primitive medium by comparison. Still photographers have tended to believe naively in the power and efficacy of the single image. Of course, the museological handling of photographs encourages this belief, as does the allure of the high-art commodity market. But even photojournalists like to imagine that a good photograph can punch through, overcome its caption and story, on the power of vision alone. The power of the overall communicative system with its characteristic structure and mode of address, over the fragmentary utterance, is ignored. Brecht's remarks in "The Modern Theatre Is the Epic Theatre" are worth recalling on this issue, despite his deliberately crude and mechanistic way of phrasing the problem:

> The muddled thinking which overtakes musicians, writers
> and critics as soon as they consider their own situation
> has tremendous consequences to which too little atten-
> tion is paid. For by imagining that they have got hold
> of an apparatus which in fact has got hold of them they
> are supporting an apparatus which is out of their con-
> trol. . . .

The critical anti-naturalism of Brecht, continued in the politically and formally reflexive cinematic modernism of Chris Marker, Godard,

Allan Sekula

and the team of Jean-Marie Straub and Danielle Huillet, stands as a guide to ideologically self-conscious handling of image and text. Americans, schooled in positivism from infancy, tend to miss the point. It was Americans who mistranslated the reflexive documentary methods of Dziga Vertov's Kino-Pravda and Jean Rouch's cinema-verite into "direct cinema," the cult of the invisible camera, of life caught unawares. The advent of the formalist reflexivity of "structural film" hasn't helped matters either, but merely serves as a crude antithesis to the former tendency.

Jon Jost's film *Speaking Directly* (1975) and Brian Connell's videotapes *La Lucha Final* (1976) and *Petro Theater* (1975) stands as rare examples of American works that write a developed left-wing politics with an understanding of the relation between form and ideology within the documentary genre. *La Lucha Final* dissects the already fragmented corpus of television news by constructing (perhaps deconstructing is the more appropriate word) a detective story narrative of American imperialism in crisis. The story emerges on the basis of scavenged material: State Department publicity photos, Tet offensive news footage, bits of late night television movies. American agents are always asking the wrong questions too late. Another of Connell's tapes, *Petro Theater,* decodes mysterious photo-postcard islands floating off the coast of Long Beach, California. These man-made oil drilling operations are disguised as tropical paradises, complete with palm trees and waterfalls. The derricks themselves are camouflaged as skyscrapers, made to pose as corporate head-quarters. Connell's tape reads the island as an image of colonial territory, as nature dominated by an aggressive and expansionist corporate order. The islands are named for dead astronauts, allowing the derricks to assume the glamor of moon rockets. Connell plays the offshore mirage against the political economy of the "energy crisis." Photography like that of Lewis Baltz, to give a counter example, suggests that the oxymoronic label, "industrial park" is somehow natural, an unquestionable aspect of a landscape that is both a source of Pop disdain and mortuarial elegance of design. Baltz's photographs of enigmatic factories fail to tell us anything about them, to recall Brecht's remark about a hypothetical photograph of the Krupp works. Connell, on the other hand, argues that advanced capitalism depends on the ideological obliteration of the base. In California, we are led to believe, no one works, people merely punch in for eight hours of Muzak-soothed leisure in air-conditioned condominium-like structures that are somehow sites for the immaculate conception of commodities.

Jost's *Speaking Directly* is a rigorously phenomenological attempt at political autobiography, setting Jost's own subjectivity as film-

242

maker, as he-who-speaks, as: particular and emblematic male, as American, as war resister, as rural dropout, as intellectual, as lover, friend, and enemy to numerous Others. Against its determinations and constraints, Jost is continually exposing the problematic character of his own authorship, suggesting his own dishonestly in attempting to construct a coherent image of "his" world. The film skirts solipsism; in fact, Jost resists solipsism through an almost compulsively repetitive rendering of a politicized "outer world." American defoliant bombers waste a section of Vietnam again and again, until the viewer knows the sequence's every move in advance. Magazine advertisements pile up endlessly in another sequence. The "politics" of Jost's work lies in an understanding it shares with, and owes to, both the Women's Liberation Movement and sections of the New Left; the understanding that sexuality, the formation of the self, and the survival of the autonomous subject are fundamental issues for revolutionary practice.

These concerns are shared to a large extent by Philip Steinmetz in a six-volume sociological "portrait" of himself and his relatives. The entire work, called *Somebody's Making a Mistake* (1976), is made up of more than six hundred photographs taken over several years. The pictures are well-lit, full of ironic incident and material detail, reminiscent of Russell Lee. Steinmetz pays a great deal of attention to the esthetics of personal style, to clothing and gesture, to interior decoration. His captions vary between sociological polemic and personal anecdote. The books are a curious hybrid of the family album and a variety of elegantly handcrafted coffee-table book. The narrative span of the family album is compressed temporally, resulting in a maddening intensity of coverage and exposure.

While covering intimate affairs, Steinmetz offers a synecdochic representation of suburban middle-class family life. At the same time the work is a complex autobiography in which Steinmetz invents himself and is in turn invented, appearing as eldest son, ex-husband, father, alienated and documentation-obsessed prime mover, and escapee with one foot in a suburban petit-bourgeois past. The work pivots on self-implication, on Steinmetz's willingness to expose his interactions with and attitudes toward the rest of the family. The picture books are products of a series of discontinuous theatrical encounters; the artist "visits the folks." Some occasions are full of auspicious moments for traditional family-album photography: a birthday, a family dinner. Here Steinmetz is an insider, functioning within the logic of the family, expected, even asked to take pictures. At other moments the camera is pulled out with less fanfare and approval, almost on the sly, I imagine. Other encounters are deliberately staged by the photographer: on a weekend visit he photo-

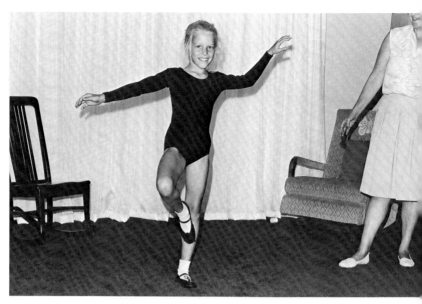

Mom: " Traci has learned how to set a beautiful table. She has your artistic abilities."

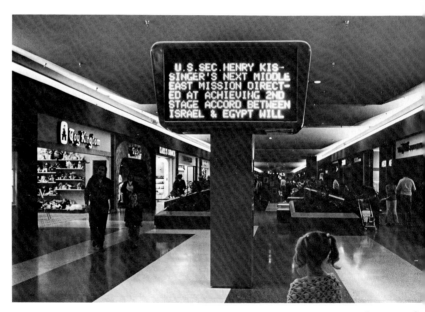

DAD: "This isn't like communist Russia where they set down the rules and feed the people only one kind of propaganda until they believe that white is black."

From PHILIP A. STEINMETZ, *Somebody's Making a Mistake,* 1976 photographic books with text

graphs his daughter in front of an endless toy-store display of pack-aged games. She smiles rather quizzically. Judging from the titles, the games are all moral exercises in corporate virtue, male aggression, and female submission. I'm reminded of a frame from Godard, but this picture has a different affect, the affect of real, rather than emble-matic, relationships.

Eventually the artwork became a familial event in itself. Stein-metz visited his parents with a handful of his books, asking them to talk captions into a tape recorder. Other artists and photographers have done this sort of thing with family archives; Roger Welch is an example. The difference here is that Steinmetz is not particularly interested in memory and nostalgia in themselves. His pictures are geared to elicit ideological responses; they are subtle provocations. The work aims at revealing the power structure within the extended family, the petit-bourgeois ambitions of the men, their sense of ownership, and the supportive and subordinate role of the women. Steinmetz's father, a moderately successful building contractor, poses by the signpost for a subdivision street he named: Security Way. The photographer's mother sits in the kitchen reading a re-ligious tract entitled *Nervous Christians*. He comes closest to identi-fying with his daughter, with the possibility of her rebellion.

The last of the six books deals with his ex-wife's second wedding. Steinmetz appears at a dress rehearsal—as what? Guest, interloper, official photographer, voyeur, ghost from the past? His wife's new in-laws look troubled. The pictures have a curious sense of the ab-surd, of packaged roles poorly worn, of consumer ritual. The camera catches a certain awkwardness of tuxedo-and-gown-encased gesture and movement. The groom is late, and someone asks Steinmetz to stand in for him. The affair takes on a television situation comedy aspect as familial protocol lapses into absurdity.

Fred Lonidier deals more with public politics than with the family. *The Health and Safety Game* (1976) is about the "handling" of indus-trial injury and disease by corporate capitalism, pointing to the *systemic* character of everyday violence in the workplace. Some statistics: one in four American workers is exposed on a daily basis to death, injury, and disease-causing work conditions. According to a Nader report, "job casualties are statistically at least three times more serious than street crime." (So much for TV cop shows.)

An observation: anyone who has ever lived or worked in an indus-trial working-class community can probably attest to the commonness of disfigurement among people on the job and in the street. Disease is less visible and has only recently become a public issue. I can re-call going to the Chicago Museum of Science and Industry and visiting the "coal mine" there. Hoarse-voiced men, retired miners,

WAITRESS'S BACK. "He said he had known other comp. attorneys in th[e] past that would work for the workers and really get in there and get for ther[e] what they deserved. Then the first thing you know they'd be becoming mor[e] pro-company, pro-company because it's easier."

OIL WORKER'S BURNS. "When it really comes down to the nitty-gritty it['s] the employees themselves who won't really make a stand on safety. When i[t] comes down to the bread-and-butter issue, if you make a strike issue over [a] safety matter, it's going to take a lot more education, in my opinion."

From FRED LONIDIER, *THE HEALTH AND SAFETY GAME: Fiction Based on Fact,* 1976, photographs, text, and videotape

led the tourists through a programmed demonstration of mining technology. When the time came to deal with safety, one of the guides set off a controlled little methane explosion. No one mentioned black-lung disease in this corporate artwork, although the evidence rasped from the throats of the guides.

Lonidier's "evidence" consists of twenty or so case studies of individual workers, each displayed on large panels laid out in a rather photojournalistic fashion. The reference to photojournalism is deliberate, I think, because the work refuses to deliver any of the empathic goodies that we are accustomed to in photo essays. Conventional "human interest" is absent. Lonidier is aware of the ease with which liberal documentary artists have converted violence and suffering into esthetic objects. For all his good intentions, for example, Eugene Smith in *Minamata* provided more a representation of his compassion for mercury-poisoned Japanese fisherfolk than one of their struggle for retribution against the corporate polluter. I'll say it again: the subjective aspect of liberal esthetics is compassion rather than collective struggle. Pity, mediated by an appreciation of "great art," supplants political understanding. Susan Sontag and David Antin have both remarked that Eugene Smith's portrait of a Minamata mother bathing her retarded and deformed daughter is a seemingly deliberate reference to the *Pietà*.

Unlike Smith, Lonidier takes the same photographs that a doctor might. When the evidence is hidden within the body, Lonidier borrows and copies x-ray films. These pictures have a brute, clinical effect. Each worker's story is reduced to a rather schematic account of injury, disease, hospitalization, and endless bureaucratic runaround by companies trying to shirk responsibility and liability. All too frequently we find that at the end of the story the worker is left unemployed and undercompensated. At the same time, though, these people are fighting. A machinist with lung cancer tells of stealing samples of dust from the job, placing them on the kitchen griddle in a home-made experiment to detect asbestos, a material that his bosses had denied using. The anonymity of Lonidier's subjects is a precaution against retaliation against them; many are still fighting court cases; many are subject to company intimidation and harassment if they do make their stories public.

Lonidier's presentation is an analog of sorts for the way in which corporate bureaucrats handle the problem of industrial safety, yet he subverts the model by telling the story from below, from the place occupied by the worker in the hierarchy. The case-study form is a model of authoritarian handling of human lives. The layout of the panels reflects the distribution of power. Quotes from the workers are set in type so small that they are nearly unreadable. The titles

247

are set in large type: "Machinist's Lung," "Egg-Packer's Arm." The body and the life are presented as they have been fragmented by management. Injury is a loss of labor power, a negative commodity, overhead. Injury is not a diminishing of a human life but a statistical impingement on the corporate profit margin.

The danger exists, here as in other works of socially conscious art, of being overcome by the very oppressive forms and conditions one is critiquing, of being devoured by the enormous machinery of material and symbolic objectification. Political irony walks a thin line between resistance and surrender.

Above the case studies, Lonidier presents an analysis of the strategies employed by corporations and unions in the struggle over occupational health issues. The final corporate resorts are closed factories and runaway shops. But implicit in Lonidier's argument is the conclusion that work *cannot,* in the long run, be made safe under capitalism, because of the absolute demand for increasing capital accumulation under escalating crisis conditions. Most businessmen know this, and are resisting reforms for that very reason. The health issue exposes an indifference to human life that goes beyond ethics, an indifference that is structurally determined and can only be structurally negated.

Lonidier's aim is to present his work in a union hall context; so far showings have included a number of art school galleries, a worker's art exhibition at the Los Angeles Museum of Science and Industry, the Whitney Museum, AFSCME District Council 37 AFL-CIO in New York City (AFSCME, the American Federation of State, County, and Municipal Employees, is the largest union of workers in the state sector in the United States), and at the Center for Labor Studies at Rutgers University.

Since the late 1940's, anti-communism has been a dominant ideology within American organized labor. Thus, for obvious reasons, *The Health and Safety Game* only makes explicit a critique of the current monopoly stage of capitalist development, without pointing directly to the necessity of socialist alternatives. This is only one of the problems of working *through* labor bureaucracy and *toward* a rank-and-file audience. At the same time, it should be noted that a number of progressive unions, mostly in New York, are beginning to develop cultural programs. Potentially, this could amount to an attempt to counteract the hegemony of corporate culture and restore some of the working-class cultural traditions that were obliterated with the onslaught of the 1950's. Recent documentary films like Barbara Kopple's *Harlan County U.S.A.* and *Union Maids* by Julia Reichert and Jim Klein keep alive a tradition of working-class militancy, emphasizing the active role of women in struggle. Both films

reveal the importance of oral history and song for maintaining working-class traditions, both emerge from the filmmakers' partisan commitment to long-term work from *within* particular struggles. Neither of these films qualifies as the standard "neutral" airplane-ticket-in-the-back-pocket sort of documentary.

Nearly all the work I'm discussing here demands a critical re-evaluation of the relationship between artists, media workers, and their "audiences." I'm not suggesting that the mass media can effectively be infiltrated. Mass "communication" is almost entirely subject to the pragmatics of the one-way, authoritarian manipulation of consumer "choices." I think "marginal" spaces have to be discovered and utilized, spaces where issues can be discussed collectively: union halls, churches, high schools, community colleges, community centers, and perhaps only reluctantly, public museums. Still photographers ought to consider "vulgar" and "impure" formats, such as the slide shows; but formal questions can only follow a more fundamental re-definition of political priorities. A number of cultural workers in the Oakland area are using slide shows didactically and as catalysts for political participation. Bruce Kaiper has produced work on the capitalist image of labor using a critical reading of *Fortune* magazine advertisements and historical material on scientific management. Ellen Kaiper has done a piece on the forced layoffs and "domestication" of women industrial workers after the Second World War. These shows are designed primarily for audiences of working people by people who are themselves workers. Fern Tiger is working on an extended documentation of class structure and conflict in Oakland. Her working method involves a lot of prolonged interaction with the people she photographs. She makes return visits with prints as part of an attempt to overcome the traditional aloofness of the merely contemplative sociological observer or journalistic photographer. Mel Rosenthal is involved in a similar project in the South Bronx.

My own work with photographs revolves around relationships between wage-labor and ideology, between material demands and our imaginary coming-to-terms with those demands. I use "autobiographical" material, but assume a certain fictional and sociological distance in order to achieve a degree of typicality. My personal life is not the issue; it's simply a question of a familiarity that forms the necessary basis for an adequate representational art. I've tended to construct narratives around crisis situations; around unemployment and workplace struggles, situations in which ideology fails to provide a "rational" and consoling interpretation of the world, unless one has already learned to expect the worst. What I've been interested in, then, is a failure of petit-bourgeois optimism, a failure that leads to either progressive or reactionary class identifications in periods of

"... a political novel in which the workers were denied the privilege of psychological treatment ... a psychological novel in which the boss invented workers ... a political novel in which the workers were allowed the privilof psychological treatment ..."

From ALLAN SEKULA, *This Ain't China: a photonovel,* 1974, photographs and text

"... i photographed the inside of the apartment ... i photographed resume ..."

From ALLAN SEKULA, *Aerospace Folktales,* 1973, photographs, text, audiotape

economic crisis. *Aerospace Folktales* (1973) is a family biography which focuses on the effects of unemployment on white-collar technical workers, on people who have internalized a view of themselves as "professionals" and subsequently suffer the shock of being dumped into the reserve army of labor. I was interested in the demands unemployment places on family life, in the family as refuge, training ground and women's prison. As Max Horkheimer has noted, unemployment blurs the boundaries between the private and the social. Private life becomes mere waiting for work, just, I might add, as work is increasingly a mode of waiting for life, for a delayed gratification. For men who have internalized the demands of production, forced idleness can breed both small and large insanities, from the compulsive straightening of lamps to despair and suicide.

This Ain't China (1974) is a photonovel which grew out of an attempt to unionize a restaurant. The work is a comedy about theatricalized food, about food as a central fetishized image in an organized drama of "service." Among other things, I wanted to portray the conditions under which people stop obeying orders, and in the way repetitive alienated work colonizes the unconscious, particularly work in crowded, greasy "backstage" kitchens.

Formally, I use long edited sequences of still photographs, usually broken up into "shots" of varying length, as well as lengthy novelistic texts and taped interviews. The photographs deliberately quote a variety of stylistic sources: from motion studies to a deadpan, clinical version of color food photography. The narrative moves self-consciously between "fictional" and "documentary" modes. A lot of scenes are staged. Both *Aerospace* and *China* have been shown on the wall, as books, and, most effectively in a political sense, as live slide shows for people who have something other than a merely esthetic relation to the issues involved.

Chauncey Hare is a photographer who happens to have spent twenty years of his life as a chemical engineer. This biographical note is central to the meaning of his work. Of all the people I've discussed, he has the least relation to a hybridized, pictorially disrespectful narrative approach to the photographic medium. His photography grows out of a by now established documentary tradition, characterized by a belief in the efficacy of the single image, and a desire to combine formal elegance with a clarity of detail. The radicalism of Hare's work lies in his choice of a terrain and his identification with its inhabitants.

Hare is beginning to be known for work done over the past ten years while traveling across the United States, taking careful, tripod mounted portraits of people, mostly working people, in their home environments. These images depict home life as a source of dignity

251

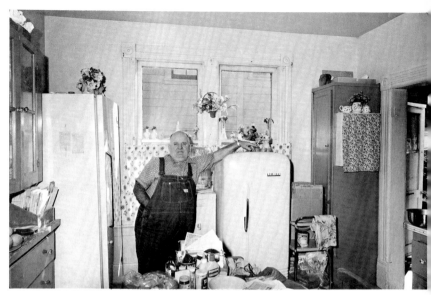

Point Richmond, California, 1976. "I was a refinery stage rigger and was hurt permanently. I get no compensation from the oil company. I still pay for my own medicines. They use you and when they are done, well . . . it's tough for you!" [signed] Orville England, Standard Oil Co.

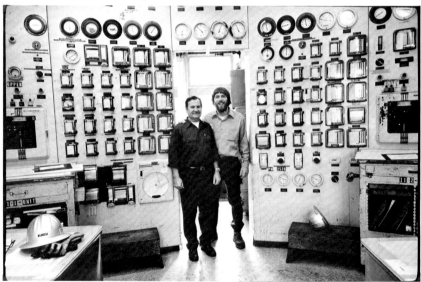

Control Room of a Crude Oil Distillation Unit, Standard Oil Refinery, Richmond, California, 1977

From CHAUNCEY HARE, *A Study of Standard Oil Company Employees,* 1976-77, photographs and audiotaped interviews

and grace (his portrait-subjects are always on balance, sharing none of the grotesquery of Arbus or Bill Owens) and as something flawed, something invaded by the horrific sameness of a consumer culture. It is in the grasping of this dialectical character of family and private life, that Hare partakes of the same general critique I've been noting in the work of other politically aware photographers. This earlier work of Hare's, exhibited in 1977 at the Museum of Modern Art and published by Aperture as *Interior America,* continues in these contexts to reinforce the dominant American myth of the documentary photographer as a rootless wanderer, of art as the project of a contemplative, but voracious eye.

Of course, Hare with his careful, sympathetic interactions, doesn't share the transcontinental anomic flaneurerie of the Robert Frank tradition. For the moment, then, I'm more interested in a more recent project of Hare's, entitled *A Study of Standard Oil Company Employees* (1976-77). It is unlikely that this work will even be exhibited at the Rockefeller-backed Museum of Modern Art which is, after all, a cultural edifice built on Standard Oil profits, notwithstanding the "relative autonomy" of John Szarkowski's curatorial decisions. Using credentials as a Guggenheim photography fellow, Hare asked his employers for a year's leave of absence from his engineering job, only that he might return to work every day and take photographs that would begin to expose what he saw as the relation between "technology and alienation." Somehow, corporate public relations agents saw the project in a positive light and approved it. After only three months of independent work, Hare's investigations were terminated by a suddenly threatened management. During his wanderings in this familiar territory, Hare photographed and interviewed at every level of the corporate hierarchy, ranging from refinery operators, maintenance workers and headquarters keypunch operators, to supervisors and executive engineers. His photographs form a kind of metonymic map of an abstract bureaucratic structure. Each portrait suggests a life and a position. One sees evidence of the elaborately coded privileges and humiliations of autocratically managed large enterprises. An executive inhabits a large office on an upper floor with a plate glass view of San Francisco's financial district. In a corner, a far corner, behind an expensive potted plant, he keeps a small photographic shrine to his wife and kids. Refinery operators, unable to leave their job sites for lunch, eat sandwiches as they stare at walls of gauges. A woman's head is barely visible in a labyrinthine word-processing cubicle. A line of refinery operators sits glumly on a bench while their supervisor lectures them about a failed valve, exhibited prominently in the foreground of the picture.

253

Allan Sekula

Hare's photographs demand extended captions. His interviews serve to reveal the subjective aspects of the work experience, something photographs can only suggest indirectly. Interviews allow for a kind of self-authorship that portraiture offers only in an extremely limited and problematic way. The photographer always has the edge; and a moment is, after all, only a moment, and only a *visible* moment at that. Speech allows for critical reflection, for complaints, for the unfolding of personal histories, for the voicing of fears and hopes. Hare was trained as a technocrat and a pragmatist, trained to submit all problems to the logic of an efficiency defined solely in terms of profit. This is hardly a personal attack, but merely a remark on the historical role of the engineering profession under capitalism. Hare brings an engineer's knowledge, coupled with an ethical integration of "fact" and "value," to his critique of the petrochemical industry. And yet he sees in the refinery workers an image of his own, previously unacknowledged, proletarianization. He overcomes the contempt commonly felt by professional and technical staff for the people who actually run the everyday operations of a large refinery complex. Refineries are increasingly dangerous, both to workers and to the surrounding communities. Understaffed and poorly maintained, many plants are potential bombs. Pipes wear thin and explode; operators have to contend with doubled and tripled work loads. This crisis situation is evident in Hare's pictures and interview transcripts. A lone worker is photographed in the midst of a large tank truck loading complex for which he alone is responsible, rather than the normal crew of three. A number of the workers photographed by Hare have since died of cancer. The Richmond, California area, where Hare both works and lives, is a petrochemical center with the highest per capita rate of cancer in the country. As a known member of the community and friend, Hare photographs many of the workers in their homes, in private life and retirement. It is among these older retired workers that he discovers the most variations on the theme of uncompensated injuries and epidemic carcinoma. The younger workers know what awaits them, and talk about their options.

Like Lonidier, Hare has had to protect many of his subjects from the potential consequences of their remarks, from company reprisals. However, he has chosen an altogether different approach to the problems of visual representation, preferring portraiture to a deadpan, clinical style of photography. Lonidier accepts the reified form of visual depiction, and works toward its subversion through storytelling and political analysis. Hare begins with a "humanized" image, but embeds the portrait within a larger frame, within the very midst of a bureaucratic labyrinth and a modern "automated" version of the dark, satanic mill with its routine, its boredom, its sterility and its invisible poisons.

254

Dismantling Modernism, Reinventing Documentary

IV

I'M ARGUING, then, for an art that documents monopoly capitalism's inability to deliver the conditions of a fully human life, for an art that recalls Benjamin's remark in the *Theses on the Philosophy of History* that "there is no document of civilization that is not at the same time a document of barbarism." Against violence directed at the human body, at the environment, at working people's ability to control their own lives, we need to counterpose an active resistance, simultaneously political and symbolic, to monopoly capitalism's increasing power and arrogance, a resistance aimed ultimately at socialist transformation. A naive faith in both the privileged subjectivity of the artist, at the one extreme, and the fundamental "objectivity" of photographic realism, at the other, can only be overcome in a recognition of cultural work as a *praxis*. As Marx put it in *The Economic and Philosophic Manuscripts of 1844*:

> It is only in a social context that subjectivism and objectivism, spiritualism and materialism, activity and passivity cease to be such antinomies. The resolution of the *theoretical* contradictions is possible *only* through practical means, only through the *practical* energy of man.

A didactic and critical representation is a necessary but insufficient condition for the transformation of society. A larger, encompassing praxis is necessary.

255

A FEW ALTERNATIVES

PAUL VANDERBILT

THE YOUNG PHOTOGRAPHERS I meet, those who have ambitions rather than solidly established reputations, seem excessively preoccupied with finding a sure route into the top elite of photography, to that company of a few hundred names which are widely recognized as those who are sought for exhibition, sales and publications. This route now seems to me both limited and overcrowded, and I venture the opinion that the path to glory now involves something beyond the turning out of even very outstanding individual pictures, something in the nature of more massive achievement, more effective showmanship and greater justification for personal identification with a particular enterprise. This can indeed take many forms, but I think it soon will have to be something more than a portfolio. I see personal distinction in that part of filmmaking which touches the objectives of still photography, in the rapidly growing field of video, in multimedia, perhaps in holography, perhaps in projection technologies yet to come. And in fully informed and sophisticated slide projection shows. Furthermore it is in such distinctive and intensive subject specialization in still photography, whole lifetimes of dedication, not likely to be duplicated, that a name becomes definitively associated not with a fragmentary coverage, but with a lasting archive, not of photography as such, but of something which photography can do, carried to fulfillment as of its time. To get beyond the ingrowing and competitive coterie of fellow photographers, an achievement will have to be big, and represent a lot of work, and reach outside of the medium itself. I'm speaking of renown and a place in the history books, where there just is not enough room for the reputations of all these aspirants. I think the future of the photographer as an artist producing precious gems of insight is something more modest, more personal, in directions which can indeed accommodate a vast number of individuals.

As a second of three outlooks, I have said that utilitarian photography, the photography of science and commerce, would probably follow indefinitely its present course, spurred by inevitable technical developments. That is, news reporting and photojournalism, portraiture, advertising, scientific recording, travel promotion, "glamour," commercial work, publicity and all manner of purposeful, salable literalness, the true photographic professionalism, is secure and proven and the market is virtually inexhaustible. Those

are the photographs with which our collective consciousness is allegedly so bombarded. This is the logical heritage of the original motivation of photography: to make a good, accurate automatic picture of something somebody wanted a picture of. Most of the purely technical expertise is found among these professionals. That's where the money is, but not the positions as direct contributors to the general culture. The success is likely to be intramural, as among any other comparable fraternity of technicians, and the achievement is collective.

A third direction is much more subtle, even more varied, and, for all its occasional outbursts of egotism, essentially personal and private. I'm saying that it is no longer very impressive, in the public sense, to be able to produce really sensitive and high quality photographic images, revelations of the personal experience. It is the experience which is important, as a personal asset, and not necessarily the disseminated proof of that experience. I think the point has already been carried, and the motive for indefinite continuation, expansion, multiplication now splits along these three lines: public recognition, professional profit and personal pleasure in the image itself, in about the proportion of one historically famous name to a hundred successes in the business to ten thousand beneficiaries of an unpretentious alternative "language" for colloquial use among friends. I think of this private photography as analogous, in its cultural fabric, to sayings, statements, sentences or passages, fragmentary expressions, some of which do indeed become immortal quotations, and to conversation, personal letters, enclosures in letters, passing observations which lend so much charm to individual friendship where heavier pronouncements fail completely. These are not all monuments, but cultural building blocks of another collective kind; it is the distillate from them, often an informal counterbalance, a kind of counterculture, which in the long run counts in perspective. They become very like oral traditions, but something less specific, handed down from eye to eye.

I want to argue that photography is not just for photographers and that its essential characteristic is not excellence but ease in proportion to scope. If the evidence of any such significance in personal photography seems lacking in student work or portfolios in circulation, we are perhaps looking in the wrong place. I claim that it is not necessary to produce pictures in order to practice photography. The making of the tangible paper photograph is but its birth, the beginning of its life as a picture; what follows more significantly is among those who see that picture and in the eventual collective, generative power to which it contributes.

257

Paul Vanderbilt

I present a very conservative view, a view which is personal, but widely held, and yet so gratifying, so inexhaustible, so widely applicable that it is the capacity I most value of all my fortunes, the constant I would be most grieved to lose. It is the enjoyment of almost everything I see about me, in some one of the myriad forms of possible enjoyment, many of which are not allied to approval, but, philosophically, to the wonder of being, complete with all its illusions. When I look at something, anything, which comes into the focus of attention, I have it completely, and I wonder whether any photographer, presenting me with a picture rather than that actuality, could improve it by adding further illusions. And I wonder whether I really want a photographer to see what I see, or prefer that he leave the momentary treasure I have found to me. Certainly, it is photographs I have seen, and thus photographers, who taught me, by exposure, to see these many fulfilling things, some striking at more responsive moments than others, all having some subliminal effect, but only a few serving as constant matrices.

The prevalent feeling is certainly in favor of experiencing the actual event over hearing about it, of seeing the original work rather than its reproduction, of one's own life, however unspectacular, as more precious than biography. Yet we need second-hand keys to the "meaning" of originals, and I often feel, in actual seeing, that the visible original confirms the perhaps not very analogous photograph which I have seen, that without the photograph which led and instructed me, the actuality would be bypassed without concern.

I confess that from this personal viewpoint, the making of photographs as an action, a process or a problem, or a disputation about individual photographers and their merits, seems much less important than the presence or consciousness of photographs in quantity, their timing in relation to my own thought, their acquisition in my own memory. In its most extreme form, I have imagined, though nothing could be less demonstrable, that I have seen something in actuality, recognized its potentiality through the guideline of a photograph perhaps far removed, and only then, by that association been able to previsualize, to project a figment of my own, quite unsubstantiated, which momentarily seems more wondrous than the picture which originally was my mentor.

I am led to transpose the stated theme of the debate ["between photography as a detached, symbolic, formalistic art and the photographer as necessarily mediating between the objective world and a humanistic vision of it"] into a question whether photography, as a critical subject, is primarily about photographers and their work or about things, and reactions to things, things and complexes of things altered and altering because of photography's subtle but controlled

258

guidance. Detachment and concern seem to me most like differences of personality, differences of taste between paths of resistance, and I wonder whether the complex discussion does not derive from a kind of frustration.

We are all constantly asked, even pressured, to contribute for the sake of humanity, to become involved, to assume obligations, to give money, to be evenhanded in our evaluations, all within an ever-accelerating system of survival strategies. We are asked and expected to remedy situations without number which cannot be charged to human stupidity, for that involves undeserved blame, but can, I think, be blamed on limitations in the understanding acceptance of change. Change is acceptable on the basis of scientific evidence, until it runs counter to human bias, and then not even inevitable death is greeted with anything but regret. We are in pursuit of an elusive quality called truth, always with the belief that truth will in the long run turn out to be to our advantage.

Now I happen to believe that conscious human activity runs on the pursuit of pleasure, and that survival is to be identified with the perpetuation of pleasure. One pleasure after another comes to preoccupy attention, growing out of antecedents and expanding from experimental experience to worldwide system. Each pleasure principle is established first, and sciences, religions, laws, parties, mores are developed to accommodate it, designed to meet its requirements, which are interpreted as right, workable, or even inevitable. Innovation is a new pleasure opening up as a new process, a fresh manoeuver applicable to a new group. Power is pleasure, and so are revolution, knowledge, security, pride, stimulus, adventure, possession, identity and altruism, to an individual or to an entire culture. Communication is its amplifier and formal design its heraldry. Art is its drawing board, the laboratory its grand jury and court of appeals. Conservatism is pleasure at rest; impatience is pleasure frustrated.

The basic photographic act of exposing a picture is very simple and can be taught in about three minutes flat. Back of and surrounding that facility is a complex technology which is optional to the photographer and which he can almost take for granted. That is, he can perfectly well draw on abilities other than his own to master the adjustments to difficult conditions of timing, light, framing, processing and printing. *Then* he, and we all, confront the questions of what and why, of relations and where the picture is going, what to do with it and whether it has potential.

We have chosen, rather than been forced, to let the term "photography" embrace a vast complex of considerations, tangential to and

interconnecting with almost every other field. The real interest, now
that the image can be fixed so reliably, lies in these interconnections.
It may be that we are trying, in our discussions, to resolve from
within "photography," questions better approached from the outside.

Not the least of these is the essentially psychological element of
photography as an aid to status, a way, as in the other arts, to upward
movement and personal distinction, so attractive because it is so
relatively easy and so many of the difficulties are solved by others,
well in keeping with modern change. I know I am not going to
endear myself to artists with this line of thought, but I'll try to make
peace with them another day. Right now I'm addressing some others
whose primary concern is not with individual reputations but with an
evaluation of broad developments.

There is very little room at the top, because the concept of "top"
is by nature selective and elitist. Neither the generalist, nor in fact
anyone except the professional analyst and inventory-maker, needs
or can handle the names and positions of every competent violinist,
every museum-worthy Italian primitive painter, every fast sailboat,
or every person of interest. The limitation is not really based on
debatable quality, but upon the capacity of memory and attention
span. We need signposts at the main intersections, not at every foot
along the way where they would be equally accurate. We need just
enough names to form a framework of reference. Somehow, pho-
tography in its usual forms does not seem to me wholly appropriate
to competition, for it has no tradition of prolonged clapping or
standing ovation, no comparative statistics of measurement, as in
sport.

It has become a habit of thinking to consider the future in terms
of highlights and pay little attention to the fabric of the ordinary
which is spread out in thinner layers. It is the highlights we can focus
on and name and use as plotting points; the ordinary and widespread
things are, in their diffusion, harder to see and grasp until they are
simplified, compacted and expressed in epigrammatic form.

There is a tendency to regard the curators of permanent collections
of photographs in museums and other institutions as arrogant ap-
pointed judges chiefly engaged in deciding what photographers'
work to buy, preserve and exhibit. The public collections are re-
garded as halls of fame, very useful for listing in the biographical
notices and résumés of those whose prints are so honored. There is of
course some truth in this, but honor to individuals is not the primary
purpose of these collections nor their curators. The primary purpose
is the storing up of resources for future study. To those self-centered
interests which have neither aptitude nor motivation for future study
of any kind, this concept of course leads to such epithets as mauso-

A Few Alternatives

leum and the idea of burial. Institutional administrators with very similar motives of reputation and financing counter with emphasis, in popular statements, on educational programs and exhibitions, events of currency and often haste, billed among places to go and things to do, among performances, show business and sports. In the same vein, the publication of a book is often seen as an event, soon dated, and the book itself as a medal or cup won in competition, its principal features the names involved more than the substance. The mystique of the carefully assembled collections and laboriously compiled books as a form of afterlife, an energizing of eternity, is understandably a minority view. The term curator literally means "caretaker," a practical or technological kind of trusteeship, in its idealistic form a priesthood. The essential challenge to a curator's expertise is the problem of adequate representative sampling, of establishing, through a wide spectrum of critical guidance, the criteria for a manageable time-capsule, a distilled essence of life, a work of works. At best, a conscientious curator is not basing his judgments on what he personally likes, but on what his professional knowledge tells him, from among the resources available, are the best structural components of a memory bank for the use of future generations of thinkers. That memory is primarily of what was formulated about what, and only secondarily by whom. The names and dates become the convenient pegs of organization for understanding and synthesis. Much understanding, for an individual, is instant, out of direct experience, but what of its cumulative effect? Every experience draws on some previous interpretation, but the essential purpose of collections and libraries, the principle which has anchored them so firmly and generously, is not the historical reconstruction of the past, nor the reference convenience of looking things up, nor even the attainment of knowledge and truth. It is the maintenance of an indestructible continuity beyond mortal life. Human beings die; artifacts and landscapes are replaced. Formulations and schemas live forever; their originals may be lost or destroyed, but the idea always finds a fresh form of vitality, jumping from medium to medium.

I rather favor libraries for the accumulation of photographs. Their record in this respect has so far been none too energetic or brilliant, though occasionally service-oriented. I favor this because of my devotion to the principle of total access to the distilled record, and I would like to see the formulations of photography consulted and absorbed by the designers of new formulations along with the books and articles directed at the same ends. This association is a vast, gradual enterprise, but it is not unthinkable, even when we are drowning in excessive paper. There are several approaches to this formidable problem of quantity. One is refinement of the judgments

261

upon which retention is based. Another is specialization and avoid-
ance of competitive duplication among institutions, so each one is
not trying to encompass the whole record. A third is miniaturization,
not only to save physical space, but to adapt resources to electronic
analysis and retrieval. One way or another, total access must involve
a network of facilities, an intercultural dispersal, and some inter-
media coordination.

Photography and electronics require expensive equipment, and
normal optical photography requires the location of an external sub-
ject but benefits by a universal vocabulary. Language is instantly
available within each linguistic group, needs externals only as stim-
uli, and, running on brains, instinct and practice, requires only a
minimum of technology. So far, language would seem to lead, not
because it is superior, but because it is immediate.

I can imagine, in my science fiction moments, that some day it will
be possible to record thought to something like the degree with
which magnetic tape records sound. I imagine an individual, an
organism if you will, with electrodes implanted in his nervous sys-
tem, perhaps inconspicuously adapted to the then current hair styles,
if there is hair, and wired to some descendant of the pocket com-
puter tribe. But the output of record of his thinking would not be in
our forms of words and images, but in their common basic structural
impulses, spontaneous as well as reactive, yet another "language,"
made out of the ancient languages we now have, but adapted to
vastly broader horizons. We are medically perhaps already well on
the way to this end.

There is healthy interest in alternatives of all sorts, and "alterna-
tive" has become a key word in the modern idiom. An alternative
is safer than a "change," for one part can presumably be retained,
and there is promise of having it both ways. In the end some things
just turn out to be more alternative than others. The notion of pho-
tography as an alternative "language" is probably its most cogent, and
of course one of its most puzzling, aspects. The suspicion (or theo-
retical conviction) that such is the case is strong, but we must be
patient. To cross over into a real alternative, we shall have to go
beyond pairing of established word concepts with parallel image
connotations, the usual journalistic devotion to pictures that "say
something." The most primitive grunt language was doubtless com-
municative, but we still speak of communication as something ahead,
still imperfect. Susan Sontag writes of photography as a language
of nouns and verbs without connecting syntax. But I think the barrier
to be crossed is precisely through the conventions of syntax, and
that an alternative language, evolved out of existing modules, may
not have or need syntax. Indeed, in the most intuitive photography,

A Few Alternatives

the very lack of rational substance, the alternative order within chaotic or random coincidences, constitutes its most valid excitement. Maybe, to provide connections without rules for connection, and working at a level underlying both words and pictures, the modules which are to become phrases and the modules which are to spark as images will properly interact, almost alternating, a protoimage filling in the connection between momentarily disoriented prewords and the embryo of an appropriate word, struggling toward the tip of the mind's tongue, will link distracted ghosts flying in from the field.

The nearest we come to this effect is doubtless the sound presented simultaneously with screened images before an audience captive to the predetermined timing, that is film or slide show. I am thinking less of dialog or narration than of the sound, music or words, which is there truly to enhance and amplify the picture sequence. *Last Year at Marienbad* is one example, but the effect can be gained with more immediate material. Each reception heightens the other. For years, I have been looking for a book of text and pictures in which the functions alternate, the text picking up from the previous picture, playing out its brief passage, then giving way to another picture, inserted like a following paragraph in the continuity, then taken up by text again, then another picture, and so on, each medium doing what it does best, but in orchestration, the central theme consistent and running smoothly. I think this concept is from something Nancy Newhall wrote. There may be such a book, but I have not seen any with pictures the same width on the page as the blocks of type, and the functional allocation I have in mind. The approximations I know of seem disjointed by comparison. Even so, I can hardly imagine, our habits being what they are, a reader led to give equal time to each alternating unit, as though he read the picture and scanned the text. Some will think immediately of multiple screens and the more elaborate exhibition techniques which combine projection with fixed images. But the limited number of multimedia presentations and tours de force I've seen have required such effort merely to follow, and such overwhelming impression of technology as such that there has been little chance for absorption of the substance. What I think is needed is the closest possible fusion.

In any case, this is neither illustration of texts nor explanation of pictures. It may be that the fusion is not overt, but underlies one phrasing or the other. There are series of pictures which rather than "saying something," lead to something which could not be said without them, and certainly there is writing which induces imagery, perhaps not explicit, but coordinate. The fusion may be in the mind of the writer, a fusion with quantitative pictures he has absorbed rather than a single symbol upon which he is expanding. He is simply

drawing upon what he has seen, just as he draws upon what he has heard, read and already thought. And what he finds applicable may not be literal at all, nor even analogous, but dimensional, range-giving, leading him where, a moment before, he did not know he could go. As the language changes, it may be under the still further liberating influence of graphic exploration into areas unmapped, unnamed, beyond logic, unrestrained by a vocabulary, where the camera goes without a mandate and often without effort. I submit that the end-product of intuitive, personal photography is not a picture at all, but the offspring of pictures as enriched language.

RHODE ISLAND COLLEGE LIBRARY

3 1510 00325 5 3